Between Modernism and Conceptual Art

Between Modernism and Conceptual Art

A Critical Response

by

ROBERT C. MORGAN

McFarland & Company, Inc., Publishers
Jefferson, North Carolina, and London

ALSO BY THE AUTHOR
Conceptual Art: An American Perspective (McFarland, 1994)

Front cover: Sol LeWitt, *Maquette for Outdoor Sculpture 1 × 3 × 6 Half Off* (1983)

British Library Cataloguing-in-Publication data are available

Library of Congress Cataloguing-in-Publication Data

Morgan, Robert C.
 Between modernism and conceptual art : a critical response / by
Robert C. Morgan.
 p. cm.
 Includes bibliographical references and index.
 ISBN 0-7864-0332-2 (sewn softcover : 55# alkaline paper) ∞
 1. Arts, Modern — 20th century. I. Title.
NX456.M667 1997
700'.0945 — dc21 97-8174
 CIP

Manufactured in the United States of America

McFarland & Company, Inc., Publishers
 Box 611, Jefferson, North Carolina 28640

To Gyorgy Kepes

Acknowledgments

I would like to acknowledge the Rochester Institute of Technology for giving me a leave of absence that provided invaluable time to work on this manuscript; the School of Visual Arts, New York, for their continued support in my behalf; and the International Writers Workshop at Ledig House in Omi, New York.

I would especially like to thank my graduate assistant, Cynthia Roberts, at Pratt Institute for her extraordinary commitment in assisting me with the preparation of this manuscript. I could not have done it without her help. Also, Leigh Winter was helpful with last minute additions and corrections.

I would also like to thank the National Endowment for the Humanities for a grant during the summer of 1987 to work on the Allan Kaprow/Joseph Beuys essay at the University of Wisconsin, Milwaukee. The artist Vladimir Jan Zakrzewski was generous to allow my text on his work to be published for the first time in English. I would like to thank the following New York galleries for the loan of photographic material: Marian Goodman, Ronald Feldman, Sandra Gering, Howard Scott (M-13), and John Weber. Gratitude is also extended to the estate of Ted Stamm. Ania Baumritter has been an ongoing source of encouragement in helping me gain a necessary distance both on myself and on my role as an art critic.

Contents

x Contents

SECTION V.
PERFORMANCE AND INTERMEDIA 141

Introduction

A lot of rhetoric has been produced in the New York art world over the last decade. While some of it appeared descriptive and formal, the more important tendency has moved in the direction of theory and ideology. In the eighties, art criticism began to turn promotional. New York art magazines got fat. There were more galleries, auction houses, vodka companies, airline companies, and fashion designers willing to advertise than ever before. As the advertisements poured into these full-color, glossy pages, the rhetoric grew to somehow accommodate the plethora of emerging artists' names, galleries, and blue chip investments.

Ironically, critics had very little to do with the changing art landscape. It was more about how an artist was promoted and by which gallery. If a mediocre show was bought by a wealthy collector, chances were that the artist would get promoted and have another show. The art system worked like a corporate hierarchy. If a good show was not purchased and not reviewed (in the "right" magazine), the artist's chances of getting promoted were meager unless the artist's dealer believed strongly in the work and had the necessary backing — both politically and economically — to keep the gallery in business. As the decade wore on, however, these kinds of situations appeared increasingly on the wane. The little store could not compete against the big store, and the notion of an accurate price equivalent for a work of art was, for the most part, completely dismissed.

In the nineties, the situation changed — both culturally and economically. There were fewer galleries. Many had gone out of business by the end of the eighties. Collectors seemed to have less discretionary income and thus less money was being thrown around in galleries and auction houses. Also, it became evident by the end of 1989 that wealthy American collectors were much less interested in speculating on art. In other words, the notion of art as commodity and investment was severely subsiding. Why?

One reason was that collectors were disillusioned with the price structure that galleries were imposing on their artists' works. Worse, they were disillusioned with the quality of the work — a point that was rarely if ever admitted by a dealer. Something was wrong with the equation. Contemporary art was

1

costing too much. One could spend four or five times as much for a recent large-scale, mixed-media painting by an artist whose reputation had been made five or six years earlier in the East Village as for a good, modestly scaled painting by an established l'École de Paris painter from the twenties.

Another factor was the external economic situation — that is, the economic equivocation that was happening in the international commodities market, beyond the art market. This trend directly implied that there was less money to buy art, and it came to be used as an excuse to avoid gallery-hopping. In fact, the charm of the venture of going to galleries and buying art was beginning to wear off. Collectors were saturated with art goods, and furthermore, many of them were interested in secondary marketing; that is, selling their art back to the gallery from which they purchased it, or to another gallery, so as to put the work back on the market at a higher price. The fact is that nobody was believing the prices, and therefore nobody — or very few — had any interest in buying art under such conditions.

Where does all this leave art criticism?

Having written on Conceptual Art, and having entered into the scene as a professional critic at the beginning of the eighties, I was struck by the changes that were occurring in the art world. I was aware of the aesthetic and anti-aesthetic issues which eventually led to Postmodernism. Yet, before 1980, one rarely if ever spoke about the economics behind a work of art or the manipulation of the art scene. It was not considered important or related to the evolution of significant, advanced art. If Minimal Art, Conceptual Art or Earth Art were important in the recent history of art it was not because the steel cubes or the typing paper or the earth-fill cost a lot of money. The notion of investment in these forms was considered beside the point, if not absurd. If anything it appeared that these developments were a transition away from the Modernism of earlier decades. There was something refreshing about the possibility that art could become invested with ideas and that being an artist could become an intellectual pursuit.

When Neo-Expressionist and Transavantgarde painting and sculpture starting appearing in New York galleries at the end of the seventies, transported largely from Germany and Italy, the art world began to change rather quickly. Not only were the changes moving diametrically opposite to the intellectual developments of earlier Minimal and Conceptual Art, but suddenly art objects were being treated fundamentally as commodities. The presence of figurative representation, coupled with an Expressionist aesthetic, began to appear reactionary, cynical in its motivation, and nihilistically heroic. With a few interesting exceptions — Kiefer, Richter, Polke, Chia, some works by Clemente, some by Baselitz — the imagery seemed less intellectually challenging than either late Modernism or Conceptual Art.

In fact, the new "expressionist" and figurative painting seemed regressive. Once the younger American art school graduates from the seventies got into

the act of trying to reinvest paintings, objects, and large-scale color photographs with "ideas"— spurred by the overwhelming influence of their much superior European colleagues — it became clear that the system of marketing had superseded any qualitative or intellectual motivation. Many of these younger or emerging artists from places like Cal Arts in Valencia, California, or Yale University, or even the Whitney Program in New York were thinking about art conceptually, yet absurdly denying any relationship to Conceptual Art. The motivation, of course, was to appear "new" and without influence. To be without influence was accompanied by a denouncement of the former generation from whom they were borrowing most of their ideas. If their work was intended to shock, it could only do so from the position of shifting art's context, not from the work itself. In most cases, the works themselves were less shocking than the fact that the artists thought what they were doing was significant art and placing them within a gallery or museum context.

Unfortunately, any critical discourse other than the so-called "anti-aesthetic" of Postmodern theory was difficult to find in the eighties. There were some interesting, provocative, and fine art critics working, but it seemed that the most vocal commentators, who appeared regularly in art magazines and cultural tabloids, were highly politicized in their motivations and not very clear.

Another generalized shift that began to occur as the eighties progressed and the art marketing phenomenon grew and the magazines became fatter was the critical difference between what the Europeans were doing and what the Americans were doing. Most Americans who were involved in something like Neo-Expressionism disliked the term and rejected it. The artists who were not painting, but instead doing objects or installations or large-scale color photographs, became the Postmodernists. Thus, European Neo-Expressionism (a term also despised by European artists in order to position themselves in terms of status and wealth) was matched against American Postmodernism. This is to suggest that the critical investigation of art as to issues of significance and quality had been replaced by a system of marketing strategies. The kind of art that was being written about in the magazines was what I call "market-driven art." This kind of art is work that depends on hype and promotion. It depends on a marketing strategy in order to sell it. If there is no strategy and no serious financial backing, market-driven art simply does not exist. It disappears just like an electronic signal on cable television. Once market-driven art is unplugged, and once the system is aborted, there is nothing there. Unfortunately, it predominated in the Postmodern eighties, existing for the most part as one sprawling media-hype. The market-driven art of the eighties is now slowly fading out. There will be exceptions, as there are in any era, but it would seem that they are few. It is more likely that the truly significant contributions to our culture were not so much about the market-driven system, but about the quality of mind and perception that has always been responsible for great art. Why should the eighties be immune to this historical and cultural process?

There is a difference between cultural anthropology and aesthetics. One is a social science, the other a branch of philosophy. Each requires a method of investigation in the formal sense. In the case of aesthetics, there has evolved a more casual usage. For example, we can refer to design or architecture as having a certain aesthetic. We can refer to fashion or even to art as having an aesthetic. What do we mean? An aesthetic may refer to a style or visual position, a point of view with regard to beauty or elegance.

In the eighties, it was not the aesthetic but the anti-aesthetic that defined Postmodernism. This prefix implied that the work (the object, the image, the installation) existed more as a sign of art than as art. It suggested a certain distance, perhaps a severe distance, from actual feeling. In Postmodern art — as it came to be defined by American art critics, borrowing heavily from French theory, psychoanalysis, and semiotics — one could no longer aspire toward resolution.

In summary, Postmodernism had placed art in suspension where Form was no longer an issue. Art was no longer about resolution or coherence, as advocated by Modernist critics ranging from Clive Bell to Clement Greenberg. Art was about fragmentation. Furthermore, art had become demystified by the media. It was not a separate or hierarchical category of culture, but existed on the same plane with everything else. Television and fashion were on the same level as art. In other words, for the Postmodernists, no image could be identified as an art image. Everything had been swept into the vast image-bank of the hyperreal. No form could claim authenticity or even originality, because the media with their pervasive flow of endless information had changed things once and for all. There was no going back, no retreat. Art had ceased to become a specialized concern; therefore art criticism was of no importance. What the real critic of Postmodernism should be concerned with is "cultural theory."

I daresay that the essays in this collection are somewhat contradictory to the foregoing comments. In "essence" — a word forbidden by good Postmodernists because of its phenomenological implications — the essays and reviews in this collection are somewhere between Modernism and Conceptual Art, as indicated by the book's title. Furthermore, and to my knowledge (a necessary disclaimer in the unlegislated terrain of the Internet), none of the essays in this collection has been previously published. Some were given as talks. Others were written simply because I am a writer and had something to say. Some were commissioned and intended for publication but for numerous (and somewhat boring) reasons, they never were.

I would like to think — or, let's say in the Modernist sense, I believe — that today these essays and reviews, beginning at the outset of the eighties and ending, more or less, at the outset of the nineties, constitute the history that was largely ignored by Postmodernism. In some cases, I am blatantly critical of the kind of detachment and cynicism that was offensively deployed in Postmodern theory as it was appropriated into criticism for the magazines. The title of

this collection focuses on a certain absence; that is, the space between, the interlude, the interstices, that constituted the real tension of the era—that being the tension between Modernism and the sublimated effects of Conceptual Art.

In retrospect, the eighties constituted a period of waning reorientation, incited through changes in economy, social organization, cultural attitudes, information technologies, and politics. I am willing to say that the decade represented a period of "high transition." Let others call it Postmodernism, but whatever the term, it was less an art movement than a general cultural reorientation wrought by the conditions described above.

One may talk about the shift from industry to post-industry, but then how does one treat a phrase like the "information industry"? The latter is an oxymoron, perhaps, but helpful in analyzing the effect once described by Marshall McLuhan as "bonanzaland" wherein the content of the previous era becomes the form of the next. In linguistic terms, the signified takes on the role of the signifier. Is information really about industry, or is it simply using the organizational structure of industry as a way to deal with the overwhelming effects that the new technologies have created for business?

To return to art, and in doing so to state the intent of this book, I would propose that too much was ignored in the eighties that should have been discussed. Conceptual art was suppressed to some degree, even misrepresented, particularly by journalistic critics—and gallerists—who tried to market the notion of "Neo-Conceptualism." I recognize the art sociology, but reject the term as significant for advanced art.

And yes, I believe in advanced art—not as a meltdown into that larger vapid cyberspace of media conditioning, but as operating at the foreground of new cultural ideas. I also believe that a stated criterion is necessary in order to distinguish between what is significant and what is not significant in the production of advanced art. I further acknowledge my subscription to the bygone Kantian notion that any phenomenon capable of inciting an experience has a moral equivalent.

It is perhaps no different at the end of the century than it was at the beginning. The educated public is still as puzzled by Analytical Cubism as it is by Conceptual Art. This leads me to believe that there is some structural link between the two. To reiterate: the real discourse in art for the eighties was the dialectical pull—the tension—between Modernism and Conceptual Art. It was within that tension that the vitality of advanced art could be found. And, to a large extent, this is still the case.

Robert C. Morgan
February 1997

SECTION I.
CONTENT
AND DISSENT

1

Participation Art: A Discussion About Content (1980)

The integration of social, political, and economic issues into the aesthetic mainstream over a decade ago brought a number of concerns and speculations still evident in the most recent endeavors by artists. The diversity of styles, subject matter, and techniques that characterized the art of the seventies has assumed a wider range of content issues than ever before. As a result of this diversity, no single trend has monopolized the attention of the contemporary art world to the exclusion of any other. Although new concepts and imagery have been adamantly announced by dealers, critics, and curators, the familiar current of modernism appears to have found a delta.

In attempting to support the notion of Kantian self-criticism, the aesthetics of modernism inadvertently reduced painting and sculpture to a series of solipsistic commentaries.[1] The rash of journalistic art movements throughout the sixties provided inbred data from which both historians and artists claimed antecedents as if to prove that modernist linearity could somehow fulfill an artist's intentions. This contradiction was epitomized in what Harold Rosenberg once termed "the tradition of the new." His astute observation indicated that art history may have to concern itself more with present issues in order to maintain a relevant understanding of the past.[2] Hence, the task of the critic-historian is to offer a method of inquiry, rather than a dogma which imposes itself upon the emergence of new content in evaluating contemporary art.

Content and Consciousness

Content is felt, but not always known. It is the signification of intended meaning embedded within the structure of the work. Whereas emotion is the essential ingredient which stirs a response to works of art, content may be

understood as a synthesis of cultural and individual ideas. According to Duchamp, it is the connection made by the viewer which ultimately gives meaning to the work.[3]

Reactions for or against a particular artwork are not always based on aesthetic choice. Instead, one may perceive the work as a reflection of certain moral, social, or political tenets. In such cases, the work may contradict the viewers' values as well as draw out unresolved feelings of taste. This is to emphasize that content in art may have strong ethical connotations which are sometimes unconsciously understood yet inseparable from the general region of aesthetic taste. Therefore, reactions to content may emerge long before any formal analysis of an artwork begins to take hold.

If form is the vehicle of the artist's expression, then content is what begets an emotional response. For some artists, any categorization of experience, prior to its realization as original work, is boring and academic. Similarly, critics have been known to categorize an artwork in order to avoid an unpleasant emotional response. In either case, reactions to content are preconceived and have little to do with the intended meaning of the work. Content in art is often subjectively construed according to the frame of mind which is brought to the viewing occasion. Therefore, it is not uncommon for viewers to allow pre-existing attitudes to shape their response to an artwork, rather than allowing the work to present another channel for experience.

In the philosophy of Edmund Husserl, issues of content in normal, everyday objects reveal themselves through perception as a matter of consciousness. His approach to understanding these "immanent" qualities in objects was to consciously set aside or "bracket-out" the routine patterns of "natural thinking" in order to perceive what is essential to them.[4] Through this process of immanent perception, one is to avoid seeking out connections between cause and effect, which Husserl regards as pertaining to the scientific method. One of the major purposes in this alternative mode of perception is to experience oneself experiencing content. This may be called "transcendent perception." In other words, the viewer becomes the authority in understanding his or her relationship to the thing being viewed.

We can learn from Husserl, in spite of his elusive idealism, something about teaching the perception of contemporary art; namely, that the authority for understanding the content of artworks may be found within the experience of individuals as they become capable of expanding their own, personal notions of content.

The viewer's frame of mind, regardless of training, will respond to a work of art according to the level of perceptual awareness which organizes the experience at any given moment. How one follows through on this response is, indeed, a matter of training. Nonetheless, the eye-brain mechanism registers insight by confronting images which have been isolated from the patterns of everyday life and given the label of "art." As a result, these images are given a

new context and, to the conscious viewer, a new sense of reality. Content, in fact, becomes the recontextualization of meaning. The function of the image changes as a result of its shifted context — from the world-as-we-know-it to the world of art. The viewer may be confronted with everyday subject matter in a work of contemporary art, but soon realizes that its usual meaning has somehow been altered to mean something else. One is then asked to reevaluate the imagery as an artwork; often this involves learning to perceive everyday subject matter in a different way. Works of art which challenge the existence of previously established categories of perception, given to the assimilation of other kinds of knowledge, are more difficult to contain and, therefore, more capable of being resisted.

Content and Subject Matter

The distinction between content and subject matter is unique to the perception of many forms of contemporary art. A conventional view held by art historians who teach the history of art prior to 1945 proposes that the meaning of a painting, for example, is commensurate with what is represented on the picture plane; that is, it assumes that the work is, by definition, consistent in terms of its medium and its intent.

If content is understood as the signification of intended meaning, then subject matter is simply a choice of imagery. In most traditional works of painting, with a few curious exceptions, there is little conflict between the artist's image selection and the visual meaning which it communicates. In recent years, beginning with Abstract Expressionism, westernized art has gradually moved away from containment within the image as a necessary source of meaning. This shift was epitomized in the work of Conceptual artists over a decade ago.

In analyzing the few substantial contributions in the area of Conceptual Art, one becomes aware of the interesting and subtle divisions which occur between content and subject matter. Conceptual Art equated language with literal content, often relying on varying documents to represent components of its structure. In a work entitled *Art as Idea as Idea* (1966–68) by Joseph Kosuth, several word entries were taken directly from a dictionary and presented as enlarged photostats.

In order to understand what each word signified within the context of art, one had to consider how language might function apart from its normative, cultural context. For example, what happens to the word "water" when its meaning is perceived as a dictionary definition enlarged on a gallery wall? The word-symbol "water" and one's actual experience with water are two different things.[5] Although the subject matter appears to be "water," the meaning of the word, as a definition, seems rather pointless. What is its function as art?

One may discover that the content of the work is not about water, but

about the function of language. The artist has attempted to show how the struc-
ture of words operates to signify meaning. The content is dependent upon how
one chooses to interpret the definition. The neutral presentation of an explicit
definition needs the viewer's response to discover its implicit meaning.

The notion of separating content from subject matter was first utilized in
the Readymades of Marcel Duchamp.[6] Upon removing a snow shovel from its
routine context, the artist chose to suspend it from the ceiling of his studio.
In so doing, he changed the context of its meaning entirely. It no longer func-
tioned as a snow shovel. A common object had been consciously displaced and
transformed into a display item. Duchamp then affixed his signature with the
phrase "In Advance of a Broken Arm," a meaningless phrase attached to a
meaningless object.

Likewise, the activity of viewing any work of art changes according to the
viewer's time and place. New content may be attributed to objects from another
era without necessarily obliterating an artist's intent. As the experience of look-
ing at works of art deepens in its intensity, so, too, does one's attitude towards
perception tend to shift outside of "natural thinking." Individual growth in
perception relies to some extent upon awareness of culture, because a culture
has already provided the setting by which to evaluate what is significant in
viewing a work of art.

Form and Criteria

To the untrained viewer, form in art is not always apparent. Whereas sub-
ject matter may be visible and capable of being described, the form of a paint-
ing or sculpture belongs in a more specialized category. It is not what is most
immediately accessible.

Form is rarely conceived in its entirety upon first glance. In viewing a
work of art, one must seek out the formal structure which the artist embed-
ded in its presentation. Consequently, some training or, at least, some previ-
ous experience is required in order to focus consciously upon the aesthetic
placement of visual elements.

In some universities and professional schools which include programs in
art education, students are taught that the correctness of their viewing expe-
riences can be measured against a series of pre-established guidelines known
as criteria. The untrained viewer is led to believe that these criteria will some-
how attest to the credibility of artistic perception and thereby inform the viewer
of his or her status in understanding art. The absurdity of such a premise does
not require a lengthy dissertation, although a number of them have been writ-
ten.

The problem in stating a criterion for students of art, and especially for
students with only a peripheral interest, is that certain assumptions are carried

into the viewing experience which relegate artistic perception to another category of knowledge, rather than allowing the viewer's concept of form to evolve through an open exploration of content and subject matter. However, if criteria are imposed beforehand, the student may be put in a position of either (1) trying to fit an emotional response into a designated category of art appreciation; (2) completing an exercise of formal analysis that fits the criteria; or (3) rejecting the criteria altogether in favor of a genuine personal response. If the objective of a stated criterion is felt by the student to be one of getting a correct response as opposed to making an incorrect or stupid response, chances are that the viewing experience will never become an aesthetic one. The very assumption that by analyzing an artwork one is capable of experiencing it aesthetically is misleading. One might better consider the possibility that, to the untrained viewer, the symptoms of an aesthetic experience may have already been felt in nature or on urban streets, but, rarely, if ever, in art galleries or museums.

Without belaboring the tenets of Clive Bell and Roger Fry, two respectable aestheticians of early twentieth century art, their regard for "significant form" emphasized the appearance of formal characteristics on the picture plane as a method of linking Post-Impressionism and subsequent abstract painting to that of representational and "primitive" art.[7] On the basis of their methods, the so-called formalists of later years concentrated the meaning of artworks solely in terms of their visual structure. A formal analysis was one which laid bare the properties of material design to the exclusion of any content considerations.

For any criterion to maintain relevance as a tool for understanding and evaluating works of art, it must coincide with what is perceived to be the signification of intended meaning. It should be clarified that the intended meaning of an artwork is not simply what the artist declares it to be, but what becomes apparent in the work on the basis of its social, cultural, and aesthetic contexts. It is questionable whether a criterion predicated on formalism alone will continue to serve critics and educators as it has in the recent past. The more interesting artists of the seventies searched the motivations of their own ideas as content in order to fill voids left by the formalist sixties.

What some critics have declaimed as the nadir of the seventies, such as the body artists of the Vienna school[8] or the punk artists of London and New York,[9] may only be an indication that the concern for individual rights and freedom is a more central issue than the formal qualities of the picture plane. The current generation of art students may see the distinction between aesthetics and social psychology as only an academic gesture. It is conceivable that a viable link is emerging between art and society which critics and art educators will be expected to clarify in association with an ever-widening art audience comprising men and women of all ages and backgrounds, seeking meaningful alternatives to the systematized thinking of everyday life.

Authority and Experience

John Dewey gave considerable thought to the role of the arts in education. As the principal spokesman for "progressive education" in the United States during the thirties and forties, Dewey was a believer in the everyday event as a source of learning and aesthetic experience.[10] According to Dewey, an individual's experience in the environment ultimately superseded in importance those learning situations which deprived the articulation of one's perceptions. Through a heightened perception of everyday events, and upon reflection thereof, educational and artistic awareness contributes to an organic unfolding and self-realization of the individual within the social structure.

Although human experience is the basis upon which Dewey sought criteria, his philosophy of education was careful to articulate the characteristics unique to human expression. He stressed the importance of refining emotional involvement in art, but not at the expense of destroying the presence of feeling through intellectualization. The efficacy of any artwork — once detached from its emotional source — loses credibility and thereby loses its authority to communicate. A similar observation led Suzanne K. Langer to exclaim a few years later that "expressive form"[11] in art was a more accurate term than "significant form."[12] Langer believed, as did Dewey, that the expressive drive of human individuals is at the foundation of all artistic endeavors.

Although technical competence does provide the authority and credentials to teach studio art, it does not necessarily inspire the most interesting or original student work. This is not to underplay the importance of technical mastery in teaching; it does, however, point to the fact that too often technique and rather obvious formal manipulations of materials define the role of the instructor. If educators are to take the ideas of Dewey and Langer seriously, they must examine the importance of communicating "expressive form" through application of technical knowledge. Such ideas are integral to the art-making experience and should not be arbitrarily separated from a student's alleged competence in making things. To hold out expressiveness as something to be dealt with at a later time, upon proving one's technical ability, is to claim that content is adjunctive to artistic form, rather than essential to it.

For this reason, an occasional studio session should be devoted entirely to the exploration of ideas in reference to specific art projects. By limiting the use of formal and technical jargon, the artist-teacher would emphasize the variety of possibilities in which closely related ideas might be handled without loss of originality. Thus, the last word of authority would not boil down to the relationship of shapes, the quality of line, or the modulation of color. These considerations, it is true, are important. Formal organization should always be a consideration, even if the student chooses to reject it at a later time. Furthermore, it should be made clear that the most skillful balance of visual elements with technique does not guarantee an exciting work of art.

Implications of Content as Experience

Thus far, it has been argued that content in works of contemporary art may be accessible to the viewer, regardless of subject matter, through more than a single approach, and that further cognizance of form is a matter of training and experience within a particular context of viewing. To the untrained eye, the communication of content in a work does not always correspond to the artist's intentions; it is conceivable that such a response will have little to do with the actual work and more to do with cultural or ethical presumptions held by the viewer prior to seeing the work. Without experience or training, one may respond to an artwork almost instinctively and without conscious awareness of how the content is being expressed. The task of bringing together the viewer's interpretation of an artwork with its intended meaning is a tricky business and has no single basis of authority. Even the artist's verbalization or statement of intention may prove insufficient. It is, therefore, the responsibility of the art educator to mediate the viewer's experience with other reliable source material; in doing so, the viewer's response must first be acknowledged as having some basis of validity.

Most unreflective or offhand responses will need clarification or expansion in order to come into their own as viable observations. Nevertheless, the viewer's initial response constitutes an important reality at a particular point in time. That reality will supersede any further sources of explanation unless another inner-directed experience happens to evolve.

The remainder of this chapter will discuss four works by contemporary American artists from the point of view of content. Each work may be considered nontraditional in the sense that it represents a tendency other than modernism. The emphasis on social issues is presented from a variety of perspectives which suggests an appropriate instructional model.

Sol LeWitt has been involved in making "wall drawings" since the late sixties. He believes that the linguistic structure of an artwork should precede and therefore determine the production of its visual manifestation.[13] As part of a retrospective exhibition at the Museum of Modern Art last spring, sixteen high schools in the New York metropolitan area were designated as sites at which an equal number of wall drawings were to be executed.[14] Students from each high school were given a printed set of instructions which served as the linguistic model for each one of the drawings. The model was treated as a sketch from which the students worked; it also operated as a kind of thought problem, familiar to students in mathematics.

The content of LeWitt's work relies heavily upon the connection between the linguistic model and the conceptual resources of the viewer in confronting the architectural plane. LeWitt's seemingly "non-visual structures"[15] have, in fact, a definite participatory as well as a perceptual aspect to them. The eye of the viewer must first translate the meaning of the linguistic model in order to

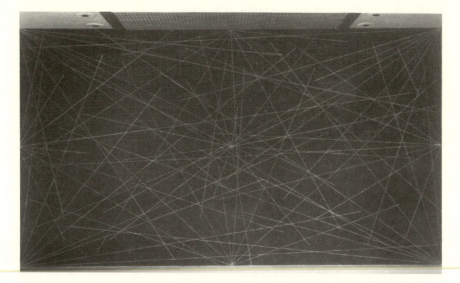

Sol LeWitt, *Lines to Points on a Grid: White Lines from Center, Sides, and Corners* (1976). White chalk on black wall, 14 ft. by 18 ft. 9 in. Collection of Whitney Museum of American Art, New York; gift of the Gilman Foundation. Photo courtesy of John Weber Gallery, New York.

perceive its relationship to the wall. If one were to view the wall drawing sep-arately from its linguistic counterpart, the content of the work would not be accessible. The subject matter alone — that is, the pencil lines crisscrossing from several points on the wall — would not be sufficient data without its accompanying thought process as expressed through language; the work involves a precise visual-verbal dialectic.

The criterion for understanding LeWitt's work is not a formalist criterion, but a conceptual one. The content of the drawing relates the structure of lan-guage — its context and syntax — directly to the architectural plane. Thus, the viewer — in this case, the student going to class — is asked to reconstruct its visual counterpart, relating it specifically to a wall selected in the building. Part of the intention of the drawing is to challenge preexisting criteria about the very nature of art. The viewer must, therefore, examine the artist's intent in order to devise an appropriate criterion; it must evolve organically through the thought process, rather than imposing itself from the outside.

One further claim: to understand the artist's intent may not necessarily qualify the work as significant, either culturally or in terms of personal expe-rience. LeWitt's work might be criticized for its lack of surface, sensual appeal; however, Analytic Cubism was certainly comparable in this regard. LeWitt's work does, on the other hand, open channels of communication between the subject matter of art and that of other disciplines; where lies the difference? In

studying contemporary art, one must be willing to leave the safety zone of stated criteria and move ahead into the unknown regions of content.

Too often, critics and art educators feel a responsibility to convert negative or pessimistic feelings derived from looking at art into more positive feelings of enrichment. The notion is based partially on expedient marketability, but primarily upon the rather naive, idealist assumption that all art is made to inject pleasurable responses into its audience. The fact is that some recent works are intended to do just the opposite. One example would be the much neglected (by American critics) tour de force from Edward Kienholz entitled *The State Hospital* (1964–66).[16]

One could hardly consider the subject matter of this work pleasurable. The two gray, distorted creatures seem to embody a kind of prophetic space-age surrealism, weirdly suspended on bunk beds in an isolated cell. In order to view the two creatures, one must peek through a small, barred window of a cell door into the sterile chamber. Upon experiencing this tableau, it would be difficult to rationalize a hedonistic response. A more enlightened docent, for example, might suggest that feelings of trepidation, claustrophobia or nausea are not entirely out of place. The power of *The State Hospital* to incite a genuine, meaningful response on both an aesthetic and a psychological level could become the focus of an eye-opening realization concerning the ethical role of art in the face of social issues.

The pop sculptor Claes Oldenburg designed a large-scale piece, executed in Cor-Ten steel, entitled *Three-Way Plug* (1970).[17] It could be interpreted, on the basis of its subject matter, as an icon of technology in monumental form. Such an interpretation raises the issue of meaning in reference to why monuments are created. What is the purpose of a monument? How does it function in regard to human life?

Although less dependent on cultural shock-value than Kienholz, Oldenburg has used monumental scale — that is, sculpture designed in view of public architecture — to transform the meaning of a common household object into something of grandiose importance. Humor is an obvious part of its content. The disproportionate size of such a mundane apparatus makes it absurd, almost cartoonish, in its appearance.

Does it represent a criticism or a celebration of electrical power? Or is it merely a whimsical gesture, a found object exploited by the artist's imagination? The function of electricity is a phenomenon of Western culture; it occurs on both a private and a public level. Electric lights, refrigerators, and television sets all operate in people's homes; at the same time, these appliances are plugged into a vast system regulated by immense corporations. *Three-Way Plug* may suggest to the viewer that electrical power is, in fact, political power. In this sense, Oldenburg's monument presents a strange bonding of metaphor and literal meaning; a subtle comment on social behavior is embedded within the content. Yet the work transcends social comment. Pursuing the interpretation

another step, *Three-Way Plug* is poking fun at the idea of "power" on all levels by ridiculing itself. Oldenburg's image of an electrical fixture questions the role of monuments as historical symbols of past events; yet, if symbolism is still appropriate, its androgynous eroticism is not entirely accidental. In this sense, the monument may be characterized as purposefully self-effacing.

The implications of any popular icon are fraught with social and cultural implications which tend to subvert aesthetic meaning. Therefore, interpretations of meaning require a close alliance with the actual presence of the artwork. In pop imagery, the input of social commentary should not be disregarded in light of its interpretation. Aesthetic considerations are not divorced from content, but are generally reflected through it.

Since the late fifties, Allan Kaprow has been a leading figure in the development of performance art.[18] During the Happenings, a group of people would perform and improvise various actions according to a generalized script. Visual props and materials were used to elicit an intensely temporal engagement with art. The viewer was literally transformed into an active participant.[19]

His more recent endeavors — known as Activities — have been less public and less sensationalized in comparison with the Happenings. The Activities are primarily involved with the structure and dynamics of intimate social exchanges. They incite methods of creative learning through shared experiences.

Within the past year, Kaprow was invited by Wichita State University to design and present an original Activity on its campus. A unique aspect of the invitation was its sponsorship. Because of the artist's direct involvement in education and curricular planning in the visual arts,[20] the teachers within the school district of Wichita believed that they should be included as participants; consequently, they helped to make the project possible by contributing time and assistance as well as partial funding for the event.

The Activity, entitled *Blindsight*, was designed for twelve groups of people with two people in each group: one adult and one child. The script for *Blindsight* called for each participant from each group to enter a private space and stand in front of a large sheet of paper with a strong photo-light to the rear. The instructions read as follows:

> alone, examining your shadow on a black ground
> painting its shape in black
>
> trying to fit your shadow
> to the image of the shadow
>
> noting where it fits and where it doesn't
>
> painting the new shadow's shape
>
> repeating, again and again
> until there is no shadow
>
> (child doing same in another place)[21]

All of the participants were then instructed to fit their real shadows into one another's painted shadows and to paint their new shadows in white over the black.

The second part of the Activity involved painting the back of one's head in a dark room, then turning on a light and examining the painting, then repeating the same process in a darkened room again and again. The child and adult would then look at each other's paintings and attempt to imagine an image of the inside of their heads which they would paint on the same surface.

The third and final portion of the script instructed each adult and each child to paint what they remembered of their mother's eyes, then to place the two paintings across the room from one another on opposite walls. *Blindsight* concluded with the following:

> meeting with the child
>
> bringing the two images together
> to appear to be looking at each other
>
> looking at the child
>
> telling each other a story
> of your mother's eyes[22]

The twelve pairs of adults and children included teachers and students, fathers and sons, mothers and daughters, mothers and sons, neighbors and friends. The children ranged between the ages of 7 and 12 years and represented different ethnic and socioeconomic sectors of the community.

After each pair had performed the Activity, without an audience, the total group of twenty-four people reconvened to discuss its meaning. Many believed that they had shared an experience which was more thought-provoking than many other forms of contemporary art. The adults recounted stories of how they perceived themselves as children in attempting to work within the shadow of a child. It was decided that these perceptions were valuable in terms of understanding the way children perceive their world and adults.

The younger people were also eager to explain the way they felt, trying to match their images to those of the adults. Many had to climb up on stools, tables, and chairs in order to make their shadows fit. Physical size was discussed as being a factor which children have to confront every day. Their perceptions came to be recognized as having a validity in their own right. In turn, the adults expressed their feelings about communicating to younger people without the normal barriers of trying to maintain authority. In both cases, the false barriers were easily and willingly shattered. Neglected sources of feeling were revealed.

Experiencing content in a work like *Blindsight* is perhaps easier because of the work's temporal nature. Nevertheless, it is important to consider that all perceptions of artwork are temporal points of view which are constantly shifting

physically and psychologically. The absence of content as a basis for criteria has, unfortunately, narrowed the scope and vision of a potentially more responsive audience.

The relevance of the four preceding works in terms of this discussion is their openness to issues of content. Each work, in its own original manner, allows the viewer an active role as participant and or interpreter. By acknowledging content in works of contemporary art, new methods of viewing and criticism are made possible on a much wider basis of response — not only for professional artists, critics, and educators, but for the everyday museum visitor in search of new ideas and new sources of feeling. It is possible that form in art may once again become the vehicle, rather than the end, of expressive concerns.

2

Allan Kaprow's Happenings and Activities and the Actions of Joseph Beuys (1987)

Allan Kaprow's early concept of performance did not evolve directly from theatrical discourse. In 1958 while Kaprow was an assistant professor in the Department of Fine Arts at Rutgers University, he conceived of the form that came to be known as the Happening. The name itself evolved from the artist's first significant participation performance in New York at the now-defunct Reuben Gallery, of which he was a cofounder. Titled *18 Happenings in 6 Parts*, this piece was concerned with the idea of a non-static art, a form that was free from the division of spectator and object. He desired a new kind of interaction, an attitude toward participation in the work itself. Consequently, the gallery was set up with partitions so that the "audience" could come into the space and interact with various props and materials according to a loosely defined script. The script was instructional, but only in a limited sense. The idea was that the conventional status by which spectators entered into the aura of the art gallery — the sanctimonious "White Cube" as expressed by Brian O'Doherty — would be dispelled. Instead of merely looking at a finished product, i.e., a painting on canvas, the spectator would be incited to participate in a "total art" experience. This total art experience was not to be confused with the utopian thinking of the Constructivists or the Bauhaus. Kaprow was not interested in religiosity or hyperdetermination. Just as Robert Rauschenberg wanted to define that precarious Duchampian wedge somewhere between art and life, so Kaprow felt impelled to open the auratic chamber on which art stood its ground; that is, to call attention to the very infrastructure of art: the gallery as the physical, commercial, and aesthetic system of support.

To do this it was necessary to logically reflect upon the outcome of Abstract Expressionist painting. Throughout the 1950s, Abstract Expressionism was pre-eminent as the leading tendency within the American avant-garde — in essence, it *was* the avant-garde. Jackson Pollock was, for many, the most important figure of that era, beginning with the immediate postwar period. For Pollock,

the son of an itinerant rancher, painting was an act of the strictest defiance, an unleashing of postwar angst, a new kind of interior archetypal venture, a nearly Artaudian morass of psychic fluidity searching the boundaries of the hieroglyph. Pollock's overdetermination to retrieve the lost father — most explicitly pronounced after his falling out with his initial mentor, Thomas Hart Benton, at the Art Students League in New York — embodied the Dionysian hero, the licentious victim of a gifted fate for which he could no longer contain the outcome. Pollock's paintings, for Kaprow, were the evanescences of a choreographic ecstasy. Kaprow's essay on Pollock, written for *Artnews* shortly after the painter's untimely and tragic death in 1956 but not published until two years later, emphasized the gestural movements of the art-maker over the finished result. Kaprow believed that what was most significant about Pollock was the evidence of how he moved in relation to the act of painting. The way Pollock moved kinesthetically in relation to the total image (his canvases would always be rolled out on the floor of his studio) implied a new kind of thought process, a synaptical linkage of creative cause and effect that defied the conventions of all previous European avant-garde painting. To conceive an image as a total overall spread of interwoven skeins of paint was, for Kaprow, a revolution in the creative thought process. It implied a notion of intelligence far removed from the Princeton SAT exams and more related to how Joe DiMaggio played baseball. (Incidentally, I am not the first art critic to characterize painting in relation to baseball; Sidney Tillim spent the better part of a panel discussion at a recent College Art Association meeting in Boston engaged in the same analogy.) At any rate, the point was a crucial one for Kaprow, crucial enough to suggest that a painting was, in fact, ancillary to the act of painting. In other words, the theatricality of painting was the only place for painting to go after Pollock — a point which the art historian Michael Fried neglected to consider in his scholarly diatribe against Minimal Art.

So Kaprow began to conceive of art as event more than object. If the infrastructure of the art object was contingent upon its placement in the gallery, it became necessary to displace art in relation to its process. To see art as art meant to see it within the context of a specific place, a high-minded cultural environ. (This issue was reiterated by Kaprow in his important essay "The Real Experiment," published in the December 1983 issue of *Artforum*.)

In *18 Happenings in 6 Parts*, Kaprow was concentrating upon the idea of art as event, giving art a sense of theatricality which considered the elements of time/space as its fundamental matrix. It was not simply a matter of making art in a gallery. It was a certain kind of focus upon the place where art happens; that is, where it happens for the viewer. The disjuncture of everyday experience did not, in most cases, allow for the kind of transposition that one is expected to make when entering into the auratic chamber to view a work of art. Just as jazz was a more accurate representation of postwar America than classical music, so the Happening was, for Kaprow, a more accurate tool for

exercising whatever was left of the capacity to engage in an aesthetic experience.

The early sixties followed. Kaprow expanded his lexicon of art to include assemblage and Environments (what later became known in the art journals as Installation Art). These are well-documented in Michael Kirby's book *Happenings* (1965) and in Kaprow's own book, *Assemblage, Environments, Happenings*, published three years later by Harry Abrams.

The Happening was, for the most part, a public spectacle. Most of Kaprow's Happenings, as well as those of his European counterpart, Wolf Vostell, could accommodate large groups of people. Examples include *Courtyard* (1962), a Happening performed by residents of an apartment complex in New York's Greenwich Village where furniture was brought outside and stacked in a rather fragile though ominous-appearing tower; *Household* (1964) performed by a group of students at Cornell University in which an old automobile was covered with strawberry jam and licked clean before being set afire; and *Fluids* (1967), a performance commissioned by the former Pasadena Art Museum in which fifteen structures were made throughout the Los Angeles river basin using large chunks of ice. (One should consider that these pieces were done long before Derrida or Lacan was popularly known in American academic and critical circles. I mention this only to suggest that the response at the time these Happenings were performed was rather mute, save the spectacular appeal they received in popular magazines. One might argue that there was an inadequate theoretical and critical vehicle by which to address many of the important linguistic codes that the Happenings revealed.)

Whereas the Happenings of the sixties carried a certain association with the countercultural "happenings," such as the be-ins, love-ins, and massive outdoor rock festivals, one can presume another level of intentionality in Kaprow's works which carried both a philosophical and a psychological substance. In retrospect, Kaprow's Happenings were not devoid of aesthetic interest. As much as he tried to reduce the formal ingredients by which a Happening could be identified as "art," the frame somehow managed to remain indelible. The spontaneous element was always guided by the structure of the piece, regardless of its openness.

It is questionable exactly where the division between Kaprow's Happenings and his more recent Activities actually resides. One might consider that whereas the Happenings were public in scale, the Activities tended towards privacy, even intimacy, often involving two people interacting together in isolation from other participants. Kaprow designates the year 1966 as the turning point, the pivot, as it were, from the publicity of the Happenings to the privacy of the Activity, stating that he "discarded the mode mainly because in the United States there is no history of high ceremony (for Westerners) as there is in Europe, and it began to seem pompous to go on. And so I turned my attention to the mundane, which Americans understand perfectly."

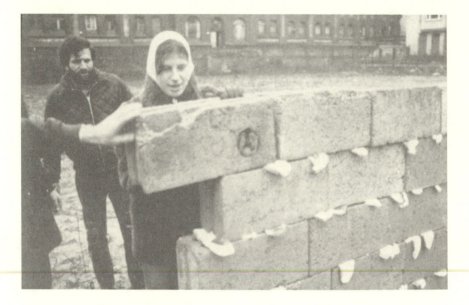

Allan Kaprow, *Sweet Wall* (1970). Performance, cinder blocks, jam, bread.

I would suggest, however, that a subsequent number of events which Kaprow has either choreographed, scripted, or performed in over the past twenty years could still be considered Happenings. *Fluids* (1967), for example, had all the ingredients of a spectacle. Not to mention *Sweet Wall* (1970), which was performed in a vacant lot near the Berlin Wall in West Germany and sponsored by Rene Block (who four years later sponsored Joseph Beuys' first U.S. performance.) In 1982, Kaprow organized a parade in Washington D.C., sponsored by the Washington Project for the Arts, in which children marched down a major thruway rolling automobile tires in front of them with a separate contingent in the rear beating oil drums. In these three cases, the element of publicity and emphasis upon the visuality of the idea, which demanded a kind of social specularity, give them the quality of spectacle. But this term requires more exploration and analysis, and I will delve further into it elsewhere, specifically in relation to Joseph Beuys.

The term "Activity" was appropriated by Kaprow from the drama theorist, actor, and playwright Michael Kirby. In an essay called "The Activity: A New Art Form," published in *The Art of Time* (1969), Kirby designates the concept as follows:

> Although Activities do not necessarily involve a sense of play, they could be compared to games that ... are played for their own sake rather than for the sake of winning or for enjoyment by an audience. Like scientific experiments and religious ritual, Activities are "performed." Even though the behavior in

carrying out an Activity is not necessarily ritualized, both Activity and ritual are performed for the sake of the action itself or for the sake of the thing that is done. Both may be performed in solitude. They may also be done by more than one person, and an audience does not change the orientation of either. An Activity is like a ritual that has no theological or metaphysical efficacy.

The decade of the seventies is generally understood as the most prolific period of Kaprow's career as a maker of Activities. This most intimate performance genre was usually intended for a dyad, two people, often of the opposite gender, performing in relation to one another. For example, *Time Pieces* (1973) originally involved 15 couples working together in relation to the script. Initially staging it in Berlin, Kaprow reconstructed the event in the form of a videotape in Los Angeles two years later. The videotape represents not a documentation of the original Activity but an abstract or illustration of it. Two people are involved, a man and a woman.

Time Pieces begins with a "Pulse Exchange" — that is, each person counting his and her own pulse, recording the count on a cassette tape recorder, and making a written notation. Each participant repeats the exercise before listening to the playback. In the second part of the first section, the partners telephone each other and count their pulses over the phone. In the third part, the two partners meet and count their pulses aloud to one another, repeating the exercise, and then exchanging places. In the fourth part they climb stairs together and then count each other's pulses simultaneously, both noting and recording the count; they listen to the tape together and repeat. It is apparent at this juncture in the structure of the piece that a certain closeness or bond is being established by the two participants.

The second section of *Time Pieces* is concerned with the physical act of breathing. Each partner breathes hard into a small audio tape recorder till out of breath. The number of breaths in either case is noted. The exercise is repeated, then listened to. In the second part of the Breathing Section one partner telephones the other and breathes heavily into the mouthpiece. A notation is made according to the number of breaths. An audiotape is made as well which is then listened to. In the third part, the two partners climb the stairs together, breathe hard into recorders and note the count, then listen. Finally, each partner breathes without recording or noting. In the last part of this section, the two partners are asked to breathe into one another, noting the count and repeating, then positions are exchanged and each breathes into the other holding noses with hands.

In the final section, called "Pulse-Breath Exchange," a cassette recorder is turned on and the participant exhales but does not inhale, then taps the microphone with a pen, repeats the exercise, and plays it back. Next a telephone call is made. The breath is held over the phone as the person taps on the mouthpiece. The opposite partner listens, then roles are reversed. In the third part

of the last section, the two partners are asked to meet somewhere and to hold their breaths for a minute while blinking their eyes, then note the count.

In the fourth part they climb stairs together, hold their breath, tap microphones of recorders, and listen to separate playbacks simultaneously. They climb stairs again, then hold their breath, counting their pulse rates and noting counts, and exhale into two separate sacks. Finally, the partners exchange bags and inhale the breath of the other.

The preceding description has been paraphrased from observing the videotaped reconstruction of the Activity. The script that is shown on the video screen and accompanied by the artist's voice reading it is more terse in its form. Kaprow wants the instructions to read like a how-to manual. Often he has published booklets which function as manuals in relation to the Activity so that hypothetically anyone who reads the manual (something between a score and a script) can reconstruct the Activity.

In 1976, in his essay "Non-Theatrical Performance" (published in the April issue of *Artforum*), Kaprow outlines five ways to make art:

1) work within recognizable art modes and present the work in recognizable art contexts
2) work in unrecognizable, i.e. non-art modes but present the work in recognizable art contexts
3) work in recognizable art modes but present the work in non-art contexts
4) work in non-art modes but present the work as art in non-art contexts
5) work in non-art modes and non-art contexts but cease to call the work art, retaining instead the private consciousness that sometimes it may be art, too.

It is, of course, this last category which is of greatest interest to Kaprow. He further states that such a non-artist's role would "suggest that such a person would view art less as a profession than a metaphor." He readily admits, however, that for most art professionals who might encounter a non-artist performing in a non-theatrical performance, the experience would simply be missed because "the art world cannot recognize what is happening because it responds to art as art." If we are to understand Kaprow correctly, I believe, he is suggesting that a non-art position is artistically informed, and therefore anyone who elects to function outside this context has to accept the reality that his work will be ignored.

In a later *Artforum* essay called "The Real Experiment" (1983), Kaprow makes a distinction between "artlike art" and "lifelike art." The latter category would appear to correspond to "non-theatrical performance" in the earlier sense of a non-art mode in a non-art context. Of course, there is the perpetual danger of solipsism in such an attitude. For example, how can the artist be certain that he or she is doing non-art once non-art has established itself as an acceptable mode of art activity? Furthermore, how can the artist be certain that she or he is operating within a non-art context if only other artists are

capable of understanding what is happening? One of the two examples of life-like art which he cites in "The Real Experiment" is that of a woman walking along the beach every day for a week and counting her steps as the wind and sand cover them. Kaprow equates the experience with a form of Zen medita-tion in which evidence of the activity (documentation) is simply not an issue; the lifelike art experience is the internally felt action. Somehow the absence is meant to intensify the feeling of presence. But would not this form of pres-ence eventually turn to solipsism as, for example, it did with the medieval Cis-tercian abbots whose extreme meditation practices eventually led to a rare form of paranoia (what they call *acedia*)? The other example, of an artist who runs for mayor in a small New York town, wins the election and convinces the officials to solve their financial dilemma by dissolving the township, is some-how more convincing as lifelike art, especially in that the artist eventually gave up art completely in order to market ski resorts out west. Here the issue of performance in relation to politics has a particular kind of topical relevance, a relevance that extends the proposition of lifelike art into the domain of moral purpose.

The late West German artist Joseph Beuys has a particular significance in this regard. Beuys and Kaprow have some curious differences and affinities which are worth exploring. Kaprow was one of the first American avant-garde artists to meet Beuys (along with George Maciunas and Dick Higgins, two important Fluxus artists) in the early 1960s. Beuys' attitude toward perfor-mance was considerably less inward than Kaprow's Activities; it was more sym-bolic than the Happenings and less formally related to the grand spectacles of Vostell. Although Beuys aligned himself with the American Fluxus group in 1963 at the Dusseldorf festival, his performance tended to mold together the political with the mystical. Kaprow was not particularly interested in either of these tendencies. The spectacle was definitely a part of Beuys' art. One might say that theoretically Kaprow had roots in the theater of Brecht, whereas Beuys' early roots were with Artaud. Kaprow never embraced the politics of Brecht-ian theater as much as he identified with the early Dada-Surrealist events of Tristan Tzara and Hugo Ball. With Beuys the Artaudian concept of spectacle seems especially relevant. The kind of physical and athletic affectation to which Artaud ascribes is characteristic of many of Beuys' "actions" (the term he used instead of Happenings.)

In *24 Hours* (1965), Beuys went without food and sleep for 48 hours before embarking upon a performance in which he stood upright on a table with his arms in the position of Leonardo's Vetruvian Man (with the help of two crutches) for another 24 hours. The sheer endurance of the action implies a kind of Artaudian intensity, a self-immolation in order to attune his mind with some fundamental aspect of nature. Artaud's statement that "these appear-ances will not exercise their true magic except in an atmosphere of hypnotic suggestion in which the mind is affected by a direct pressure upon the senses"

suggests the kind of physical and mental endurance involved in Beuys' early Fluxus actions. Beuys' obsession with organic materials, such as felt, blood, and fat, as relics of his performances is again in strict opposition to Kaprow. In another Beuys performance from this period, called *Trying to Explain Art to a Dead Hare*, the artist covered his head with honey and gold leaf, cradled a dead hare in his arms for several hours explaining the meaning of an exhibition of paintings using the aesthetic terminology of nineteenth century German Romanticism. Artaud again: "Just as there will be no unoccupied point in space, there will be neither respite nor vacancy in the spectator's mind or sensibility. That is, between life and the theater there will be no distinct division, but instead a continuity."

The legacy of Beuys begins with a wartime experience on the Russian front while he was a pilot for the German Luftwaffe. His small plane was shot down. After some length of time in freezing cold weather, he was rescued by a tribe of Tartars who wrapped his body in fat and felt to contain the body heat. The predominant relics which Beuys used in his performances, both as properties and as documentation, are fat and felt (*fetteke*). In addition to the Beuysian spectacles, related to Fluxus, there is also the concept of "social sculpture," which is less connected to symbols and metaphors and more explicitly involved with instruction, an area in which Beuys and Kaprow have a particular relevance and affinity to one another. In essence, social sculpture is involved with the potential of individual creative energy in contrast to the deadening attempts of the state to thwart the flow of creative human energy. Beuys likens the role of the contemporary artist to that of a physician or, better put, a meta-physician, one who detects social ills with the structure of society and who attempts to regenerate sources of energy to heal those ills. This is accomplished, according to Beuys, by recognizing that every individual in the society has a greater resource of creative energy than is initially apparent. Either everyone is an artist or no one is an artist. For to designate certain individuals as artists and relegate others to menial tasks which involve menial thinking is to further forestall the outward flow and recycling of that energy. It is the condition of human freedom and responsibility that Beuys was striving to attain. In his teach-in at the 1977 Documenta in Kassel (an international art festival every five years that aspires to exhibit the most important art of the time) Beuys conducted a marathon dialogue, talking around the clock for 72 hours with anyone who wished to discuss current political issues. This was a period when Beuys was particularly active in the founding of the Green Party in Germany. During this teach-in, an enormous pump was situated in the lobby of the building pumping honey through plastic hoses from one classroom to the next.

In spite of their extreme political and cultural differences, Kaprow and Beuys share a particular attitude about the artist in contemporary times as one who heals through the raising of issues within a performance context. With Kaprow the healing process is unpretentious and far less mystical than it is with

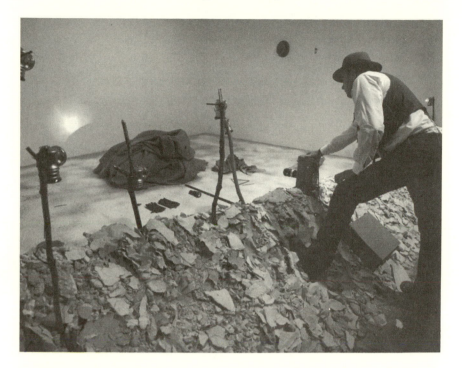

Joseph Beuys, *Aus Berlin: Neues Vom Kojoten* (1979-80). Mixed media installation. Photo by eeva-inkeri. Courtesy Ronald Feldman Fine Arts Inc.

Beuys. Kaprow, in the sense of a sociologist or social anthropologist, wants us to concentrate upon certain aspects of psychological and social behavior that we often choose to deny or to ignore. In this sense, Kaprow is closely aligned with the work of Erving Goffman, who spent considerable time in researching the daily habits and routines which people develop within social contexts and which eventually become institutionalized and accepted as normative social codes.

Beuys is more the shaman, the alchemist. Whereas Kaprow looks at human behavior as a researcher might and develops a frame for an Activity which explains what a typical research program might not explain, Beuys avoids this kind of observation in order to signify social and political ideals. Beuys saw the artist as a charismatic figure, a shaman who represented the forces of nature which he felt were being ignored or threatened by greed and ignorance of ecology. It is then a fitting gesture that one of Beuys' last projects was a Happening on the grand scale of planting 7,000 oaks through the German city of Kassel, each one marked by a slab of cut stone.

Whereas theatricality may be the demise of traditional aesthetics, intermedia — that is, ideas which move between various mediums (as defined by

Dick Higgins) — may be the most hopeful possibility for restoring a viable role for the artist in a society that no longer looks at art. Regardless of the paradigm — whether the alchemy of Beuys or the pragmatics of Kaprow — performing art has the advantage of bringing significant ideas out in the open.

3

The Conceptual Imagery of Komar and Melamid (1980)

Although the workings of any political system are supported within the context of an ideology, it does not necessarily follow that an artist making "political art" is addressing a single ideological posture. Often, the absence of explicit ideology within an artwork has greater emotional substance in terms of how the individual spectator responds. Ideas and metaphors of the human condition may stir a more intense, subliminal feeling than ideologies and direct, political translations.

Whereas politics attempts to categorize human events into a functional, institutional framework, an ideology is much more abstract. Any theoretical set of beliefs upon which a governing body exists is open to official interpretation. It is, therefore, conceivable that an artist may address a political situation on the basis of systems and ideas which extend far beyond the party ideology being offered at a particular time. In Soviet art history, for example, one may choose to consider Suprematism. Malevich's formal concerns were implicit but not always apparent in terms of their appropriation to the ideology of Lenin's New Economic Policy.

The acceptance of a socialist realist style is most certainly "other-directed" in its intention. Since its adoption in 1934, artists have either worked in this style or they have left the country to pursue their art elsewhere — or in some cases, as with Oskar Rabin, a nonconformist artist now in his late fifties, they have remained in the Soviet as part of an underground contingency.

Rabin works in a small apartment in Moscow with limited access to quality materials and supplies. He has been denied an airy, spacious studio — a benefit routinely granted to "acceptable" artists — by the Union of Soviet Artists. Although his paintings have been smuggled out of the country and collected by major museums throughout Western Europe, his own government will neither support nor acknowledge his work. Paradoxically, Rabin's paintings follow in the tradition of academic realism; they do not, however, appear bright and cheery in the facile manner of Soviet poster art; hence, his work gives an improper ideological connotation. His paintings, which tend

toward somber colors and themes of interiors, are highly expressive of deep, inner feeling. Indeed, they attest to the alienation of a truly creative artist from the public spectrum of everyday life. The quarrel between the Artists' Union and Oskar Rabin is not over style, but over subject matter. Rabin's humanistic posture addresses the "wrong" issues. As a result, his paintings are considered unshowable by any gallery in Moscow or elsewhere in the Soviet state.

Alexandr Melamid and Vitaly Komar, two artists currently in their early to middle thirties, graduated from the Art Academy in Moscow over a decade ago. Their initial confrontation with the Youth Section of the Artists' Union occurred in 1972. Upon presenting a selection of their milder detente paintings before an exhibition committee, the artists, who have worked as a dyad since art school, were not only refused an exhibition, but were ejected from the union altogether. The official comment was that their paintings were "a distortion of Soviet reality and a deviation from the principles of social realism." At this point, Komar and Melamid joined the company of Oskar Rabin as "dissident" artists.

In September 1974, the group organized and participated in an outdoor exhibition with other ostracized artists. It was held in a vacant lot in Moscow. A spokesman for the group, Vladimir Nemukhin, attempted to clarify the purpose of their action: "We are not avant-garde in our art," he stressed, "only in our behavior, in trying to stage a Russian show." Evidence has indicated that the police, having been notified of the exhibition in advance, deliberately incited disorder, whereupon trucks, bulldozers, and firehoses were summoned to break up the outdoor display. The fact that injuries were suffered by artists and spectators alike, including American press correspondents, gave the Soviet police much bad publicity. Tass, in order to justify the disruption, reported that the exhibition had occurred illegally on a construction site; furthermore, it was a "cheap provocation ... to catch the public eye and gain publicity for [the artists] themselves." Eighteen paintings were confiscated by the authorities during the upheaval; a week later ten were retrieved, still splattered with mud from the firehoses, in a small apartment near the Kiev railroad station. Two Rabin paintings considered important works were not among those recovered.

The activities of Komar and Melamid, prior to the September 1974 incident, were primarily directed toward mocking the eclecticism in socialist realism. They believed an inherent contradiction resided in the fact that the official style, which supposedly represented the spiritual elevation of the common worker, was indeed no more than an academic amalgamation of Modernist techniques brought forward from the nineteenth century. Within Soviet art, one may find traces of Byzantine art with its peculiar brand of Russian iconography, folk art, German Expressionism, French cubism, Fauvism, chiaroscuro techniques, photomontage, and art nouveau, as well as reductivist signs, assorted emblems and letter-symbols. In a work completed in 1973 called *Biography*, one may analyze a series of 197 painted panels, each measuring $1\frac{5}{8}$ inches

square, in terms of diverse formal elements. The content of the piece concerns a struggling youth, a fictional personification of Komar and Melamid, who evolves through various programmed stages of adolescence. Personal escapades are shown as detours which angle off from a linear pattern. The majority of the narration shows typical confrontation with various state agencies with heavy emphasis given to military service.

Biography contains historical and modernist techniques of image-making which reflect as well as comment upon the eclectic style of Soviet art. The separate units comprise a private fiction which has been assimilated and abstracted into a public scale. The total work evolves as a visually coded, systemic structure. It reads as a documentation of mythologized events comparable to the kind of linguistic schemata that one is likely to find in children's imagery at the early operational stage. The format of *Biography* reads as a film, a road map, a puzzle, a cartoon strip, a game of dominoes — a composition that merges literal and metaphorical time.

One may observe, with some superficiality, resemblances to the diaristic notations of the narrative Conceptualists of the seventies in Western Europe and the United States — such artists as Ben Vautier, John Baldessari, Vito Acconci, and Alexis Smith. Yet, there is a historical consciousness in the work of Komar and Melamid which far exceeds any of these. The power of *Biography* is further substantiated by the mobility of its design, which adds a new dimension to its political content. Because of the modular structure and scale of the parts, the work could easily be smuggled outside of the Soviet Union should the need arise. The need arose early in late 1975 when Ronald Feldman, a New York art dealer, was persuaded by a friend of the artists to show their work. The exhibition opened on February 20, 1976, and was considered a success by American standards (namely, the number of people who saw it).

One problem for Komar and Melamid prior to their contact with the outside world was their lack of exposure to current developments in Western art. In addition to the weighted influences of socialist realism and early Modernism, their primary influence was American Pop art. In 1973, they acquired catalog reproductions of paintings by Andy Warhol, Roy Lichtenstein, and Robert Indiana — all typical Pop icons of American culture from the early sixties. The emblematic characteristics of these works apparently struck Komar and Melamid in terms of their political ideology more than as works possessed by aesthetic value.

With reproductions in hand, the artists set out to copy each of the paintings according to actual size, color, and detail. Upon completion, they scorched and burned the canvases using a blowtorch. The final step was to adhere the remaining, charred fragments to three unprimed canvases and to retitle them *Post Art No. 1* (Warhol), *Post Art No. 2* (Lichtenstein), and *Post Art No. 3* (Indiana).

In burning Pop art, Komar and Melamid believed that they had given it

Komar and Melamid, *Post Art No. 1 (Warhol)* (1973). Oil and canvas, burned and mounted, 48 in. by 36 in. Private collection. Photo by ceva-inkeri. Courtesy Ronald Feldman Fine Arts Inc.

a tradition, a historical context that would never have existed otherwise; thus, calling themselves "the celebrated artists of the end of the second Millennium A.D.," they believed their actions to have restored aesthetic value to the plain depiction of commonplace objects. In further commenting upon their work, Komar explains:

> In capitalist life, in America, you have an overproduction of things, of consumer goods.... Here we have an overproduction of ideology. So your Pop art puts a tomato soup can in a painting or on a table as a piece of bronze sculpture, to look at, and our "sots art" puts our mass poster art into a frieze for examination.

The term "sots art" is supposedly an acronym, a transliteration of the first

Russian letters in the term Socialist Realism. Alexandr Melamid's interpretation of this phenomenon in art seems to extend the cultural boundaries of both the United States and the Soviet Union; he remarks, "The general idea of your Pop art and our "sots art" is to provide understanding of modern life and of products of mass civilization." This attitude is, indeed, at the conceptual base of a more recent endeavor entitled *A Catalog of Superobjects — Supercomfort for Superpeople* (1976). This series of thirty-six 8 × 10 color photographs illustrates the use of various absurd objects, each of which serves as an apparatus to accompany a physical or sensory phenomenon. An accompanying text reads, "Articles of everyday European life have been transformed from instruments of elitist self-affirmation, the property of the ruling class, into the common possessions of the plebeians."

One need not read too far into the images to see that this catalog is easily reminiscent of department store mailers ranging from Sears to Bloomingdale's. The objects are invented by the artists as a spoof on materialism and the contemporary drive to consume synthetic products and devices which are intended to make life easier.

The catalog places the objects in the following subgroups: Prestigious Things, Sensation Things, Wearing Things, Land-Owning Things, Projection Things, Self-Penetrating Things, Contacting Things, and Anti–Energy Crisis Things. Komar and Melamid felt that introducing such items, or the possibility of such items, would help the new aristocracy define itself more clearly. The uniqueness of these objects may be accounted for by the fact that other manufactured items all have the same appearance; the elite is no longer separate from the plebeians in terms of the products currently available through most advertising networks. The idea of "superobjects" is to give the user a sense of self-importance, a feeling of "superiority over anyone or anything in solitude as well as in the company of your friends and dear ones."

The following product descriptions, which are accompanied by photographs in the catalog, are typical examples:

OLO

A Language Ornament
Your every word is gold, your every word — a pearl!
OLO is proof of your ideal marriage with Truth!

KHAASHA

For a Healthy Body — a Healthy Spirit!
A sniffing apparatus for the head, KHAASHA-200 will replace the anxious odors of the world with the single, stable scent of your desire!
This elegant piece of jewelry made of gold or silver holds the source of the smell you want to smell.
Just fill this special, medium-size chalice with a small piece of your love's skin or hair, flower petals, or whatever you prefer — by inclination or conviction.

UDAM

Take UDAM and Listen to Yourself!
UDAM-II, the Auto-Auditor, is made of natural rubber with gold-plated points.
Helps you concentrate on yourself and brings out your CREATIVE POTENTIAL.
The special, soft padding for the ear contacts completely, which halts pene-
tration by extraneous noise.
Before work....
Before every important decision...
Listen to yourself with the help of UDAM

KHUDAM

Take KHUDAM and smell yourself!
The smells of the world block out your own smell!
Smell yourself!
KHUDAM-212, the Self-Scenter, is made of natural rubber with gold-plated
points. Helps you concentrate on yourself and brings out your SPIRITUAL
POTENTIAL.
The special soft padding of the point completely halts penetration by extra-
neous smells.
Before work...
Before every important decision...
Smell yourself with the help of KHUDAM!

Upon coming into contact with *Newsweek* art editor Douglas Davis, shortly
after the outdoor exhibition of 1974, the two artists discovered that their dialec-
tic between Pop and sots art was outdated and that their ideas could be more
readily adapted to Conceptual Art, a growing international trend which had
been in existence for close to a decade. Davis pointed out that conceptual art
was concerned primarily with the content of systems and ideas and less involved
with the importance of an actual, material object. By its very nature, concep-
tual art was suited to political issues. The designation of art as a nonmaterial
structure with a language of its own may challenge the role of any preestab-
lished system; therefore, clarification of an artist's stated intention may alert
the receiver — that is, the audience — as to a contradiction of values. One ques-
tion that often arises as a response to works of conceptual art is, Where lies
the support system for such a piece? Inevitably, the receiver comes to the con-
clusion that the support system clashes with the monetary system to the extent
that ideas are not really salable, yet the human mind is free to think them.

On the basis of their discussion, the American and two Soviets agreed to
do a Conceptual Art piece which eventually got under way a year and a half
later, roughly corresponding to the exhibition at Feldman's gallery. The struc-
ture of the piece, entitled *Questions New York Moscow New York Moscow*, was
described by American art critic Mary Ann Tighe as follows:

> On four days that hold special significance for American and/or Soviet soci-
> ety — January 1, May 1, July 4, and November 7 — the artists were pho-

tographed standing beside a long, black vertical line and holding a sign whose words formed a question. Davis's picture with the line to his right and the sign written in Russian, was taken in New York, and Komar and Melamid, with the line to their left and the sign in English, were photographed in Moscow. The photos were exchanged, and through the miracle of photomontage, the two pictures met and mated, becoming a single image. In this way, a series of four photographs were created. In them, the Russians and Americans ask each other a question. On January 1, 1976, they inquired "Where is the line between us?" On May 1, the question was "Why is the line between us?"; on July 4, "What is the line between us?"; and on November 7, "What is beyond the line?"

As they shifted their emphasis from sots art toward Conceptual Art, Komar and Melamid began examining new ways of expressing their views of routine Soviet life — ways that were independent of socialist realism, which had always given them the necessary resistance in order to evolve their own eclectic style. In their search for new methods, the two artists sought out political issues in their experience that could be stated through means other than those of conventional image-making. One issue to emerge was the problem of identification, as represented by the numerous cards required of every Soviet citizen which are constantly in a person's possession.

Documents (1975) is a conceptual piece in which twelve cards of varying sizes were made into twelve Plexiglass plates, each according to the relative size of the original document. For example, their identification might include a union card, an electric railway ticket, a telephone subscriber's payment book, and the ubiquitous internal passport. By transcribing twelve of these "documents" into plexiglass, then taking an overall average, they were able to determine one average-size document — the thirteenth card — which was entirely red. Hence *Documents* represents a kind of absurdity — one in which cards of identification have a certain dehumanizing effect upon the individual in a society where bureaucracy controlled the right to a private life. Even so, Komar and Melamid do not see the meaning of *Documents* as one reserved for Soviet citizens alone; indeed, there are correspondences everywhere.

In 1976, the artists extended the theme of *Documents* to a more complexly interwoven system called *TransState*. The major focus of *TransState* concerned the power of the state as not being in the realm of a bureaucracy or government, but in the hands of individuals; that is to say, membership is open to any person on earth "who in his own opinion falls outside the structure of the functioning state system — and does not agree with the degradation of his 'I' to any sound in space and a naked letter on paper." The artists further comment that "all social systems until TransState were built and are built on a false axiom in essence degrading for an individual proclaiming that between the state and the individual it is impossible to place an equal sign."

Shortly before the invention of *TransState*, the artists had proclaimed in Moscow that they were not artists, but conversationalists — their new role in

art was to extend their interpersonal dialogue to the outside world. Thus, in February 1977, they were expelled from the Union of Graphic Artists, which had provided them with a major source of income. They had little choice but to apply for emigration visas.

In September, Alexandr Melamid and his family were given papers to emigrate to Israel; three months later, Komar was to follow. Upon their reunion they performed a ritual happening in which Komar's suitcase was offered up as a sacrifice during a quasi-religious ceremony, out of doors in Jerusalem's Valley of Hinnon. The work was not taken as seriously by art critics as their previous works in the Soviet; however, they are persisting in their work, given a climate more supportive of their concerns.

The critical and metacritical issues found in the art of Komar and Melamid have thus far evolved around four major themes: 1) their polemic against the outmoded yet unofficial style of socialist realism; 2) their polemic against rampant technological materialism and its effects upon world society; 3) their exorcism from Soviet society, characterized as "the evil angel hovering over Jews born in Russia"; and 4) the general clash between the individual and the state — in essence the freedom of individual choice, regardless of ideology or political association. These issues have been the major focus of their art for the past decade, from the Moscow Art Academy to their emigration to Israel. Within the context of these four general issues, the two artists have managed to crystallize some of the more predominant concerns related to Conceptual Art as a method by which to reveal an expanded political as well as aesthetic awareness.

4

Anselm Kiefer (1988–92)

The structuralist paradigm in Anselm Kiefer's paintings is an omnipresent concern. It seems that this factor is often ignored given the abiding interest in mythology and iconography attributed to Kiefer's work. It is curious that the museum brochure which has accompanied the exhibition throughout the United States tour in Chicago, Philadelphia, Los Angeles, and New York gives considerable attention to spelling out references to Germanic history and culture. The brochure, in fact, read like a glossary of terms or a conversational guide to assist the viewer in making the correct authoritative associations with the work. The exhibition carried an odd academic tone as if by distancing Kiefer's works from the gaze of direct experience they will achieve greater meaning and somehow prove the genius of the artist to be a reality.

Take the painting *Tree with Palette* (1978), which has a thickly encrusted surface of paint clearly evoking the representation of a tree trunk — an oak, perhaps — with a lead palette affixed to it. One may interpret this painting rather directly; that is, the oak, representing ties to the German cultural past, and the lead palette as a symbol of the hardened strife of the artist, malleable, yet persistently romantic in its existential overtones. The question may be evoked: What is the role and function of the artist in postwar Germany? This, of course, was the very question posed by Kiefer's progenitor, Joseph Beuys. For Beuys, the answer was a directly political one, yet never forsaking the domain artifacts, objects, and documents as material claims to accompany his particular brand of mysticism within the realm of ideology. For Kiefer, the answer is more elusive, more dependent on traditions or trying to connect the present with both the recent past and the eternal mythological past.

The medium of oil painting is one way of finding this connection. But for Kiefer, the oil pigment cannot be pure. The surfaces cannot be original. There are traces of other elements that provide a hinge between the literal and the metaphorical. This internal tension is what gives Kiefer's work its structuralist foundation and enables the symbolism to be taken seriously. The *Mastersingers* (1981–82) for example, refers to the Wagnerian opera in which singing competitions are held on St. John's Day in Nuremberg. It is a comic opera. The symbolism of Nuremberg, however, is loaded with paradoxical meaning

Anselm Kiefer, *Twenty Years of Loneliness* (1992). Mixed media installation. Photo by Tom Powel. Courtesy Marian Goodman Gallery.

because it was in this city that the trials for various war crimes committed during the Second World War were held. The element of the existential absurd is that the painting hinges between the comic and the tragic. There is resolution. The voices of singers are transformed into the voice of persecution and horror. Likewise, in *The Book* (1979–81) there is a shoreline with waves rolling in. Placed on the devastating beach is an open book made of lead. What does the book represent? Again it is an equivocal situation. The book can be either a war manual or a scripture. The weight is both literally and metaphorically significant; yet there is no resolution, only the hovering of a sensation that is at once grim and unsteady.

One may look for clues within this grim experience — answers from this German painter as to why the Holocaust occurred and what it means from the point of view of a German born in 1945. How does Kiefer's generation come to terms with its dilemma — the guilt, the despair, the economic transformation of a country ruined by conflagration and bloodshed? The experience of this exhibition in New York is broken somewhat by the fact that the concluding two galleries are placed two floors above the major body of work downstairs.

In ascending an escalator to see the show's conclusion, it is bewildering as to how the mood will be sustained. With this show the sustaining of a mood is a necessary aesthetic component. One is supposed to feel something and to feel it rather strongly. The appropriation of German cultural figures through the use of old wood engravings impressed on canvas, the use of one-point perspective, the application of tar, pitch, lead, and straw to the pictorial surface — these are powerful signifiers. Kiefer has embedded the psychic effects of politics into his work more exuberantly than Beuys. Its ties to the tradition of art history are stronger and therefore the work appears more assessable. But as for the resolution of the problem, Kiefer does not proclaim one; nor is the function of art required to operate in such a fashion. The net result is more like a cry in the dark — a call for rescue — but the exact nature of the cry is never understood. It is a partially thwarted cry. The pain is felt, but so is the obsession. The pathos in Kiefer's art is sometimes too rigid as it staggers between sincerity and cynicism. Yet the overall effect is unforgettable. Ironically, his role as a Neo-Expressionist is perhaps less related to his work from the eighties and more applicable to the artist's recent installations, such as *Twenty Years of Loneliness* (1992). Kiefer's later work is in some ways more indirect than works by other German contemporaries, such as Lupertz or Baselitz. Yet Kiefer continues to reach deeply into both historical roots and ontological sources. The indirectness of his existentialism offers an oblique vision of the recent past; and it is for this reason that the criticism about Kiefer may appear as controversial and unsettling as the work itself.

SECTION II. TECHNOLOGY AND MEDIA

5

Techno-Products and the Beauty of the Absurd (1989)

The picturesque medieval hamlet is appealingly portrayed in charming paintings, but the smell, the putrefaction and the decay that were part of that sewerless society are forgotten.
— Witold Rybczynski[1]

There has been a persistent debate going on since the outset of Modernity as to whether art and technology can survive as a unity or are destined to occupy antipodal realms of experience. The Romantic movement heartily denied the appropriation of technique as valid for the moral cause of humankind. Ruskin was perhaps the most passionately critical spokesman in the denunciation of technique, believing that it was nothing more than a self-indulgent extravagance that prevented one from thinking in terms of aesthetic beauty and basic social concerns. Technique was the application of science to the world of industry and its effects were nothing more than a mindless, bloodless production cycle. Rather than embracing technological innovations, artists emerging from the Romantic era into the age of Modernity were frequently committed to espousing the virtues of the natural world, the sublime wilderness, the simple pleasures of the outdoors, the untainted environment.

Gauguin, one of the more obvious exemplars of this reactionary tendency in early Modernism, wanted to capture the symbolic purity and the simplicity of another world, a lost primitive world in the South Seas that had already given way to the effects of Western technology. His vision of this paradise was largely a fabrication on canvas, yet it was something he dreamed of and longed for. Even while there in the Tahitian climate Gauguin wanted an unmediated paradise, fraught with origins, cravings, and rhythmic spirituality, a mythical paradise that might transcend the limits of historical (and technological) time.

In his essay "Art and Technology: The Panacea That Failed," critic Jack Burnham claims that technological art is often approached with a polemical vengeance by those who wish to preserve a romantic or sentimental view of what static forms of expression have endowed to us.[2] After examining his

involvement in five different experiments in which the wedding of art and technology was expected to occur, all during the late sixties, Burnham makes the conjecture that perhaps there is an exclusion principle intrinsic to the historical evolution of art. For Burnham this exclusion principle "does not allow the aesthetic-cognitive functions of the brain to accept an electronic technology as an extension of inanimate objects."[3] He sees this schism as a metaphysical problem that he attempts to clarify in the following way:

> ... Western art leads a double existence. It operates as an unveiled and esoteric activity, taught pervasively in schools (usually badly) and subject to the most commercial exploitation. Yet it contradicts Barthes's everyday mythic invisibility because art by its very paradoxical nature ... openly signifies an apparent mystery concerning the fusion of spirit and matter. So at the highest level, secrecy and a code of concealment are imperative for its cultural survival.[4]

Burnham's reference to Barthes is important. According to Barthes the structure of a myth is bound by a set of codified images that are visibly read as the signs of contemporary culture. For Barthes the limits of a myth can be expressed in formal rather than substantial terms. When Burnham advocated in his earlier book, *Beyond Modern Sculpture,* the passage from "objects" to "systems" in art he perhaps erroneously assumed that it was the substance of aesthetic belief that ruled in the course of art's historical evolution.[5] In citing Barthes some years later Burham's sense is that the art world is contained by a myth about what art should be, and this myth appears to be expressed socially in formal terms. Still, it is conceivable that the substantial relationship between art and electronic technology is tautologically the same in that both art and technology cognitively strive toward "an illusionary form of conquest over the forces of Nature."[6] Nevertheless, the efforts to keep them apart at the level of "everyday mythic invisibility" offers considerable resistance to those artists bent on trying to fuse them together.

To place this argument in historical context, it would seem that the birth of Modernity in the late nineteenth century was completely dependent upon its identity apart from technique and the effects of industry as felt on the production lines, in factories, in homes, and in the changing architecture of the great urban centers. It also became a matter of class identity, status, and ownership in that Modernity tended to separate the meanings of art according to privilege. For those who could purchase oil paintings and bronze or marble sculptures, art had a particular kind of signification. For the *haute bourgeoisie* in Paris, for example, art was a means of escaping the ravaging vision of the industrial workplace. Collecting art was a pastime, to be sure, but it was also a means of overdetermination. The sensuous life of art was at the opposite end of the spectrum from the humdrum effects of factory life. Industrial magnates did not want to be reminded of the workplace after leaving their offices. The

alternative was a comfortable armchair, a drink of cognac, and the mythic invisibility of art. Modernity began as an escape from the social, and it claimed social status.

It is no wonder that the avant-garde movements from Paris to Petrograd became involved in redefining the concept of Modernity by transforming it into a definitive Modern*ism*. The Russian Constructivists had no interest in replicating the serene pastoral environment. Machine culture had arrived, as it had arrived for the Futurists and eventually the Dadaists. When Picabia began painting machine parts — cogs and gears — as subject matter, using oil paint on canvas, the effect was truly shocking. Picabia was purposefully committed to defying the standards of visual pleasure to which the middle class had grown accustomed. Duchamp, of course, had a similar attitude of defiance: *épater le bourgeoisie*, to shock the middle class.[7] In defying bourgeois intellectualism, the Zurich Dadaists maintained that they were sounding the death-knell of nineteenth century Romanticism once and for all. Whereas Modernity at the end of the last century was heavily endowed with the bucolic efficacies of the Romantic vision (a fetishizing of Nature in response to the Industrial Revolution), the Constructivists, the Futurists, and the Dadaists turned completely toward the art of the machine. One can argue that this rebellion against the bucolic had its own romantic inclinations — as, for example, in the paintings and sculptures of Jean Arp — yet one cannot so easily defend the reactionary stance of a painter like Gauguin in view of what was to happen after the October Revolution and at the end of World War I. The early avant-garde had accepted the meditative powers of industry with violence and ingenuity. For a while, technique was foregrounded, even if it was to be acculturated in the manner of the absurd. Beauty was no longer the issue, as Duchamp so ironically maintained. Nineteenth century aesthetics had suddenly vanished except to academic philosophers. Meditation was slowly being replaced by mediation, a transition that Mondrian's career, in spite of its originary intentions, could not finally deny.[8]

The embracing of the machine by early twentieth century artists was partially a naive response to the earlier schism proclaimed implicitly at the outset of Modernity. By the time avant-garde artists had rebuked the pastoral themes of Impressionism, the spread of mass production had already taken place. There was an element of irony in the defiant gestures of the early avant-garde. Eventually this defiance led to another form of utopianism. Some evidence of this was seen in Malevich's Suprematism and, of course, with Mondrian and the De Stijl movement. The Bauhaus would concretize the utopian ideal even further, though not as evenly as some aestheticians would have us believe. What happened with De Stijl in Holland and the Bauhaus in Germany was an effort to refine the initial defiance of the avant-garde into a more systematized and pragmatic way of transforming the architectural and design elements of Western culture. With these movements, primarily during the twenties in

Europe, there was a return to the concept of beauty as a viable means of expressing a moral position in the industrial workplace. Through aesthetics one might obtain moral precedence. This was, of course, exactly what thinkers like William Morris, Walter Crane, C.R. Ashbee, and others connected with the arts and crafts movement in England had preached several decades before. Beauty was not simply truth; it was an avenue toward moral fulfillment. It was an ideal, an absolute, an eternal verity, but — according to Ruskin — only when it was understood within the context of social reformation; that is, beauty could no longer be an end in itself.[9] Industry had made that a certainty once and for all.

This historical background is necessary in coming to terms with any form of exhibition related to art and technology, particularly in recent years. In another essay, published in 1987, an attempt was made to clarify the problem of technological art as perceived from the psychological and social perspectives of the spectacle in mass culture.[10] The various artists discussed in that essay were part of an ambitious exhibition mounted in a SoHo gallery space in the Spring 1987 called P.U.L.S.E. Given the background of numerous art and technology experiments in the late sixties, including Burnham's "Software" (1969) at the Jewish Museum in New York, Billy Klüver's "Experiments in Art and Technology" (E.A.T.), and Maurice Tuchman's extravagant "Art and Technology" exhibition at the Los Angeles County Museum of Art in 1971, it seemed important to clarify how the artists of the more recent P.U.L.S.E. show were dealing with so-called "high tech" in the form of containable objects and installations. By "containable" I am referring to the fact that they were easily observed within relatively small spaces within relatively short periods of time.

Some of the artists in P.U.L.S.E. were selected to exhibit works in "Interaction," an exhibition curated by Ellen M. O'Donnell in the summer of 1989 at the Aldrich Museum of Contemporary Art in Ridgefield, Connecticut. The timeliness of this show relates to an ever-increasing sophistication and awareness of electronic devices and fabrication techniques as the computer age develops further into a new *fin de siècle*. Whereas a hundred years ago the first tremors of the avant-garde were being felt, now it would seem that its full crystallization has come about. One does not get a sense of outrage upon viewing the "Interaction" show the way one might have upon entering a Futurist exhibition or an evening *sintesi*. Instead the atmosphere of this show was much subdued and perfected. The feeling of the spectacle had not so much diminished as it had taken a different form. What we have come to know as technological art or kinetic sculpture or video installation is less about shocking the museum-going public and more involved with a hybrid of traditional aesthetics combined with an attitude toward mediation. Such oppositions can be framed linguistically as oxymorons. In contrast to Burnham's expectations about the systemic applications of technology in future art, it would seem futile for art to attempt to replicate the cultural function of technique on a purely informational level.

What is interesting about "Interaction" and other recent installations is how the eclectic views of the various artists manage to survive despite the absence of a strong critical dialogue. Instead of criticism that approaches technological art on the linguistic level one generally gets a type of art journalism which does nothing more than appeal to experiential attributes of fun and excitement without really addressing the work in contextual terms at all. If one is going to defend such art as "the art of the future" then it is necessary to understand what issues are really at stake. Do the kinetic aspects of the work alone justify its importance? Such a criterion in itself seems insufficient both in terms of the seriousness with which some artists deal with their ideas and also in terms of how perception and interpretation actually function in relation to any work of art, static or kinetic. What, then, makes this work different? Why is it considered by some critics to be marginal? Immediately there is a problem. When one addresses "technological art," what actually defines it beyond the collector's or the curator's prerogative? Why, for example, should a video installation by Nam June Paik be shown in the same exhibition as James Seawright's computerized *House Plants* (1984) or one of sculptor George Rhoads' playful kinetic constructions? Clearly these works have appeared together in various exhibitions over the years, and in some cases have even been housed in the same collections, both public and private. But this does not resolve the problem of what linguistic connections these works possess in relation to one another. If we are to "interact" with these forms, then that is certainly one aspect of the work. But how do we interact? In the sixties the term was "participation art." Whatever the terms, what are the actual signs and symbols that give these works a common conceptual ground?

While this essay is not intended to focus solely upon a single exhibition, many of the comments will relate to works in "Interaction" simply because of the questions this show raises about the grouping and display of techno-products. Critically one can address some rather exceptional works by artists who deserve considerable attention as much for their ideas as for the media and techniques with which they are engaged.

James Seawright, an established figure in the art and technology movement, is an important artist not simply because of his use of technique but because of his extraordinary insight into how human perceptions adapt to the new visual and tactile environment. Some of Seawright's works are very contained and intimate, such as *House Plants*; others are meant to function more on a public scale, such as his mirrorized walls. In either case, his work has tremendous breadth and insight, both on a psychological and a social scale.

Kristin Jones and Andrew Ginzel have worked as a team since 1983. Their work *Apastron* (1986) is a multi-media installation using both static and kinetic elements. In contrast to *Thelion* (1987), a work shown in the P.U.L.S.E. exhibition, *Apastron* is more concentrated in that the viewer is literally consumed

by the focus of the installation. The primary elements include two spheres — one gold, the other black — encased in a glass box and resembling a shrine or altar. Between the two spheres is a long needle that moves between them as if to suggest the infinitely tenuous balance of the universe. Behind the glass encasement is a stratification of ash and cinders. Beneath the spheres the ash is revealed as a kind of burn-out or residue of some galactic conflagration.

In *Analemma* (1988), a long-term installation at the Wadsworth Atheneum in Hartford, Connecticut, Jones and Ginzel have again expressed cosmic duality in relation to light and darkness. Using two windows on the north side of the museum, the installation is sometimes bathed in sunlight and other times darkened. The title refers to a graduated scale having a figure 8 configuration in which the sun's declination is shown, thus registering an equation of time for each day of the year. Time is an essential factor in these artists' installations, but that in itself does not explain the symbolism used in their work. Time can mean many things, both subjective and objective. For Jones and Ginzel, the concept of time has many ancient and cross-cultural roots. They are not concerned with mundane time, but time that expresses some form of universal wholeness, some sense of completeness about the structure of the cosmos and how that structure might be used to obtain self-awareness and cognitive responsiveness in what we perceive relativistically as matter and energy.

One might contrast the medieval symbolic function of Jones and Ginzel's installations with a work such as James Turrell's *Meeting*, permanently installed in P.S. 1 in 1987. In this contemplative environmental piece the emphasis is also on time as perceived through both natural and artificial lighting effects. Whereas works like *Apastron* and *Analemma* are significant in symbolic terms, Turrell's *Meeting* maintains a literalness in its use of space and time, a tendency more characteristic of Minimal Art.

Another artist who was represented in P.U.L.S.E. and again in "Interaction" is the Greek-born Takis. For years Takis has been fascinated by electromagnetic structures. In his work *Signal* two lights, one red and one blue, flash on and off at various intervals. Takis has generally worked with a considerable economy of means, and in that sense his work stands apart from other artists in the show whose works seem to depend more on elaboration and complexity. *Signal* operates persuasively as an open signifier more than a sign. To use Charles Morris' semiotic model, there are pragmatic, syntactic, and semantic meanings that one might glean from Takis' work. Its banal quality is something of a decoy. Its technical apparatus is not hidden, but apparent. It is highly charged, metaphorically speaking, yet reserved in its timeliness. The flashing lights have an almost biological rhythm that suggests survival, even exuberance, but also a warning.

Takis relates closely to the Dada artists in the sense that there is something of the absurd in his work. The absurd has certain existential overtones,

as for example in the theater of the absurd, especially the plays of Beckett, Pinter, Arrabal and Ionesco.[11] Duchamp's *Large Glass* was said to have been provoked or inspired by the French proto–Surrealist writer Raymond Roussel, whose absurd novel and theater piece *Impressions D'Afrique* involved lengthy descriptions of fantastic machines. Roussel's work is absurd in its cyclicality. Its static evolution goes nowhere and resolves nothing.[12]

In Takis one senses something of an absurd condition in being a part of this mediated culture where signs and gadgets are ambiguous and references are scattered in many directions creating chaos, conflict, and disjuncture. R.M. Fischer's fantastic machines also appear closely related to the vision of Roussel. The upper and lower segments of Fischer's *Royal Wedding* (1981) reveal an abrupt discontinuity, pitting fake elegance against a makeshift apparatus. *Fountain* (1987), a recent work by Fischer, is also within the tradition of Roussel and closely related to Duchamp as well. William Stone's *Caves of Steel* is yet another example of an aesthetic of the absurd. Instead of light and magnetism Stone deals with water and conduits. In this vertical construction of galvanized pipes, Stone has attached six stethoscopes at various levels of the construction. As water pours from a faucet at the top and descends through the pipes, one can listen to the variations of tones. It is a truly interactive piece that involves the aesthetics of listening. It is a sculptural sound experience in the same way that Duchamp's Readymade *Object with Hidden Noise* (1916) is less about the formal logic of what is seen and more about the isolated contemplation of what is heard.

In *Observatory Tower* (1985) by Alastair Noble, a large, awkwardly shaped obelisk is supported upside down with four armatures that extend from a base resembling Mayan architecture. The pinnacle of the obelisk is constructed in glass and touches the convex side of a Chinese wok. Within the pinnacle, one can see the prismatic patterns of a black and white television moving in various patterns and reflecting on the copper surface below. Noble, who was formerly associated with the Art and Language group in England, is interested in television light as a sculptural medium; that is, matter transforming itself into energy.

In another exhibition in the fall of 1989 called "Forecasts: Visions of Technology in Contemporary Painting and Sculpture" at the Nerlino Gallery in SoHo, curator Gail Levin has included another television work by Noble along with works by Donald Lipski, Richard Thatcher, Cork Marcheschi, Christopher Sproat, and others. In this exhibition the emphasis is given less to the interactive aspects of the new technology than to the effects which technology has produced in defining an extended social view of contemporary culture.[13] Entropy is as much an issue here as science fiction and utopia. Thatcher's pristine and elegant *Energy Container* (1985) is juxtaposed with Donald Lipski's weirdly enervated *Anshe Emet* (1986). The convergence of aesthetic beauty with Neo-Dada absurdity is very much at home in both works.

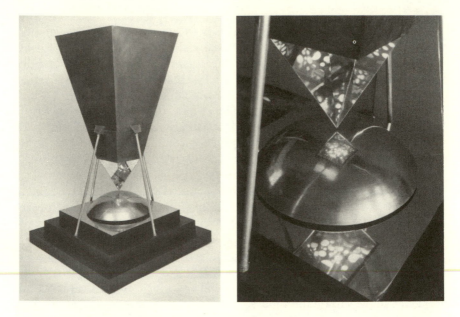

Alastair Noble, *Observatory Tower* (1985); detail at right. Glass, steel, video, aluminum, wood. Photos by Erik Landsberg. Courtesy Alastair Noble.

Jon Kessler is another artist who constructs and deconstructs memory based on the myths of technology. In *No Radio* and *White Silence*, two works included in "Interaction," Kessler manages to convey a means for transmitting imagination by way of the simulacra. His sense of color in these dramatic machines is highly stylized, giving the work a definite pictorial quality. This quest for the pictorial within an installation situation is also evidenced in Ted Victoria's *Tom and Lucy Left Their Mark Here* (*God Bless America*), in which more than twenty film-loop projectors throw pop images onto several individual rear-screen cut-outs. This kinetic assemblage, shown upstairs in the attic gallery of the Aldrich Museum, offers a subversive homage to American pop culture in a highly luminescent manner; the iconic references cannot be mistaken.

In the adjacent gallery, Shigeko Kubota's enormous video installation, *Dry Mountain, Dry Water* (1987), elaborates upon the structural duality between nature and the simulation of the natural environment. Using mylar-covered "rocks" of various shapes and sizes, three video projectors cast reflections of them at various angles. The aura of simulation is present throughout the space. One may relate Shigeko's piece to the earlier "non-site" pieces of Robert Smithson in which actual rock samples were brought into the gallery and often associated with topologies of the environment from which they were excavated.

In addition to those already discussed, artists who are currently involved

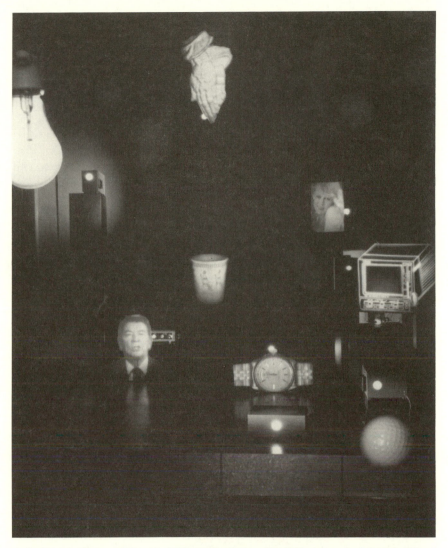

Ted Victoria, *Tom and Lucy Left Their Mark Here (God Bless America)* (1984). Mixed media room installation, rear projections, size variable. Courtesy Ted Victoria.

in the synthetic uses of light — everything from neon and argon mercury to stroboscopic and fiber optics — include Clyde Lynds, Moira and Alejandro Sina, Art Spellings, Cork Marcheschi, Milton Komisar, Christopher Sproat and Tsai. Many of these artists' works function mainly in the context of architectural design in that they illuminate space using a formal aesthetic vocabulary. For this reason it would seem that some of these artists, especially Art Spellings and Milton Komisar, might fare best in exhibitions focusing on Postmodern

ornament. These artists' works are relational in the sense that their semiotics are essentially tied to architecture. There is neither a subversive strategy, as in Nam Paik's *Fish Tales* (1986), nor any particular comment that extends metaphorically or ideologically beyond the limits of their specific spatial/temporal activity. This is not to imply that these works lack visual power; quite the contrary. It's just that they function on a different level from works by artists such as Tsai or, for that matter, Takis.

The element of mystery, as Burnham once maintained, is essential to art in some way, regardless of how literal the form may seem. Wen Ying Tsai is an artist whose computer programmed stroboscopic lightworks clearly transcend the limits of architecture. In writing on Tsai's works at M.I.T. in 1971, Gyorgy Kepes explained:

> To see his work in an "exhibition," one discovers soon enough that the term "exhibition" does not fit anymore. These dazzling pure lines that move with the unerring effortless precision of nature's logic transform the space and make you a part of it.... Tsai's work captures the core of every vital art, the rhythmic of life.[14]

Tsai's work is aesthetic art in the same way that American Color Field painting is directed toward visual pleasure. Yet the mysterious presence of Tsai's high frequency light lines is less about mystification than it is about wonder and delight. There is a hedonistic element in Tsai's work, an almost childlike quality combined with electronic precision that manages to confound our expectations of temporality.

Rebecca Horn's piece entitled *The Pigment of a Whole Ocean Stored on a Sponge* again remarks upon the condition of the absurd in a very forceful and direct way. A mechanized hammer hits a wire-mesh container overhead at repeated intervals, whereupon powdered blue pigment falls upon a sponge several feet below. Horn's reductive mechanical gesture summarizes the hypothetical status of machine culture as if the Postindustrial Era had not left us with an electronic deluge. Her technique is minimal, yet the metaphorical power is vast. Just as Takis' *Signal* takes us beyond the literal without enforcing its effect (as in a traffic signal), so does Horn's machine offer the metaphorical power of subversion by alluding to a rational process that has no apparent result. One may understand the function of the event in perfectly literal terms, but one cannot easily explain its reason.

Horn's implicit attitude about high-tech culture seems loosely related to the mute optical experiments of Duchamp or the more recent "metamatic" sculpture of Jean Tinguely. Although the condition of the absurd is present in each of these artists' works, there is also a feeling of transcendence caught within the deliberate anti-aesthetic posture. With Horn the attitude is Poststructural to the extent that the subject of her work is never clear in that the signs appear to function autonomously without ever giving way to a narrative

structure. It is a poetic work into which formal and linguistic elements are intrinsically woven, yet the statement is liberated from any practical or methodological reference to mainstream high-tech. Utility is clearly not the issue. The makeshift gadgetry of the piece operates within its cyclical and cynical system of action and response. The product offered to the viewer is both paradoxical and challenging in its obversity, yet it is as beautiful as dry blue pigment falling over a sponge.

If technological art is ever going to establish itself as a major part of critical discourse it must establish internal consistency as it projects metaphorical value — a point that could be made about any serious art. The Canadian writer Witold Rybczynski has tried to address the problem of technology from the point of view of those who control it. In his book *Taming The Tiger: The Struggle to Control Technology*, his concluding remarks warn against the romanticizing of previous eras in an attempt to displace the present:

> Not a little of the difficulty that our culture experiences with new technology stems from this romantic posture. No sooner does a new technology come along than we suddenly discover previously unrecognized values in its antecedents.[15]

If Rybczynski is correct in his assumption that advances in technology somehow unveil the past in a way that allows new insight and meaning to become associated with former technologies, then it would follow that art's position in this dialectical route should be to use the past as a means to illuminate the present. This is not to suggest that art should resign itself to self-consciously playing off the effects of art history as the tendency seems to be now. Nor should art lag in terms of taking an informed position on the present. It is unlikely that science will ever forfeit its claim to progress in favor of art. Art should not resist science but challenge its use.

As Rybczynski has spoken about the problems of romanticizing technology, one might find a parallel with what the late media theorist Marshall McLuhan once described as "bonanzaland." For McLuhan, "bonanzaland" was a retreat from the present into the immediate past (the term was borrowed from the popular television western of the sixties,) a retreat from the complexities of the urban environment into the great unsettled frontier of nineteenth century America. What Rybczynski is warning against is a rejection of technology in which denial blocks the natural transformation of familiar objects so that they become defamiliarized artifacts of the past. When denial of this sort occurs, the immediate tendency is to go backwards in terms of ideology while trying to maintain the capital advances of the new.

When Rybczynski speaks about the separation between an artist's vision of a medieval hamlet and the unseen putrefaction that is rarely considered in one's contemporary experience with the painting, he is speaking of the tendency to romanticize the past by giving the past a sense of removal from the history of

technology which has been a perpetual struggle for humankind, even though until recently it could hardly be called advanced.

In one sense technology can be seen as neutral: neither good nor bad. It implies progress, yet progress with its own positivistic agenda. As I have tried to argue here, the products made by artists who use technology have broader cultural implications. Techno-products can be overtly decorative. Yet they can also make statements that are material, social, and psychological in intent. The probability that technology will ever become art is absurd, and therefore suggests that the role of artists is, at best, a dialectical one. Any form of technology — no matter how advanced — requires some sort of adaptability to human needs in order for it to perform culturally. However, the problem with technological adaptability lies in discovering its phenomenological basis in time and space. This is also what defines the relationship of technology to art. Since the advent of Postmodernism, aesthetics can no longer be discussed in terms of the old universals. It is precisely this disillusionment with the recent scientific past that has made technology's appeal to the absurd all the more profound today.

6

Gyorgy Kepes: *Blue Sky on the Red Line* (1986)

Gyorgy Kepes articulates a human point of view in his art that reaches to the viewer's most basic emotions. These emotions form the basis of a profound sensibility, an ineluctable spirit of nobility, perseverance, and comprehension. The art of Kepes is the capacity to sense order within chaos, and chaos within order; there are no complete formulas. The criteria exist not because of reason, but owing to causes that exist beyond the grasp of reason: the basic function of consciousness.

A public artwork by Kepes, *Blue Sky on the Red Line*, was completed in the spring of 1985 in Cambridge, Massachusetts. The work is underground. It was designed to be viewed by passengers waiting for public transportation, those standing on the platform below street level. The location of the work is an underpass where buses descend from Harvard Square to receive passengers from the "red line" subway which goes between Boston and Cambridge and various outlying suburban areas.

As with former public artworks designed by Kepes, the intention was primarily a humanistic gesture, a compassionate understanding of the socio-pyschological circumstances that influence and deeply affect people on their way to and from the congestion of an urban metropolis.

A lesser artist might have conceived the task as hopelessly mundane, as an opportunity to "decorate" the large curving wall of the underpass. For Kepes, it was not merely a task, but a challenge, an action to inspire hope and courage. Here the criteria of the master artist emerge as something beyond simplistic reason or technique. Art functions as a gift of consciousness through a mature sense of giving. Gyorgy Kepes has given something special to an environment where people live and conduct their daily lives by making use of unusual techniques, materials, and processes to communicate his ideas.

Kepes chose to work in stained glass. This choice of material may appear unlikely for an artist associated with science and technology. But this is where Kepes has been misinterpreted. Technology functions as a tool, as a medium, the way any material or tool might function. Technology as an end in itself is

not the glory or salvation of art in the late twentieth century. It is the artist who makes use of these tools and materials in order to effectively communicate ideas. The goal of public art is to speak the inexpressible to people who see it and walk by it. The objective is to produce a heightened sense of awareness and pleasure through a work which holds a multi-sensory impact.

Stained glass recalls the great Gothic cathedrals, the glorious rose windows. Kepes had worked in stained glass previously on projects in San Francisco and Japan. Stained glass has a tradition in the West, a special religious significance, a particular cultural sign-value. Kepes wanted to bring the sky underground to a space where it is not normally accessible.

This, of course, is a symbolic action which affects people's emotional presence — not as a singular mode of behavior, but as an uplifting awareness of oneself in relation to others, a spiritual awareness that transcends the mundane and despairing conditions of the location.

Natural light flows through glass. Initially Kepes wanted to transmit natural light underground at Harvard Square. The operation proved unfeasible, however, given the architectural and budgetary constraints of the project. Also, at an early stage in the design of his proposal, Kepes wanted to incorporate the use of computerized light sensors which would trigger a "red line" display against the blue wall. Again, budgetary concerns stood in the way, and endless complications related to the maintenance and surveillance of the apparatus. The computerized light-display had to be abandoned.

The Cambridge Arts Council, working in close coordination with the Metropolitan Boston Transit Authority (MBTA), commissioned Kepes to do the work in the late 1970s. It was part of a larger project to incorporate works of art in the outlying subway stations that were being constructed to extend public transportation beyond the Harvard Square terminal. The project took several years to complete as a consequence of endless complications, particularly in relation to engineering problems and legal complexities. When it became apparent that a kinetic light display would not be possible, Kepes translated his idea into a static form.

His objective remained constant until the final realization: to bring the feeling of the sky underground, to create a sense of openness and hopefulness, and to enhance the dreariness of the passageway with a vital humanistic symbol, an overall quality and rhythm of light. Kepes is not a decorator; he does not function in an adjunctive or secondary role to architecture. He is a designer, city planner, painter, architect, photographer, scholar, educator, and environmentalist. Kepes is more than an image-maker: he revitalizes those necessary symbols that are latent or dormant within our cultural milieu, indeed, within our history. He is a seer, a visionary. Kepes thinks symbolically, yet always in relation to real time and space. He is a wizard of subtle manipulation in his speech, in his language of symbols, with a tactile sense of reality that transcends the normative aspects of the industrial prototype.

Kepes worked closely with the Willet Stained Glass Studios in Philadelphia, which fabricated the 7-foot-high, 112-foot-long wall, using 27 varieties of blue glass, according to the design's specifications. The wall is composed of several vertical panels with thick facets of glass epoxied into steel armatures. These panels can be easily opened to replace the lights when necessary. When the computerized "red line" display was abandoned, Kepes designed a horizontal red line which divided the faceted blue wall about a quarter of the way from the top. This bright red horizontal accent works dynamically as if possessed by a comet-like speed, especially if one happens to be inside the bus as it enters the passenger platform.

Kepes is a master artist because he intuits through reason; in concrete terms, he understands the language of art and how that language must not only appeal to the viewer, but also challenge the viewer to ascend beyond the normative banalities of automatic reflection. *Blue Sky on the Red Line* is a symbol of hope for the individual person living in the throes of an alienating and intimidating technopolis. This is an important work that restores the presence of art to the everyday world, where people need it most.

7

On the Process of Viewing Discrete Things Discreetly (1987)

"I sometimes think that civilizations originate in the disclosure of some mystery, some secret; and expand with the progressive publication of their secret; and end in exhaustion when there is no longer any secret, when the mystery has been divulged, that is to say profaned"
— Norman O. Brown, Closing Time

When the critic Harold Rosenberg decided that the aftermath of Abstract Expressionism was becoming engulfed in what he called "the tradition of the new," he directly implied that the art of the late 1950s was qualifying its message primarily in terms of innovation. The criterion for a successful work of art was one in which the idea or the look of the work appeared "new." If the work had the appearance of not having been done before, then automatically the artist was assured of some level of recognition. Ultimately, the issue of newness became one of how cleverly the artist could reframe or repackage an older idea. If the "new" had some implicit connection with the "old"— that is, art history — then surely the work must be deemed significant.

Another way of stating the problem was that this criterion of innovation, as Rosenberg meant it, had become institutionalized — that is, integral to the function of the modernist art academy — so that the vitality of art as a real force within our society was quickly being dissipated. By the late sixties, art schools and art departments in major colleges and universities throughout the country were filled to capacity with students working to become professional avant-garde artists. Within these institutions, art students were asked to conjure an "intention" the same way a graduate student in the philosophy of science would be asked to submit a thesis proposal. Although not similar in practice, the educational concept was the same. The academic manner in which art students would strive to achieve stylistic and conceptual originality was considered normative; it was the means by which to show one's seriousness as a

truly professional artist — that is, an artist who fit the academic "high art" stereotype. One was expected to produce something new, or if not new, at least up-to-date.

During the seventies, a period erroneously referred to as the era of pluralism (as if contrasting viewpoints were not evident throughout the sixties), the way in which an artist dealt with innovation began to shift its emphasis. Conceptualism had worked its way into the academy; as a result, the whole process of how an artist worked took a back seat to how one thought about one's work. That is to say, one could arbitrate a position for one's work regardless of how it looked or where it was coming from. The art object no longer was expected to look a certain way. The gap between the rawness of the fifties and the refinement of the sixties was now a matter of discourse. And within the discourse, an artist was expected to evolve a context of righteousness; that is, a place of purity where the solipsism of the discourse proved sacred, a place virtually (sometimes visually) uninhabitable except for the provocation of further discourse. One was not expected to respond to the work directly but to the discourse about the work.

By the end of the seventies, after two economic recessions, the discourse began to run thin. Concomitantly, art school enrollments had dropped severely from the previous decade. For younger artists who stuck it out there was a need for another form of discourse that could replace art solipsism with something more substantial, grounded in the social sciences. Art language was in need of more specific roots; neither formalism nor Conceptualism could abate the dilemma. Artists sought the help of critical theorists in order to bolster their opinions about what they were trying to do — to reinforce their efforts through a discourse outside but not unrelated to their individual concerns.

Discourse in the eighties began with an ideological split (which the popular news media have thoroughly confused by calling everything "Postmodernism" or "new wave"). On the one side is the appropriation genre, Neo-Conceptualism or political art, supported by the apostles of deconstruction, both in critical and psychoanalytic theory. On the other side are the various Expressionist tendencies, including figurative and graffiti artists, whose work is often analogous to the philosophical lyricism of Nietzsche.

This superficial division has, however, become much less readily apparent as the decade of the eighties has progressed, bringing forth a much greater complexity of discourse — one which appears to be pushing in many directions simultaneously and thereby increasing the latitude of ideological tension to include both internal processes of art-making discourse and new amalgamations of external theory.

The emphasis now appears to be on the spectacle, not as a representation or deflection from the laws of production, but as a means of entering into the discourse through dialectical tension. The emphasis is on the embeddedness of temporality as a condition of viewing and of thinking in concurrent relation

to the spectacle isolated from the automatic reflexiveness wrought by commercial culture.

It is precisely this complexity of discourse that Richard Milazzo and Tricia Collins have aspired to address in a series of exhibitions which they have curated over the past three years, primarily in East Village galleries. In one recent exhibition, entitled "Time After Time," Collins and Milazzo have projected their combined aesthetic fervor into another territory: a discourse involved with the sensory and tactile physicality of form as it connects with and or divests itself from the postmodern condition (what has come to replace the "human condition" of the immediate postwar period in the writings of French existentialists). Whereas the previous curatorial stints of Collins and Milazzo have dealt almost exclusively with the fictionalism of recent painting, "Time After Time," organized for the Diane Brown Gallery last March, investigates the theme of three dimensional, metaphorical permutation through interior sculpture.

If anything, this recent show has a certain revivalist spirit about it, a spirit that by implication calls into question the viability and current significance of large scale sculpture, including both environmental and site work. "Time After Time" returns sculpture to the gallery, creating an allegory of salesmanship, appropriated from "new wave" East Village art in the early eighties, based on questions of size, worth, materiality, mobility, tradition, and decorativeness.

Of course, "Time After Time" carries an immediate reference to the film made some years ago as a takeoff on the famous H.G. Wells novel; thus, the exhibition has an air of science fiction about it as well as an entrepreneurial spirit. This science fiction aura is one which has been thoroughly informed by the postmodern condition, by the propensity to reproduce and to simulate. It is clearly not a revival of past auras in relation to art and culture; the old modernist dialectic has been vanquished here. Instead of the former tension, Collins and Milazzo begin their investigation somewhere within the realm of phenomenology and project it into the absurd, completely and mysteriously bypassing the terrain of existential reality.

Indeed, "Time After Time" offers a discourse clearly in opposition to existentialism and therefore undermines any possible reference to Expressionist aesthetics. Yet the move from perceptual phenomenology — that is, beyond the faltering idealism of the late Husserl, beyond the stoic temporality of Heidegger, even beyond the political finitude of Merleau-Ponty — to the realm of the absurd is unwittingly disguised as ethereal spectacle. "Time After Time" locates the major dilemma of advanced three-dimensional art in the eighties within a discourse that provokes conflict between thought and feeling.

The densely packed verbiage of their exhibition statement was interpreted by some as pretentious, even superfluous. Having read the various Collins and Milazzo manifestos from previous exhibitions, however, one may begin to feel

that there is something going on in the language that is decidedly unpretentious. Even so, the rigor of their ideas necessarily emerges as preeminent. Certain phrases jump to the surface of their text, resonating with ecstatic temerity — phrases such as "the glib life of adjectives" or "the latent temporality of negligible form" or "bound to the loop of consciousness." Another sentence reads, "A neutral subjectivity and a strident neutrality bespeak, perhaps, the belated temporality of a mode of extrinsic consciousness after culture." The rancor and pulsation of their prose carries the full weight of the absurd, fraught with metaphorical and lyrical humor and delight. Their manifestos and their exhibitions represent a kind of pop phenomenology, a projection of the postmodern condition into another fictional hierarchy — one that never rejects the formal rigor of those art-making procedures which may sometimes simulate but never equate themselves with more commercially gratifying brands of aesthetics.

The "Time After Time" manifesto runs parallel to the exhibition; it is not superfluous. It is the representation of a mutual will, a striving toward an openness and a freedom of expressiveness (exactly the condition of the absurd) which is bereft of the more explicit tendencies of Expressionism. There is the paradoxical interaction of what Collins and Milazzo label "primary forms" and "simulated forms," an opposition of concepts made concrete, thus challenging what we look for in a work of art, suggesting that in the postmodern age what we expect art to be may have actually atrophied our instinctual human device for relating form to memory. In primitive societies, this synaptic charge between sight and syntagm is an essential apparatus for survival. In "Time After Time," the presence of the spectacle is anything but one-dimensional; instead we are jarred into another kind of sensorium, another process of ideological conscription. We are not reading information; we are reacting to form through our sensoria, engaging our sights through the windows of culture, both derivative and mediated from the past.

The sculpture is not large-scale; it is a work to be studied on the aftermath of arousal. There is a certain tactile appeal, a traditional unity within the diversity of objects. Three-dimensionality suggests touching. But how do we touch objects which reflect alien circumstances, objects capable of engendering fear and dismay? Yet the need to touch is often irresistible. Sculpture should provoke, it would seem, a desire to associate oneself with an experience, a compression of time, a relationship in which one's memory works with the presentness of form.

Haim Steinbach's *Lead Part*, a multimedia construction, sits on a shelf at eye level. Two monster heads — Halloween masks made from Rhoplex — sit beside six digital clocks. Another large clock with hands sits at the opposite end of the tricolor vinyl shelf. The memory is of a child's room: the rites of puberty projected from childhood through adolescence, the Oedipal dilemma, the fixation; where does time stop and real life begin? The dilemma absorbs

consciousness; there is no easy exit. The world is a processed one, a synthetic one.

Wheel Animal by Not Vital, a large bronze wheel with an interior cruciform with a nondescript creature on the rim, is poised against the back wall to the front gallery. The sign is an ancient one — from the ancient Celts, a mystical symbol. It is a sign of the sun. Formerly, it was thought to empower certain rites of passage, to cast magical spells, to reap the harvest. In front of *Wheel Animal* stands Joel Otterson's *Designer Nucleic Acid*, a copper coiled pillar, resembling something from the laboratory of a 1920s science fiction movie. Across the gallery, Gretchen Bender's *Untitled* wall and floor piece connects phallic detachment with its opposite: the image of hysteria, anger, and frustration. Beside it, another tabletop assortment of objects by Saint Clair Cemin, titled *White Elk, Blue Mask, Swan Gondola,* and *Book Ends.* Are these objects of contemplation? If so, a strange morbundity exists in the spaces between them, an insoluble emptiness, a disturbing sense of displacement, even horror.

In Richard Jarden's piece titled *Allen Ginsberg's Desk,* a conceptual lamination of ideas serves to monumentalize the figurine at the top. It is absurd in its vacancy; there is no essence to perceive. The eye deflects inwardly to conjure the ritual basis of the form. The pedestal gives importance to the formal problem which is left purposely without resolution.

Allan McCollum's *Five Perfect Vehicles* is again about repetition and reproduction in a most explicit way. The primary colored vases are without content; they are solid casts. They might appear as amphoras. A macabre sensibility engulfs them but is offset by the brilliant color, a characteristic not unrelated to the last paintings of Van Gogh. The desire for simulation has usurped our powers of primal reason. The eye swallows the vases like gumdrops, like bombs, candy-coated for optical pleasure.

Two bronzes by Gary Stephan and Joel Fisher play upon biomorphic concepts of sculpture, convolutions of space. Stephan's *Leda as the Swan* moves inward upon itself in an act of unionism, a narcissism wound in upon itself. Fisher's arcane *Ir* builds a biomorph out of the disposable, the traces of a drawing reformed. On the floor, Joseph Nechvatal's *Tear of a Clown* is an absurd metamorphosis, an excretion transformed into a hedonistic ideal.

Annette Lemieux's typewriter on the floor tells a narrative about the surface and topography of the Earth as a photostat rises upward to the ceiling. In the back gallery, *Robe de Jardin* by Maureen Connor revives a Baroque marvel of flowing spirit, an embodiment captured through the process of instigating materials to function naturally as physical force.

The discourse continues. Everything is within the context of the spectacle, the dialectical tension of structure, its containment, its private projection of metaphor. In "Time After Time," we are summoned to view sculpture not as a set of ideas, not as a series of reductive exercises, not as the representation

of a movement or as a style, not through the eyes of an institution, and not because there is anything in particular that declares them new. Rather the exhibition of these diverse object/entities — a polymorphous cross between the surrealism of the past and the ever-present processes of heightening our perception of the absurd — suggests that the discourse can no longer escape the confines of what we see, and that what we see is the reflexive source of the conceptual integration of all our facilities functioning at slow speed. "Time After Time" is about getting inside of time and, like Roussel, moving somewhere beyond time through the imagination.

8

Un Chien Délicieux by Ken Feingold (1990)

This 19-minute videotape, shown at the Museum of Modern Art in September 1991, is not precisely a Surrealist one, yet it depends implicitly on Surrealist ploys to make it happen. Ken Feingold is primarily interested in language, and it is through language that *Un Chien Délicieux* acquires significance. Surrealism is the subject matter but language is the subject. In addition to its discursive manner of presentation, especially during the first half of the tape, Feingold incorporates a certain degree of humor resting almost completely on the absurd.

The beginning of *Un Chien Délicieux* is derived from video footage that Feingold made near Chaing Dao Mountain in Thailand in 1986 during one of his many travels to Asia. The camera stays fixed on a native of the region who holds a spear and speaks to the camera. The scene is animated by the presence of tropical birds who have alighted on his spear and, of course, the scenes of the mountain village in the background. The talk goes on without interruption for several minutes. There is no conversation, merely a monologue. Dubbed over the native's speech is the voice of the translator (David Lamelas) who appears to be simultaneously recounting an incident in which the speaker prepared a dinner for Andre Breton in Paris, presumably in 1948 at the Surrealist's studio.

The monologue seems endless as the native recounts the incident in his native tongue. The translation, however, is not exactly what the speaker is telling us. We do not know precisely what the native is telling us. The overdubbing of the voice of Lamelas is convincing to the extent that just the right amount of time is given between the spoken phrases. Lamelas's slight Spanish accent is helpful in giving credibility to the translation even though it is completely false. The fiction of the translation — in fact, a narrative written by Feingold — is further legitimated by the occasional insertion of a photograph documenting such a dinner in Paris. In the black and white photograph we see a dog being served on a platter to Breton, the poet Benjamin Peret, Elisa Breton, and Suzanne Cordonnier. Essentially we are being told that this man —

66

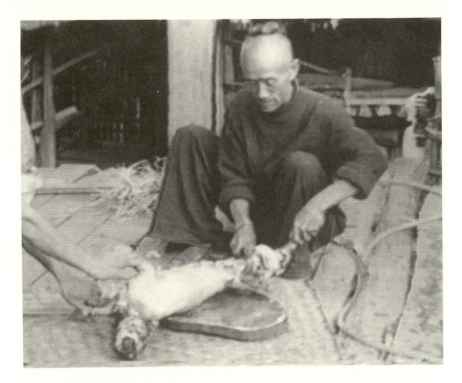

Ken Feingold, still from *Un Chien Délicieux* (1991). Video. Courtesy Ken Feingold.

the speaking subject of the tape — was the cook and preparator of the meal served to Breton and his retinue.

The second part of the tape is drastically different from the first. Whereas the first part of the tape dealt with speech, the second part deals with action. We witness through the camera's eye, often in slow motion, the slaughtering of a dog in the village and the gradual preparation of the delicacies. We witness the speaker, whose machete cuts the charred carcass of the animal into a series of steaks in a manner not dissimilar to that of the sushi chef in suburbia.

Needless to say, the preparation of this meal by the apparent narrator of the tape is difficult to watch. People leave the screening room at the moment they catch on to what is happening. (New York City has a number of dog lovers, some of whom detest their neighbors and other people in general.) One comment that Feingold seems to make is that we abhor the killing of a dog as a means for sustenance, yet at the same time we ignore the suffering of people around us, particularly homeless or less fortunate people who have been relegated to lives of dogs in the street scrounging for a meal. The language game, however, is the most substantial and the most significant aspect of *Un Chien*

Délicieux in that we are shown how speech is made and how action is translated by way of "framing." Herein lies the significance of the absurd — not as metaphysical reality but as everyday semiotics invades our lives and transcribes meaning.

SECTION III.
CULTURE
AND SPACE

9

Space Shifts:
The Art of Jan Zakrzewski
(1991–1994)

I.

In looking at some of the recent polyptychs and paintings of Vladimir Zakrzewski, I am reminded indirectly of the structural method of Cézanne. It is always curious how one comes to understand the structure of an artist, particularly early in one's visual and plastic training. Cézanne's structure is not obvious. His method of painting, specifically in the late period, consisted of a series of overall patterns. Cézanne possessed a certain anxiety that he embedded in his approach to the canvas; that is, a certain doubt in which he attempted to struggle beyond himself in order to resolve the conflicts between matter and spirit.[1] The little dabs that Cézanne applied in a simultaneous way, without concentrating on any specific area, gave a certain tactile sensation to the picture plane. The shapes in these paintings, particularly the foliage, trees and rocks, painted out doors, have a kind of patterning or, more precisely, a construction of several visual sensations that read as if they were patterned overlays.

It is interesting that Zakrzewski's early career as a painter upon leaving the Academy in Warsaw in 1970 has two important and fundamental aspects: still life and landscape. For this is precisely where the artist Cézanne arrived in his greatest works. The geometry of nature is the basis of artistic intuition. This evolution in artistic consciousness is what constituted the birth of Modernism. The geometry of nature was the fulcrum upon which the Modernist principles of art developed. Whether it was within a utopian context, such as Constructivism, De Stijl, or the Bauhaus, or within an Expressionist context, such as Fauvism or *Die Brucke*, the concept of a formal order within an apparent chaos was an intrinsic part of the Modernist project.

Of course, artists are always most influenced by those who reach them at an impressionable age. In Zakrzewski's formative years, it was the paintings of Piotr Potworowski that helped determine his structural relationship to the

landscape. and influenced the young painter to think in abstract terms. His teacher, Juliusz Studnicki, also proved influential in providing a theoretical impetus. As Zakrzewski's development at the Academy became evident, there was a persistent series of discoveries which included the early abstractions of Kandinsky and the still life motifs of the Italian painter Giorgio Morandi.[2] In Morandi especially the young artist began to absorb a sense of order within a separate, observable reality — a sensibility about time, light and space.

This sensibility was in a nascent stage of development in the late sixties. It was not until the early seventies, a few years after he had graduated from the Academy, that Zakrzewski's vision of the still life began to mature into a complex arrangement of spatial intervals and densely textured planes. In 1974 he painted a series of four still life paintings that perhaps best express the original conception of spatial interlude and surface tension that would later comprise the pictorial vocabulary of his current nonobjective method. One can observe in these four still lives some debt to the French Purist Amadee Ozenfant, yet one can also envision the trace of Morandi. What characterizes Zakrzewski's method, however, is an obsessive urge to shift the position of the objects in space and to employ color in such a way as to disrupt an easy access to their spatial location or their objective identity. It is no wonder that for a brief period toward the end of his years at the Academy he became fascinated on a theoretical level with the Readymades of Duchamp.

The concept of discovering order within chaos has always been a strong ingredient in Zakrzewski's thinking as an artist; yet he has also felt a continuing impulse to disrupt the surface of his paintings. This disruption carries a certain linkage in relation to Cézanne's "doubt." With Zakrzewski there is a certain dissatisfaction with the predictable response that most formalized paintings admit. The lesson of Duchamp was in some ways an indirect lesson — that to look at objects as alien things would allow a fresh point of view. There was no reason to simply accept the appearance of objects in predictable formal terms. The shifting of space in his still life paintings from the early seventies suggests a mode of pictorial structure that would carry forth to the present. Zakrzewski's concept of space as a factor of time and, obversely, time as a factor in space, began as an impulse to defy what was deemed predictable in formalized arrangements. If one were to consider the shifting effects of time and space in relation to one's experience of a painting, then the predictable aspect of pictorial structure could no longer sustain itself.

There is a still life painting from the artist's last year at the Academy, entitled *Composition with Chess*, 1969, in which a chessboard element has been employed within the structure. This diagonal and rhythmic geometrical insertion (actually more like an intrusion) operates as a grid askew within a grid. The interior grid is seen in perspective to the physical frame of the canvas itself. In subsequent paintings, the grid begins to disperse as evidenced in a series of works from 1974–75. Here the flat broad planes of color, accompanied by

diagonal lines in a densely repetitive and parallel pattern, defy any stable sense of spatial location within the picture plane. In a series of paintings labeled *Four Abstract Works*, Zakrzewski implies movement outside the frame using parallel diagonal lines. The viewer can no longer enter the pictorial space in an arbitrary manner. With *Four Abstract Works* the viewer must stand outside or in relation to the blunt composition. It is almost as if the paintings declared themselves as pictorial objects rather than functioning as pictorial containers for relational elements.

In 1976 there is a brief transitional period in Zakrzewski's work in which the relational elements and the arbitrary sense of space re-enter the frame. A painting called *Still Life with Cards* is an example of this transition. Although it appears as if the artist is retreating into an even denser compositional mode, it is a period of invention in which new forms start to emerge in a more literal, less narrative way than before. Yet the narrative impulse is not entirely dismissed. Just as the Synthetic Cubists allowed definable traces of signs to enter their pictorial realm so Zakrzewski retained the abstract signifiers from his still life period. What changed was the spatial consciousness in which these traces were represented. For example, in an exhibition at the Galeria "Zapiecek" in Warsaw in May 1979, the artist introduced a new series of paintings that emphasized his new literal attitude toward space. Within the composition of these paintings one detects images related to table games such as cards and chess. It would seem that the artist's still life concept had evolved from table arrangements in the early seventies to a more flattened idea about formal structure. In a painting dated *"July 21, 1977"* Zakrzewski extends some of his previous structural elements into an almost mannered depiction of form and space. This manneristic approach to the pictorial surface may have come from his attempt to synthesize the still life with the landscape in abstract terms. While not unrelated to the Bauhaus period of Kandinsky, Zakrzewski claims that it was the more direct maneuvers of the Polish-Russian painter Kasimir Malevich that partially inspired this synthesis. In a statement published on the occasion of his first important exhibition in New York City at the Marian Goodman Gallery,[3] Zakrzewski explains his intentions as follows:

> In 1976-1977 two trends in my work met with letters and symbols were added to the canvases. It has given way to multilateral interaction of abstract elements, symbols and recognizable objects at the same time. It reflected my concern with what actually happens when information from different artistic and symbolic levels or languages crisscross and interfere, often out of their natural context.[4]

It was also during this fertile period in the late seventies that he started to actively produce drawings as a formal counterpart to his paintings. It was at this juncture that polyptychs and serialized paintings made their entry into his method of work. When asked about this development, Zakrzewski has

commented that his involvement in film and cinema had some influence on his thinking. During the early seventies he was working as a cinematographer producing documentary films in Poland. It is perhaps his relationship to film that made him aware of time and temporality in terms of vision and visual structure. The layering of patterns of visual stimuli against one another, as his paintings from this period suggest, could have evolved as a natural extension of the artist's cinematic thought process. Time became an inescapable factor in how an image was constructed. One cannot help but relate this idea to the Hungarian Bauhaus artist Moholy-Nagy. For Moholy the concept of vision was entirely connected to the twentieth century experience of space/time.[5] This relativistic perception of reality was difficult to avoid. In Moholy-Nagy there was a strong graphic contingency combined with an architectonic juxtapositioning of form. In his Bauhaus publication *Painting, Photography, Film*,[6] the artist shows the connection between these media as necessary components for expression in the new industrialized, standardized environment where speed and motion are the given conditions for human perception.

This is not to suggest that Zakrzewski was necessarily influenced by the work or the thinking of Moholy-Nagy. However, it is fitting to suggest a certain (admittedly vague) conceptual parallel in terms of how the problem of space/time operated in relation to Constructivism. It is also quite accurate to state that, at the end of the sixties, Zakrzewski was not looking back to former concepts or earlier forms of abstraction, but conversely he was looking for some type of affinity with contemporary art in the West. There are a couple of important exceptions, however, and these should be noted. The young Polish artist was clearly taken with the work of the Polish Futurist painter and mathematician Leon Chwistek (1884–1944), from which he discovered an intense relationship between painting and the logical permutation of abstract forms. He related to the rigorous practice of Chwistek, perhaps in the way of an alternative to the more Romantic style of landscape painting inherited from his father.[7] Another painter, Witold Wojkiewicz, was also important to Zakrzewski in terms of introducing the concept of "freezing time" in relation to the transitional image. Of course, earlier in the sixties, the young artist could not avoid an intellectual interest in Polish Constructivists, such as Katarzyna Kobro, Wladyslaw Strzeminski, and Henryk Stazewski, and in the principles employed by such organizations as BLOK, Praesens, and a.r. Nevertheless, by the mid-seventies, his vision as an artist had matured and his identity as an abstract painter had taken its own course. Along the way he had become interested in avant-garde forms in the United States and in other parts of Europe, including Minimalism, Conceptualism, Performance Art and Pop art. While this attraction was of great intellectual interest for Zakrzewski, he was never seduced into changing direction. He remained steadfast to the personal concerns that he had embedded in his work. Yet he related to the work of American artist Ad Reinhardt as someone who had taken painting to its finite state

through a literal process.[8] This connected with Zakrzewski's shift to a literal, more confrontational concept of painting. It would become the direction of his painting by the end of the seventies. Even after his move to the United States in 1981, one can detect a complexity of factors that inform his work, ranging from an Eastern European sense of tactility and internal dynamic tension to an American sense of pragmatic form and literal space. Essentially, after 1977, a new spatial premise begins to evolve in Zakrzewski's painting that heralds a new approach to the surface, less as a container and more in terms of a delicate frame to allow the free expression of forms to either pass through or to rest.

II.

Prior to his exhibition at the Marian Goodman Gallery in 1981, Zakrzewski had an exhibition at Galerie MDM in Warsaw. In a short introductory statement for the catalog, the Constructivist painter Henryk Stazewski made the observation that the younger Polish painter "does not express or transform the forms of nature, as was the case with Cubism...."[9] Rather Stazewski found a certain pictorial gravity in the younger painter's work where flat geometrical forms search for "mutual relations and balance."[10] Stazewski also pointed out that Zakrzewski's paintings were not merely concerned with geometrical form but were indicators of other "forces, energy, and motion."[11] The accuracy of this evaluation became somewhat problematic in the light of the first New York exhibition where Zakrzewski's interest in modularity and process were becoming more and more evident. In viewing the paintings from 1981 one could see a clear indication that the artist had broken away from the compositional centeredness of his past and was attending to the spatial fields as a literal device. It is conceivable that Reinhardt's black paintings from the late fifties and early sixties were important here. Indeed, one could feel a certain tension evolving from the abstract vocabulary of the still life and landscape paintings toward a complex obsession with another spatial definition. Zakrzewski was moving away from a classical Constructivism of binary systems into another kind of spatial openness and compositional displacement. By adopting a serialized format, he had begun to unravel and reinterpret the significance of Constructivism. By 1979 he was becoming more involved with modularity and sequence. In essence, the work appeared lighter as a result of its rhythmical sequences and more cinematic in its framing. Rather than showing containment, the architectural aspect of the interior forms was less static and more dynamic. The surface was becoming less contrived, more in touch with the process of seeing. As with Merleau-Ponty's analysis of Cézanne, Zakrzewski's paintings were becoming a direct representation of the conceptualization of seeing.

In an eight-part painting from 1980 (now in the Arco Collection) a similar effect is evident. Each square module carries its own weight, its own gravity (as Stazewski puts it), yet, at the same time, the interrelationship of the parts to the whole achieves a dialectical encounter not only with the exterior space (that is, the wall support) but also, in a metaphorical way, with the viewer who is a participant in the space. There is an environmental context in the work that elevates the sense of vision that a viewer might feel, not in abstruse terms but in terms of a metaphysical relationship to the architecture. In this sense, Zakrzewski's polyptych succeeds in administering an openness of interpretation between the frames or from one frame to another within the spatial environment: the place itself. This rhythmic sensation is entirely unique in that both serration — the variations of a formal arrangement in a regular progression — and sequential permutation as innernarrative work interactively.

By allowing the metaphysical content in the work to emerge through the formal arrangement and therefore open itself to the interpretation of the viewer, Zakrzewski avoids the problem of an overburdened notion of imposing a point of view. He has moved the centeredness of the painting into the field itself, but in such a way as to entice the viewer to see parts in relation to one another and to establish a tactile subjective reading that is not imposed. Often the stark differences between one panel and another offer the necessary disjuncture in order to make a connection happen on the basis of reading rather than on some formal prescription. The reading and interpretation of visual form relate to the notion of sequence. As the viewer's eye moves from one panel to the next, as for example in the polyptych from 1980, there is a narrative sensation that is constructed in the process of seeing. Given that this kind of sequential perception is not dissociated from the process of thinking or interpreting, it would follow that the coherence or, for that matter, the apparent lack of coherence from one panel to the next, as they collectively constitute the visual field, operates on a level that is both conscious and unconscious. In such instances one cannot *see* the work as a conceptual whole. Rather one's perception admits a stream of imaginative and fragmentary parts working together. The psychologist Anton Ehrenzweig has spoken of this phenomenon in the following way:

> Art structure is very complex; in a great work of art we continually discover new formal ideas which have escaped attention on previous occasions. Even the simplest work of art has this complexity, however bare its construction may appear on superficial scrutiny. This is the reason why it is impossible to control consciously the many form-processes of art. The focus of attention is far too precise, too narrow for that.... Gestalt psychologists established that our eye — or rather our brain — has an overwhelming need to select a precise, compact, simple pattern from any jumble of the forms presented. This selectiveness, narrowness, precision of conscious focusing is not sufficiently elastic for controlling the complexity of art form.[12]

In contrast to painting, advertising plays on the simplistic notion of the emblem or the logo, something that is immediately retainable and without any need of reflectivity. Recognizing Zakrzewski's background as an Eastern European, it is significant that this type of propagandistic reading is something that is more or less understood in his culture. Graphic representations of politicized ideals, often within a formalized socialist-realist context, are apparent everywhere. One cannot miss the significance of their message. The ideological constraints are pervasive and obvious. In Western culture, particularly in the United States, this type of ideological subterfuge is often overlooked or underestimated. There has been the assumption that the corporate mentality of late capitalism is not about propaganda, but "publicity." The latter is considered less ominous than the former. Whereas propaganda is associated with Communism — or, for that matter, any ideological "Other"— publicity is the fuel of the enterprise system. Corporate logos, for example, are carefully constructed signs that emit a plethora of consumerist associations, often through a simplistic emotional means.

American Pop art — that of Andy Warhol, in particular — played upon the notion of the corporate logo or insignia, but in willfully naive terms. One does not look at a Warhol in terms of a constructed field in which patterns must be deciphered in order to obtain a subtle reading of the form. Warhol's work is unrelated to Ehrenzweig's gestalt or any "hidden order" that evokes feelings from the unconscious and brings them into a heightened consciousness. In general, his art is concerned with the quick register. It is a piece of aestheticized sociological datum. Part of his strategy, of course, was to somehow offer a counterpoint to the expressive field activity of the Abstract Expressionists. With Pop art we have the mergence of aesthetics and advertising. Supposedly the hidden message is made explicit, but not necessarily in terms of consciousness. Rather the message is made explicit in terms of a cynical acceptance of sociopolitical conditions as they are. Pop art signifies a style of aesthetic and political resignation in terms of the sign. The overall field of consciousness is suspended in favor of that "overwhelming need to select a precise, compact, simple pattern."[13] Ehrenzweig understands this need as having the potential to incite anxiety in certain subjects who fear the abandonment of "directed purposeful thought."[14] Yet he also maintains that it is precisely this anxiety that allows for the creative impulse to emerge. According to Ehrenzweig, it is the conscious mind that needs to be assaulted in order to reveal something new, another order that was previously unavailable: "Conscious surface coherence has to be disrupted to bring unconscious form discipline into its own."[15] In a later discussion on Modernist painting he makes this pertinent observation: "To infuse life into the hard forms of Constructivism we must break down in our vision their rigid frontiers so that they begin to interact, to deform each other in innumerable complex interrelations."[16]

III.

In an interview from 1977, an important transitional year in Zakrzewski's development, the artist made the following claim: "I do not in this or that way describe the exterior (visible) world. I choose things from the world which I feel are fit to represent my own world."[17] In one way this statement suggests the kind of binary split found in most forms of Constructivism — that the forms within the painting constitute a specific personal content, a state of mind. This visualization process does not have to result in an either/or proposition. Even though the artist's shift from an arbitrary to a more literal pictorial field became increasingly apparent shortly before he moved to the United States in 1981, this should not imply that the tactile subjective quality of the paintings was lost or submerged as a trace from the past. Essentially what Zakrzewski did was to reinvent a structural format whereby the former estrangement between signifier and signified suddenly collapsed into a sign of another order, a more cognitively conscious order, yet still contingent upon the reservoir of the unconscious.

It is interesting to compare and contrast the Constructive idea of Zakrzewski with another Constructivist thinker from an earlier period, Naum Gabo. Whereas Gabo would agree in the collapse of the signifier (Form) in relation to the signified (Content) in order to evolve a new unity of expressiveness within the sign, he would not have agreed that the unconscious plays a significant role in the formation of this process. For example Gabo stated in his essay from 1937, published in *Circle*, that "These two elements are, from the Constructive point of view, one and the same thing. It does not separate Content from Form — on the contrary, it does not see as possible their separated and independent existence."[18] Later, in the same essay, Gabo explains,

> In the light of the Constructive idea the purely philosophical wondering about real and unreal is idle. Even more idle is the intention to divide the real into the super-real and the sub-real, into conscious reality and subconscious reality. The Constructive idea knows only one reality. Nothing is unreal in Art. Whatever is touched by Art becomes reality, and we do not need to undertake remote and distant navigations in the subconscious in order to reveal a world which lies in our immediate vicinity.[19]

Although not mentioned directly, Gabo is clearly criticizing the approach of the Surrealists and their interest in the unconscious mind or dream-world imagery as a source in the production of art. What Zakrzewski is attempting to do is quite different from either Gabo or the Surrealists. Given his concern for time, seriation, and the framing edge as a cut-off point, where his labyrinth of lines and shapes rush through, Zakrzewski's relationship to the unconscious is more about the literal process in which the work evolves. By recognizing that the creative process, in Ehrenzweig's terms, exists as a continuum

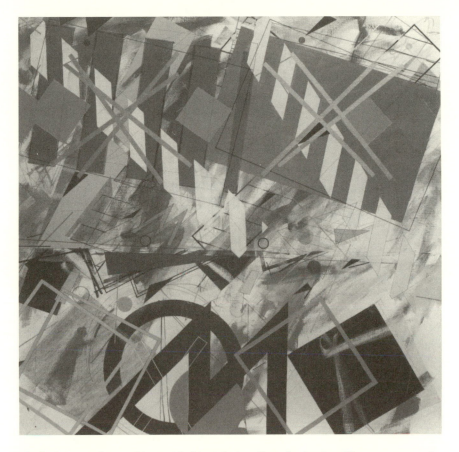

Vladimir Jan Zakrzewski, *Untitled* (1987). Acrylic and mixed media on canvas, 48 by 48 in. Courtesy Vladimir Jan Zakrzewski, Vanderwoude Tananbaum Gallery.

of consciousness rather than as a binary system of signifiers, Zakrzewski admits the unconscious as an integral aspect of consciousness. From a phenomenological point of view, the unconscious continually informs the conscious whether we are aware of it or not; the essence is in a perpetual state of being sought after. To categorize the unconscious — that is, to isolate the unconscious — as an entity separated from the conscious maneuvering of thought in relation to material does not seem conscious with Zakrzewski's project.

Another important difference between the two approaches to Constructivism by Gabo and Zakrzewski is that the former is associated with a utopian concept of Modernism. On the contrary, Zakrzewski sees reality in "skeptical" terms.[20] For the Polish artist, the idea of certainty is always held in question. The blind optimism in the rhetoric of Gabo would be anathema to Zakrzewski.

Rather than Utopia, Zakrzewski works toward the challenging possibilities of disjuncture. In that nothing can be certain, including one's own view of reality, the process of art is what redefines the world for us. Art gives us another possibility for reality, but it does not resolve the dilemmas of existence, either in personal, sociological, or technological terms. It may suggest a metaphysical state of awareness, but this is always a temporal state. It is not an absolute metaphysics. It is this pragmatic focus on the world that has made the philosophy of Spinoza so appealing to Zakrzewski.[21] With Spinoza, we have the iconoclast who questions every moral system, including his own. Rather than presume the condition of the spiritual in relation to a moral state of being, Spinoza opts for an ethical resistance to all governing laws, whether they be religious or secular. This resistance is within the realm of a perpetual discourse, a questioning of self-righteousness. The ethical code is determined through a practical means, a constant focus on the world, in search of joy and vision.[22]

The cropping or framing-edge of Zakrzewski's square modules is an important and significant part of his art, whether in his paintings or drawings, or his multiple or singular formats. Once the artist shifted his sense of spatiality from what I call an arbitrary to a literal or pragmatic one, somewhere in the mid-to-late seventies, the edge of the painting's shape and structure became increasingly more important. I have maintained that Zakrzewski's earlier still-life paintings from the late sixties and early seventies, which often included a chessboard image, were intensely concerned with the containment of the forms. In spite of the artist's interest in the framing edge, even at this early date, the emphasis of these paintings is clearly on how the density of shapes and colors is packed within the format of the pictorial plane. As the work begins to expand in the late seventies we begin to see a marked difference in how the framing edge is affecting the progression of shapes, gestures, colors. There is a new freedom that enters into the forms at the beginning of the eighties, a fresh sensibility. It is not a rupture that leaves the pictorial vocabulary of the past behind. Zakrzewski's paintings do not function on a superficial structural level. There is a deeper logic to this evolution. This logic is reminiscent of a comment once made by the French mathematician and philosopher Blaise Pascal, that the correct way for intuition to emerge is after logic has run its course. The point of Pascal's remark, relative to Zakrzewski, is that the subject must be alert to the possibilities of intuition while never equivocating from the course of one' s own development.

Of course, not all of Zakrzewski's paintings since the early eighties have relied on the use of square modules. He has done multipanel paintings using squares, but he has also done single format paintings. The relationship between the four-part square modular paintings and the single format paintings is a curious one. There is a definitive semiotics that informs the process so that the language components carry a systemic juxtapositioning. In the four-panel works, such as the painting dated *October 20, 1989* or another dated *May 25,*

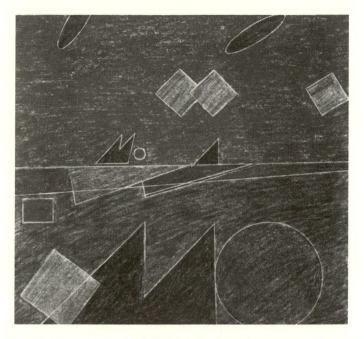

Vladimir Jan Zakrzewski, *Untitled* (1984). Mixed media on paper, 8 by 8 in. Courtesy Vladimir Jan Zakrzewski, Vanderwoude Tananbaum Gallery.

1990, one can reconstruct the component variations between the separate panels. For instance, in *October 20, 1989* each panel is the same dimension, approximately 4 feet 6 inches square, adding up to a total larger square format that measures 9 feet 2 inches (including a 2-inch space between). As one reads the variations of shape and gesture within each of the panels it is difficult to think in terms of a simple "visual" composition. Rather one might consider the cinematic sequential effect of the panels as having a kind of architectural presence. Each panel requires a distinct reading. There are no obvious similarities between them. Yet one can make analogies and associations; that is, one can think in terms of a synchronic reading. The complex aggregate of hard-edge forms in the lower right is most obviously Constructivist in its semiotics, yet one can read the black and white dot patterning in the panel above it as having a unique minimal presence in relation to the complexity of shapes below. The upper left painting carries a gestural Expressionist reading, yet it is clearly beyond the constraints of Expressionism in that the quality of the gestures is more detached and less deliberate in its emotional content. The lower left panel is paler and without contrast; the shapes are more obtuse. Their effect is less about an emblematic presence. The four panels have a relationship in the synchronic sense but also carry their own separate weights as if to suggest that the painting must be read, even studied, as an exegesis, a hermeneutic obsession

with formal attributes that carry their own internal system as a discourse on painting. *October 20, 1989* has the authority of Spinoza's *Ethics* in that it runs parallel to the ethical decision-making process in fully pragmatic terms. This is a painting that is in the world, not a pretentious spiritual excavation of hidden truths. It is a literal space in which one feels the disjuncture of origins in favor of skepticism.

One can make a similar comment about the work dated *May 25, 1990*. Here the panels are not equal in dimensions yet they are within a large square format that measures 10 feet. The two lower panels are equal in dimension, measuring 60 by 60 inches, whereas the two upper panels are each smaller, the right side larger than the left. The juxtapositioning of the two upper panels fills out the total square format so that there is a spatial interference within the piece. The complexity of semiotic relationships in *May 25, 1990* is more apparent than in the earlier four-panel painting due to the shifting dimensions between bottom and top. This fact, combined with the disjuncture in color, placement, shape, and value, is profound. What Zakrzewski seems to be doing in *May 25, 1990* is extending the limits of the definition of formalism. This term "formalism" is intrinsic to the Constructivist aesthetic, yet it is a term that is culturally bound and useful only according to a pronounced aesthetic system.[23] In the Soviet and Eastern European hard-edge painting, formalism has a linguistic relationship to form; that is, one reads the configuration of shapes differently as having a particular kind of intellectual weight and emotional substance, perhaps (at least in the case of Malevich and the Supremacists) a kind of iconic reference. (One could further argue that in Rodchenko the iconic reference is shifted from "spiritual" significance to secularism in the sense that Productivism was an instrumental use of the new Soviet aesthetic.) In the United States, the term "formalism" has an entirely different connotation, primarily based on the theoretical writings of Clement Greenberg. Formalism, for Greenberg, is more closely aligned to a late Modernist aesthetic where the self-criticism of Kant is reinterpreted in terms of a dissected aesthetic point of view, and where lyrical content and "taste" supersede any notion of moral value in relation to art. This kind of formalism is not about the binary oppositions or the semiotic formalism that is found in the Supremacists and Constructivists.

With Zakrzewski, it would seem that there is a kind of synthesis between the two kinds of formalism that does not appear at all inconsistent. That is to say, Zakrzewski's paintings do not dismiss the cause and effect relationship between surface and content; rather they attempt to recreate the linguistic apparatus of Constructivism in terms of a direct response. Hence, with Zakrzewski, one can see the gesture and the drawing on the canvas revealed. Nothing is concealed, only covered in relation to the definition of each modular surface and of each form that constitutes the surface or exists within the systemic relationship or sequencing on the surface.

This is why one can look at the singular panels as fragmentary components — as paintings, in fact — that imply a passage of form yet do not dwell on multiplicity as a means for showing it. Some of Zakrzewski's most refined and energetic paintings in the late eighties have evolved as single panels, but each painting still exists as part of a continuum; that is, the concept of a sequence or of a development in time is always present. There is no stasis of unity as in the Paris paintings of Mondrian. Stasis, for Zakrzewski, always implies kinesis. In this sense, one cannot complete a discussion of the artist's work without an examination of the drawings. For over a decade and a half, it has been the artist's involvement with the process of drawing that most clearly reveals his intentions.

In reviewing Zakrzewski's exhibition at Marian Goodman in *Art in America*, the critic Marjorie Welish made this cogent statement, specifically citing the drawings:

> In the paintings, this progressive devolution of forms is clearly delineated. The drawings display a more complex visual syntax and are more problematical. Scrubbed over the precisely delineated geometries are crayon, chalk and ink marks that blur the forms' delicate spatial relationship and push their contours off register. Occasionally, a fusillade of strokes obliterates the underlying drawing entirely. This varied graphic repertory seems barometric, registering the range of the artist's stylistic responses to his own linear compositions and their permutations.[24]

In an exhibition catalog published on the occasion of a collaboration between the Haags Gemeentsmuseum and the Museum Bochum in 1987, the curator Flip Bool remarked:

> Drawing gives him the opportunity to explore the dynamic balance between the rational and the emotional, order and disorder, construction and destruction, in all of its possibilities. Often this happens in series of ten or more sheets of paper, one drawing being either a conscious or an unconscious comment on the former.[25]

Much of what has been said in relation to sequence as a temporal device in Zakrzewski's work has been most adequately expressed in works such as the ten-part drawing dated *January-February 1988* and shown in an exhibition of Zakrzewski's drawings at the Brooklyn Museum of Art.[26] This temporality and tempo, working inextricably together, restore the concept of space/time in art, but not according to the old principles of Constructivism. The concept of space/time in Zakrzewski's drawings is a rhythmic sensation, an elevation of the mind being engaged in the process of pure visual thought. These drawings represent a dynamicism previously unknown in art, a cinematic consciousness that unfolds and unravels its own causes and effects, a meandering of the thinking process into a sudden burst of patterning that is caught for a moment and then released.

This kind of formal tension and conflict between the elements within the space of a page or within a sequence from one page to another has given Zakrzewski an increased freedom to explore fresh possibilities in terms of relationships and occasional weird disjunctures that illuminate the task of drawing in a way comparable to the improvisations of some American jazz music. Drawing, for Zakrzewski, expresses a newfound freedom. While it is problematic to say that this freedom is entirely related to or contingent upon his move to the United States, given the oppression of the Solidarity movement in Poland throughout most of the eighties, it is still a factor that has impressed the artist in dealing conceptually with his new spatial terrain. Indeed, the terrain of a creative mind, the psychological terrain, and the terrain of political authority exist only in terms of a contradiction. It is not inaccurate to say that for the avant-garde artist, no matter what style is practiced, the struggle between art and politics is unlikely to find repose. They are virtually without resolution. One can contemplate the drawings of Zakrzewski in the eighties and say that they represent a visual and metaphorical discourse on freedom. Still, it is necessary to understand that this kind of artistic expression is not contingent upon the absence of struggle, but, on the contrary, is dependent upon it. It is the ability to secure a manageable sense of freedom through a recognition and acceptance of this struggle; this is what an artist seeks. Zakrzewski's pursuit is a kind of leveling process where the mind and the hand of the artist process to issue vitality and warmth, but in the most pragmatic way, the ethical way of pure insight — the joy of vision.

IV.

The desire for self-historification in painting — wherein the subject enters into the work as an observer — is part of the Modernist legacy as it is part of the history of art in general. What makes Zakrzewski's work of the 1990s so challenging is that the self-historification process achieves the status of a codified absence. In one sense, the artist is taking the models, signs, and influences of the past in terms of his own history, his autobiography, and reformulating them into a structural pattern. It is a kind of self-appropriation, an autosymbolism. The complexity of this maneuver cannot be underestimated in Zakrzewski's new paintings.

In the case of Zakrzewski, form comprises of appropriation and overlay — a consolidation, in fact, between representation and abstraction, nearly to the point of dissolving the differences between the two. Within the course of modernism's evolution the sedimentation of styles has accumulated to the extent that a pure abstraction cannot exist within some reference to other styles, other influences, and other painterly vocabularies. The entire language of

modernism has evolved a breadth of concerns which cannot so easily be demarcated into nearly entrenched categories.

The fact that Zakrzewski's paintings carry a conceptual infrastructure which informs all of the visual operations and maneuvers on the surface is a necessary starting point. One cannot ignore the political, geographical, and cultural circumstances inscribed within his paintings, nor to the patriarchal influence of his father's work. All of these circumstances have had a direct impact in defining his recent work. The weaving and interweaving back and forth, between part and present, between representation and abstraction, offer a series of conflicting elements which suggest a condition of postmoderism.

At the core of Zakrzewski's new work is the internal absorption of history, transformed microcosmically as self-history, working in relation to the immediacy of his external reality. This process of absorption and transformation in painting carries a certain truth, yet it is a truth held in abeyance, surrounded by a skeptical aura.

To accurately perceive and comprehend the recent paintings of Zakrzewski it is necessary to understand something of the complexity of their dialectical relationship between history and autobiography. One could make the observation that any painting is "historical" to the extent that it deals with some sort of cultural evolution. At least, one can make this point in regards to Modernism.

Yet there is a certain rigor in Zakrzewski's paintings that cannot be avoided. This rigor has something to do with the ordering of time and the placement of images and events in time. Therefore, one might say that Zakrzewski's recent paintings and sequential drawings are not so much a departure from his previous abstractions of the last fifteen years as they are an allegorical or symbolic extension. He is a painter of history in a most complicated sense, or, it might be said, in a most postmodern sense. His paintings have come to represent the lamination of events in time through a kind of simultaneity, an ever-changing, ever shifting construct of reality.

Zakrzewski's vision as a painter having a strong conceptual basis is less cynical than it is skeptical . The urge to doubt what one sees in the environment is an important attribute. It is a necessary tool by which to overcome the indulgent absence so prevalent among the American and German revivalists of the 1980s. For Zakrzewski, art is still involved in a process of change and transmutation. Feelings can still be expressed or signified through art, though their expression might be skeptical of the environment that has nurtured them into being.

Father's Painting #1 (1991) is a four-panel work that incorporates an actual painting by the artist's father within it. Zakrzewski took a painting of a landscape done by his father in Lombardy ten years prior and transformed its context by adding three additional elements: two "abstract" panels and a photo-image on canvas. The abstract images are significant in that they point toward

the inevitable shift that Zakrzewski's painting would take toward abstract inter-pretation. (This shift is particularly evident in *Still Life with Cards* (1976). In this painting one begins to see how the representational subject matter of the still life is being subsumed by the abstract manipulation of primary shapes. One can even detect the extraordinary complexity that has become characteristic of the artist's recent work.)

In *Father's Painting #1*, the Sabaudia landscape by Zakrzewski's father is flanked on the right by a linear black and white configuration typical of the younger artist's style of abstraction in which contours are drawn from a per-ception of the landscape. Below the landscape is another more reductive panel, implying the genre of American color field painting, that attempts to simulate the compositional device through the use of a horizon. Finally, in the lower right, a black and white photograph, blown up and grainy, shows the 14-year-old artist at the easel with the looming presence of his father standing over him, observing his every stroke — as if checking the formal accuracy of the compo-sition. In many ways this painting is a clue to what has become evident in Zakrzewski's work since 1990 — a kind of deconstruction of the artist's past, not only from the perspectives of culture, geography and politics, but also from the perspective of psychology. The current interest in analyzing the impact of history and autobiography on the artist in terms of component parts is evi-dent in the three triptychs called *Three Times Self*— all from 1993. The first trip-tych consists of the following parts: the left panel is a quoted statement, drawn on the canvas, by the late Polish constructivist Henryk Stazewski; the middle panel is an Abstract Expressionist landscape called *Autumn Landscape Near Warsaw* (again, a painting within another painting); and the right panel is a contour drawing taken from a photograph of the artist with friends during a vacation in 1973. There are nostalgic, even sentimental overtones in this work; yet, concurrently, there is a particular toughness, a formalist rigor with intense psychological depth.

The same can be said of the second version, another triptych by the same title. Here, in version two, there are the following elements: the left panel is an abstract, nonobjective painting called *Armenian, Dutch, Polish, Russian*; the middle panel is another Abstract Expressionist landscape (this time, a paint-ing of Columbia County in upstate New York, the place where the artist spent the summer of 1993); and the right panel is the same contour drawing as in the first triptych, only it is painted on bare linen.

For Zakrzewski, painting does not cease to explore new ideas once a for-mal code has been established; instead, painting in the Postmodern environ-ment is a commitment toward breaking the codes of conventionality by explor-ing time as a lamination, as a subjective and mythical archaeology of self-knowledge. In contrast to much Postmodern painting, Zakrzewski does not reject the presence of memory as absence, but foregrounds this reality as a means of visual representation.

His father's insistence on realism and on a strict formal method by which to obtain specific results is clearly anathema to Zakrzewski's desire to move beyond this formality into a more reduced visual (and conceptual) vocabulary. Hence, the artist is both paying a tribute to his own history and, simultaneously, paving a new way that is more relevant to the fragmentation and dissemblance of language as having the potential to express identity in the current "information" environment.

One can see in *Vladimir on the Balcony* (1993) a contour representation of the back of a child standing next to a wall. This contour is taken from a painting of the same title made by his father in Poland in 1949. It is a painting of the artist as a small boy. The contour image is appropriated directly from his father's painting and is centrally positioned against a faintly painted landscape in yellow which, in turn, is covered with an arrangement of small circles appropriated from an early abstraction by the artist himself, entitled *Painting with Circles* (1970–71). This tripartite layering represents a division of time — both historical and autobiographical time. Time is shown as an equivocal juxtaposition between states of mind and therefore reifies a psychological mood, a quest for certainty, a stasis.

A similar tripartite structure is used in another painting, *23 Years* (1993), a work that is also part of what the artist calls his "Historical Series." Zakrzewski refer to this single panel painting as a "composite" painting; it is, in fact, an overlay of three images borrowed from other paintings at three discrete intervals in the artist's formative career. (It is important to make the distinction between the composite overlays and the panels as used in *Father's Painting #1* and *Three Times Self.* In the latter works, the lamination of images is less the issue than the tangential sequences by which the panels unfold their allegory.) In *23 Years* he again uses *Painting with Circles* from 1970 (mentioned above) with two recent paintings: one, a landscape borrowed from *Yellow Landscape (Warwick)*, completed in 1992, and another, an appropriated contour of the abstract painting *Armenian, Dutch, Polish, Russian* from 1993, mentioned earlier.

Often dots, circles or points operate with visible significance in the recent paintings of Zakrzewski. An example would be *Triangle No. 2* from 1992. In this two-panel painting, there is the familiar contour style taken from a photograph of people gathered together in an interior space, a room. They are relaxed and seated. The artist emphasizes the architectural space by separating the upper and lower portions of the painting with open and closed volumes. Adjacent to this abbreviated contour rendering of people is a polygon with hard-edge angles — the interior of which reveals a group of constellations, suggesting triangular configurations of stars. The connection between a closed architectural space inhabited by people in a social situation and the expansive and mysterious openness of the constellations again suggests that the artist is moving in the area between representation and abstraction, between dark and light, between night and day.

There is another single panel version of *Triangle* in which a view of the surrounding countryside of this artist's summer community in upstate New York (Triangle Workshop) is laminated against a triangular constellation represented by an overall pattern of small dots. In this case, Zakrzewski gives us a view of the general in relation to the specific. The heavens of Copernicus are registered against a bucolic field interspersed with shabby barns and industrial artifacts.

The artist goes one step further in the painting *Hunting Dogs #3* (1992-1993). More straightforward than the general/specific metaphor, discussed in the previous painting, *Hunting Dogs #3* reveals a constellation of silver dots, representing the constellation Canes Velaci, scattered across an angular black field painted on a white square. Zakrzewski has appropriated an illustration of "hunting dogs" which is represented as a contour overlay in cerulean blue in relation to the constellation. Yet there is the possibility of a further reading. The angular black field within the white square is the same one that appeared in the diptych version. The metaphor is both humorous and profound, suggesting a symbolic relationship between the hunting dog scene and the search for artistic fame and fortune.

The state of in-betweenness, or the hovering allegorical connotations in Zakrzewski's work, is not insignificant. It is precisely in this zone of transition that the artist locates himself; thus, even though he is not severely distanced in his irony — as, for example, in the manner of a simulationist strategy — Zakrzewski accepts this hyperreality from a skeptical point of view. He deliberately eschews the overbearing assertiveness of lesser artists and has supplanted superficiality with an advocacy of indeterminate placement. What makes Zakrzewski a Postmodern artist in the true sense is his deliberate lack of specific placement. There is no resolution, only a suspension of belief. This is where the power of his allegory resides.

Take, for example, *Cruel Pessimism,* another series of works from 1992, exhibited at the Galeria Foksal in Warsaw in the spring of 1993. In this series the artist uses a series of framed texts in relation to vertical paintings. There are three variations on the theme. They correspond to the lyrical, the romantic, and the skeptical interpretations of a book review of a scientific treatise in which the term "cruel pessimism" appears. The lyrical version is a representation of the constellation Orion on a vertical format equaling the height of the artist. This hangs adjacent to the framed text appropriated from the "scientific" book review.

The romantic version is a mottled surface painted in silver, of the same dimensions, with a bright red horizontal bar "floating" near the lower right. (The location of the bar in each case is determined by the presence of the words "cruel pessimism" as they appear in the text.) This is also placed adjacent to a framed text. Finally, the third version, the skeptical one, has the Orion constellation not hanging, but propped against the wall and beside another framed

text. The configuration of the three elements functions as an installation and comment on the metaphysical assumption of a single monolithic system of truth; thus, Zakrzewski is reasserting the problem of language as a challenge to scientific assumptions about reality.

Here again, Zakrzewski departs from other Postmodern painters by using the cynical conclusion of "scientific" research as subject matter rather than allowing cynicism to become the message of the work. This group of paintings is concerned with the demystification of assumptions that are prioritized according to science.

It is often the case that Zakrzewski's sequential drawings are seen discretely from his painting. In other words, the artist's drawings seem to constitute another modality, another method of visual interpretation. This is not entirely true. While the drawings can be viewed as works unto themselves, the structural relationship to the paintings is of interest. There are two recent drawing sequences that illustrate this point. One is called *Nostalgia* (1991) and consists of four parts — that is, four drawings within the sequence, mounted in the form of a grid, a quadrant. The other is called *This Year* (1991-92) and has nine parts, also presented in a grid.

Nostalgia is based again on a landscape done by the artist's father in 1942, four years before the artist's birth date. The three other components are variations of the landscape which explore the more contemporary aspects of abstraction in relation to the subject matter of the landscape. The mood is solemn, yet the transport of liberation, from an enforced reduction of formal method to one of postmodern exploration of ideas, is significant. The other drawing sequence, *This Year*, involves contour images, abstractions, landscapes, sketches of interiors — a kind of semiotic of visual structure, but also the memory that enforces one's sense of identity within the postmodern situation. There is the perennial interplay between history and autobiography, the "in-between-ness" spoken of a moment ago, the interstice that lingers within memory and become the binding element of memory whereby the inner and the outer find some reflective comprehension.

Through the passage of time, Zakrzewski has found the raw material of his current work and his current aspiration to paint as an artist with an intercultural frame, yet the frame is without a single ideological dimension. This is not to say that the artist has freed himself from political responsibilities. It is merely to point out that ideologies are no more sufficient for dealing with political realities than they are appropriate in dealing with the multivalence of cultural influences.

As Zakrzewski's art takes a journey through time and transforms time into allegory, his pictorial effects become less fashionable and less stylized in their fundamental conceptual impact. Just as Duchamp, in his painting *Tu 'm* (1918), compressed a lexicon of personal and conceptual iconography into a single frame, so Zakrzewski has compressed his own history into a variable

frame, a fluctuating frame, that is parallel to the recent history of representation, and he has done so without alleviating the immense possibilities of emotional resonance.

The complexity of Zakrzewski's art is worth considering in terms of the complexity of the political situation his art represents. He is an artist of the future, aspiring to tell us his story through signs and symbols that decompress the false ideologies of the present, yet give us a sense of functioning in relation to a new intercultural stratosphere — a time/space age embodied in the basic desire to visualize history beyond the simplistic categories of representation and abstraction. Zakrzewski refuses the categories of the past and opens the door to the refined complexities awaiting us in the art of the next century.

10

Tania Mouraud and the
Paradox of Language (1990)

I.

In coming to terms with the work of Tania Mouraud, one has several options. Although simple in its directness, her art presents many puzzling aspects. Mouraud operates between the extremes of black and white. Her concentration is upon the structure of the sign. She is given to a repeated usage of those intervals that constitute the sign. The extremes of her work move from the secular use of language toward a more reductive form of abstraction. Expressed another way, Mouraud appears interested in the limitations of language by way of showing its absence. While language is the subject of her work it is also the means toward another discourse that ranges from metaphysics to current events, from Minimal to Pop art, from an investigation of the media to a focus on subjective meaning within the context of existence.

Although reductive in its posture, Tania Mouraud's work is never facile or without contemplation. On the contrary, her work positions itself dialectically in relation to the noise of the world. In this sense, Mouraud is searching for a means of utterance within a chaotic climate where language is built from the Tower of Babel and descends perpetually into an emptiness of mediated rhetoric and advertising slogans. One is reminded of Wittgenstein in Mouraud's work. In the *Tractatus* especially, Wittgenstein offers a method for the investigation of language. Words are understood because they function as signs. But these signs are complex as the problem of signification and meaning is complex.

> A particular mode of signifying may be unimportant but it is always important that it is a possible mode of signifying. And that is generally so in philosophy: again and again the individual case turns out to be unimportant, but the possibility of each individual case discloses something about the essence of the world.[1]

For Wittgenstein language disguised thought. The only way to understand

a concept was to examine the structure of the signs that produced it. Tania Mouraud has produced a body of work in the last few years in which the viewer is asked to examine "each individual case" within the construction of words or short phrases. Her emphasis is not upon the form of the word but the spatial components that visually comprise its identity. Sometimes the words appear in French, sometimes in English. The words are always short, terse in their expressive potential, and always to the point. One cannot deny their importance in terms of contextualization. In this sense Mouraud's work shares much in common with other Conceptual artists who have been working with the problems of syntax in relation to meaning. Her relationship to the early Conceptualists is worthy of serious consideration.

When Wittgenstein speaks of the unimportance of the individual case as a means of signifying it is understood that, while something essential may be perceived about it or in relation to it, finally it is the particular that requires a general framework, a contextual clarity, in order that it can be understood. To understand the signifying power of a word it is necessary to understand its logic; that is, how it fits within the logic of the whole.

> In order to recognize a symbol by its sign we must observe
> how it is used with a sense.
> A sign does not determine a logical form unless it is taken
> together with its logico-syntactical employment.[2]

Conceptual artists of the sixties were aware of Wittgenstein and the tremendous importance of his contribution. One may cite examples ranging from Daniel Buren to Joseph Kosuth where the principles of the *Tractatus* were in operation. To recognize the signifying power of Buren's stripes it required that the viewer recognize their institutional framework, their cultural, historical, and political significance. To recognize the function of Kosuth's word-definitions or his use of neon light was to recognize their contextual relationship to the history of recent art, particularly American-style formalism.

With Tania Mouraud the case is similar, but the resemblance is quite distinct. Her work has a subtle subversiveness. Whereas both Kosuth and Buren maintain a separation from overtly metaphysical issues in art, Mouraud's work rarely leaves this realm completely. Nevertheless, she finds herself operating within the world by way of what Wittgenstein describes as "everyday language."[3] In this sense, Mouraud would concur with the opening proposition of the *Tractatus*: "The world is all that is the case."[4]

Her work clings partially to the world and partially to her metaphysical grounding. She has never wavered from this position except when she has clarified a particular concept of art, as in her 1972 language piece entitled *Wall is seen*. Even here the propositional sequence of the three questions leads to the silence of description in relation to what cannot be classified as fact. It

reveals that Mouraud's basic empirical nature seems predicated on a meta-physical concept of space/time. This is perhaps most explicit in her various plans for installations, environmental pieces, and "initiation rooms" which will be discussed later. In another sense, her work is like a parallel track between early Wittgenstein and the phenomenology of Merleau-Ponty. A good example would be her word-sign posters placed on billboards in Paris in 1978 — a "performance" contingent on the surrounding information that is relative to the perception of everyday events or facts. Again, one might find associations with Buren's nullifying stripes or Kosuth's "Text/Context" billboards from 1979. In the former, the information becomes visually and conceptually reduced to the point of identifying mark or a homogeneous sequence of marks that carry the weight of culture resistance; therefore, the information behind the stripes is perceptually significant only if the viewer is aware of their accompanying discourse.[5] In the latter, the discourse strives to comment dialectically upon itself to the point that the critical statement is internally nullified. Here the process of the language subverts the means by which the statement is achieved.[6]

Thus, between mediated abstraction and textual obfuscation Mouraud's word-signs emerge as a more specific reading of the text. In her *City Performance No. 1*, the posters consisted of the word "NI" (neither). At this point in her career, she had not as yet reversed the positive and negative spaces of the letters, so that what one read operated as a highly reduced advertisement, an architectural adjunct, or a construction in the visual environment that managed to challenge the meaning of all surrounding fragments of information. The word was both formal and direct — "NI." There was no hidden discourse. It carried something of the typographical power of a Rodchenko. There was an extended logotypical relationship of the word to the world. That is, the text was both an emblem and not an emblem. One may have recognized the word "NI" as a matter of repetition from one site to the next. What happened in the spaces between the posters contributed to the conceptual whole. Perception of the word, of the negation of its "substance," was a central and immediate action.[7] The action of seeing and of being in the world is not merely a linguistic metaphor; it is a phenomenon of being, a metaphysical action as well.

The word "NI" signifies a negation; but a negation of what? The instance of perception here is a specific one. It is an occasion of the moment, of being in time, and of seeing. To see the word is to reflect upon its significance. But the frame of the word is negligible. One does not see the word "NI" isolated from other things. Consciousness is deceiving in this regard. For example, television imposes a frame on our perceptions of the world. We look at television as we once peered into the picture frame. The television is a window on the world, and the reality of that world is closed except for the information that is being delivered — transmitted — at a particular moment. The light of television is mesmerizing, perhaps, hypnotizing. We stare at the image with a certain disbelief. This disbelief, however, should not be confused with skepticism.

Tania Mouraud, *City Performance No. 1* (Paris, 1977). Billboard, 3 m. by 4 m. Courtesy Tania.

For in skepticism there is the notion that the mind is at work offering some form of contradiction to the pseudo-text on the screen. Disbelief suggests that the pseudo-text is a manipulation of events in the world. What we view through the frame is a fabrication, another product to digest, another commodity with all the gloss of capital investment as it has come to permeate the environment. When we see the word "NI" we are seeing a negation of something. Is it the sign itself or what lies outside the frame?

To presume that all perception is conscious is a difficult, if not impossible, notion. What enters through the eye is only one aspect of a more complete transsensory experience. Also what we consciously register by way of visual perception is less than what actually enters our brains. "NI" may be understood as framed the way any other billboard is understood. In fact, in most instances, there was a frame around the word. By expanding one's perception (and conceptual mode of operation) in relation to the two letters, the word "NI" was transformed into an interval or a space between advertisements, a break between other signs, an integral part of a more expanded text that moved into a new *gestalt*, an environmental view of the sign. Once this consciousness of seeing was expanded outside the frame, while at the same time holding the sign in abeyance, the viewer began to perceive the tension of meaning that Mouraud had intended. "NI" as a word is nonsense unless it is part of

a logical whole. The placement of the sign, therefore, carried weight. It found its place in the mediated environment by way of contrast.

Then there is a question of the sign's disappearance. After a passage of time, the appearance of the sign begins to fade, to become absorbed in one's memory. The impact of the word is diminished. It becomes part of the mediated environment. We learn to live with "NI" as we have learned to adapt to other signs in the environment. Thus, the temporal aspect of its placement is essential to the meaning of the work. The fact of its impermanence is significant. The placement of the word has a duration, a time-cycle. Eventually, the word, operating as a negation and a signifier of negation, was concealed by another poster, thus giving the word yet another level of negation. To consider this sequence of negations is to recognize its opposite: mundane assertion. This is the substance of advertisements. Through constant assertion the cultural environment is mediated and neutralized. The repetition of assertions becomes a cacophony. There is a complete and total dissemblance of meaning.

What is brilliant about Tania Mouraud's gesture in 1978 is the manner in which negation is transformed into a life-giving force. "NI" implicates the use of dialectics. What is being perceived in the environment is neither this nor that. There were 54 signs throughout Paris, each declaring the absence of something already in place. Whether it was a commercial or a political sign, whether it was a poster or a building, whether it was a traffic signal or a placard, the word "NI" stood between them, splitting their significance, and heralding the absence of the cultural frame. Mouraud's *City Performance No. 1* was a gesture of refutation, an outcry against the plethora of assertions that constitute nonsensical meaning. It was an installation that recalled the "state of affairs" designated by Wittgenstein in which "The world divides into facts."[8]

II.

Tania Mouraud's concept of painting is more related to production than it is to product. How the painted elements appear in her wall installations is more important than the idea of making a painting. To paint, for Mouraud, is to engage in an activity of production. Once the word-concept has been established it is simply a means of working out the thickness of the supports of the painted elements and then adhering the black pigment in such a way as to give the elements a consistent, standardized texture. She calls this texture, combined with the logotypical shape and thickness of the elements, "pizzeria aesthetics — the middle-class idea of comfort which is spreading, now, and to which one might link the idea of painting."[9]

Immediately the concept registers significance. The sign is convincing. Pizzerias are fast-food joints exemplifying Americanized food production. Mouraud is frustrated by this phenomenon — the standardized plasticity of

production-line restaurants. At the same time, she is enthralled by the possibility of using this standardized appearance in order to deconstruct the ideological and socioeconomic aspects of this phenomenon.

The opticality of texture operates as a sign. The light plays off these textured black surfaces in a particular way, differently from on the surface of an automobile, for instance. In her series of works from 1988-1989 called "Black Power," Mouraud uses various short words, each of which carries a particular connotation within the context of her installations. In a piece from 1988, she used geometric shapes to express the negative spaces of the words "ICI" ("here") and "LA" ("there"). These two short words appear spaced equidistantly on the white wall in three different sizes. The optical challenge is to read the absence of the signs and to come to terms with repetition and negation. The activity of perception in this work is a perpetual cancellation process. The "pattern recognition," as McLuhan defined the term, is all that exists in the display of information. The eye scans the wall, reading the rhythmic intervals and textured elements. The units appear discrete from one another, yet they fall into a definite pattern. By extending our perceptions from the individual shape-units to the spatial interrelationship it is possible to understand a patterning. One may conclude that the repetition of the words suggests a quality of infinity, an extension beyond the mundane look of a pizzeria toward a more metaphysical concept of perceptual being. In this sense, the "ICI" and the "LA" patterning poses not so much a decorative concept but an environmental threat. Just as the negative spaces are read instead of the words themselves — that is, the words, are presumed once the code has been deciphered (once the software is in place) — so one might take the concept of "mechanical reproduction" into the vague zone between the fictional pictoriality of the sign and the representation of the sign's value as mundane morbidity. The cost efficiency of the noncreative use of certain building materials, such as theaters put up overnight in shopping malls where logotypical emblems run amok, is the dark side of pizzeria aesthetics. Yet, from another viewpoint, Mouraud's words are pop emblems to be celebrated — without the colors of Warhol, Wesselmann, or Rosenquist. They exist without a referent. Mouraud's words have no specificity. They do not refer to products. More than to pop culture, they seem to refer to the history of non-objective art. They carry a certain Constructivist perspective within a high-tech genre. They have the appearance of a systemic code — bits of information positioned on an invisible grid. They resemble a scatological view of standardized culture: mass culture is shit! "Advanced" communications systems begin to function on the level of primal feces, a cultural detritus.

One may also perceive a certain link to such Futurist works as Marinetti's *Paroles en liberté*. As with the poet's vision of a nonspecific language, signs without referents, only the sounds of the city, so Mouraud's rhythmic cancellations of "ICI" and "LA" spell out a manifestation of systemic chaos — in fact, the anti-substance of a postmodern culture.

When Mouraud uses the term "Black Power" to articulate a position in relation to language, she is playing upon the notion of absence. The absence of the visualization of the word is an abstraction. What we see is what is not there. Through a visualization of the absence, the hidden structure of the word is revealed. Mouraud puts this absence in the foreground of being. It is this consciousness of perception in relation to the existential ground that intensifies the purposes of language. Language manifests itself through the sign. The sign, in turn, manifests the viewer's relationship to culture. The problem resides in the fact that culture is not necessarily tied to the language of art. In this sense, the language of art is highly specialized. This reference to language in Mouraud's work can be cited in two earlier works: *Wall Is Seen* (1972) and *Memory of a Non-existent Seeing* (1977).

The earlier piece is stated as a sequence of propositions in reference to an installation site. It is a language piece in which three statements and three substatements are made in relation to three questions. The piece is a manifestation of the abstraction of language in reference to a thing or a place: a "wall." The deduction moves from "wall is seen" to "form is seen" to finally "that is seen." Concurrently, the questions are posed as to whether a "name" can be seen, then to whether an "inference" can be seen and finally to whether a "concept" can be seen. The point of this work is to suggest that the naming of a thing is dependent upon a proposition.

Much in the tradition of Wittgenstein's *Tractatus*, Mouraud's *Wall Is Seen* restates a very important concept: the necessity of language with regard to the naming of a thing or a place as art. This piece challenges the fundamental notion posited by Minimal Art several years earlier as to whether the cubes of Judd or the neons of Flavin could exist as art apart from the context of their placement. Did the syntactical reading of the work carry the meaning independent of a gallery or museum setting or, more recently, from an art historical reading of the work? This is to suggest that whereas now we identify these arrangements of cubes and lights as "art" in that they have entered into the lexicon of recent "art history," this was not always the case. One could discuss earlier abstract forms ranging from Brancusi to Malevich in terms of art because the materials of bronze and oil on canvas were already a part of art history. The ideas used by these artists may have been transformed, but they were transformed in relation to the material conventions of art. On the other hand, Minimal Art was destined to rename the materiality of art and thereby to posit the naming of art within the realm of philosophy. The concept, in turn, was a feature of the stated proposition.

Mouraud's *Wall Is Seen* extends the parameters of Minimal Art from the structuralist position of the concept and the material to a questioning of the concept in terms of visuality. Her piece concludes by asking: "Can a Concept be Seen?" This, of course, is a rephrasing of Wittgenstein's problematic as to whether language is capable of expressing what is unknown or, in this case,

what is absent within the configuration of the sign. In his *Notebooks*, which preceded the publication of the *Tractatus*, Wittgenstein states, "What is mirrored in language I cannot use language to express."[10]

The philosopher goes on to emphasize that language "stands in internal relations to the world"[11] which further declares the limitations of language; yet it is these very limitations that constitute "the logical possibility of facts."[12] The structure of the sign has its own significance. According to Wittgenstein, in his formative period, it is the logic of language that cannot be expressed as language. One must search for a logical equivalent. That is to say, the sign is not the thing itself. In *Wall Is Seen*, Mouraud attempts to defy the possibility that a concept can be so easily materialized, that the concept can only express itself through revealing the absence of language. In this sense, one might talk about Mouraud's work as a kind of negative statement from the perspective of her instrumental use of language in relation to culture.

Again, it is the tension between this absence as a kind of metaphysical or existential ground and its application to the linguistic operations of culture or the process by which "naming" occurs within a cultural mindset that reveals itself in a language piece from 1977 called *Memory of a Non-existent Seeing*. Installed at P.S. 1 in Long Island City, New York, this piece consisted of black letters that surrounded the interior of a room as a continuous sentence. The placement of the letters included both the walls and the row of arched windows on one entire side. The sentence and the arrangement of the sentence in the room existed as a total sign. For Mouraud, the sentence could only exist within a context in which the architecture of the space functioned dialectically with the language of the piece. The concept of an absence was revealed as one read the sentence within the space. Through the absence of the "memory" one could only imagine what was "non-existent." There was a resonance that provoked responses and negations. Did a "non-existent seeing" indeed constitute a concept? Was there a contradiction in the fact that one was reading language that, at the same time, was negating the meaning of what was being read?

According to one commentator on the early works of Wittgenstein, a negation "is not a name for something in the world; it is rather an operation with signs, which thus offers no new experience, yet which does serve to order and elucidate our knowledge."[13] For Wittgenstein positive facts constitute "the existence of states of affairs," where negative facts are "the non-existence of states of affairs."[14] At the outset of the *Tractatus* Wittgenstein asserts that the world is not constituted by objects but by states of affairs. The latter is defined as "a combination of objects."[15] Therefore, one can say that the relative relationship between objects has significance. With this in mind, one might speak about Mouraud's P.S. 1 installation as dealing with the relative perception of a concept as determined by the moment of memory (a rehearsal for a past state of affairs). For within the act of perception, the duration in which cognition

occurs is already feeding the memory its facts. The concept therefore becomes through transference an intentional object. This point relies more on Merleau-Ponty than it does on Wittgenstein; still, one cannot separate the act of perception from that of memory no matter how conscious one may be of bracketing what is unconscious or what has already happened or been recognized as past-time. Non-existent seeing, for Mouraud, is a problematic that carries considerable significance. It might be called "memory of a negation." But within the process of this negation there is also an absence. Whereas for Wittgenstein, absence may constitute "the non-existence of states of affairs," for Mouraud it constitutes a focus on the phenomenological reality of being. To understand how this enters into Mouraud's use of language — particularly in her recent work, such as the "Black Power" paintings, it will be necessary to examine the other aspect of her work that concentrates specifically on metaphysics and contemplation.

III.

Reductivism and dematerialization are two terms that characterize much of the aesthetic development of ideas prevalent in the sixties. The work of the American composer John Cage had become well-known in avant-garde circles throughout the United States, Europe, South America, and Japan. Cage's appropriation of "chance operations" by way of earlier Dada artists, specifically Marcel Duchamp, and his relationship to the Zen Buddhist teacher D.T. Suzuki were instrumental in offering a fresh attitude toward aesthetics. Whereas much of the fifties was characterized as a highly charged period in which boldly assertive abstract forms were taking the forefront of attention in the international art world, another attitude toward experimentation in the arts began to evolve rapidly after 1959. These experimentations took the form of Happenings, Fluxus, Minimal Art, Conceptual Art, Body Art, and Earth Art.

Generally, these tendencies in American art had counterparts in Europe, such as Nouveau Realisme and Arte Povera, that gradually became understood as alternatives to abstract formalism. The spirit of these counter-aesthetic or anti-aesthetic developments was important in opening up another possibility for a discourse among avant-garde artists. The pivotal position of John Cage in relation to this discourse cannot be underestimated. Much of the thinking that would develop in the sixties was directly affiliated with his theories. One attraction of Cage's work among younger artists at the time was his interest in methods that functioned systematically but according to principles of randomness or chance. This idea alleviated the burden of a disciplined formalism, in which the expression of the ego was a preeminent concern, and permitted a more free-form, non-stylistic approach to art where the concept within the work had greater significance. Cage's well-known silent

piano sonata *4'33"* (1951) was an example of how the absence of music declared another kind of music based on the random sounds produced by the audience during a specific measure of time. Another attraction offered by Cage was his interest in Zen Buddhism. Based on the absence or relinquishment of the ego as the source of all worldly pain and bondage, Zen Buddhism presented a view of the world in which "nothingness" was a key factor. It was this focus on "nothingness" in contrast to the ego that suggested new possibilities for some artists working with the avant-garde in New York during the sixties.

One of the younger artist-musicians influenced by Cage was La Monte Young. Young was a member of the loosely defined group known as Fluxus in the early sixties. He grew increasingly interested in relinquishing the ego and became involved with Eastern forms of musical notation and performance. The cyclical idea of time held a greater fascination for La Monte Young than the linear forms of tempo and temporality practiced by Western composers. During the seventies, Young collaborated with Marian Zazeela and the Hindu raga singer Pandit Pran Nath, performing music with an open spatial environment. During the late sixties, Mouraud was influenced by the teachings and music of Cage and Young. She wanted to construct spaces for "thinking" that could be available to anyone in either a private or public place. The earlier period of Mouraud's "Initiation Rooms" was between 1969 and 1973. In addition to the indoor rooms which she designed and built, there were more elaborate outdoor environments — much more costly to construct — such as *Close to It All* and *Initiation Space No. 1*, both from 1970. Mouraud's interest in the work of Cage, Young, Minimal Art and Conceptual Art led her to this series of projects — sometimes dealing with audio elements, such as her *One More Night* (1969) — in which the subject of the work was the participant. Inspired by Zen meditation, these projects were empty environments where the lighting and the sound were carefully controlled, and where a participant could enter into the piece and contemplate "nothingness." Given the atmosphere of the time, this work fit perfectly into the vocabulary of signs that defined the counterculture. It was a highly reduced, yet complicated series of constructions that somehow have managed to maintain their relevance, even though few of the larger projects have ever been realized.

Recently, Mouraud designed and executed *Initiation Room No. 4* at La Criée in Rennes. In contrast to the horizontal dimensions of some of the earlier Initiation Rooms and Spaces, this one emphasized verticality. Designed in the form of a hexagonal interior, *Initiation Room No. 4* is constructed with lacquered wood. As with the others, it is painted completely white and has a reflective quality. Because the room is sealed off from any natural light source, fluorescent tubes are used to illuminate the space in such a way as to provide even, ambient light throughout. One enters the space through a large, heavy doorway and steps up onto a platform that is slightly raised from the exterior

floor. When the door is shut, it becomes one of the six walls in the hexagonal configuration. Given the emptiness of the space and the pervasive whiteness, one may begin to concentrate upon one's physical presence without identifying with objects outside of the body. In this sense, it functions very much like a deprivation chamber. Mouraud has added an additional aural element to the space. As the door begins to close after one has entered into the room, the participant notices a high-pitched sound. This sound element may become the focus of concentration at the outset until the sensory input has reached a level of adaptation. Because of the vertical shape of the hexagon, the participant may become aware of the reflective patterns of the interior.

Tania Mouraud, *Initiation Room No. 4* (La Criée, Rennes, 1989). Sound, white enamel on wood, 397 by 296 cm. Courtesy Tania Mourand.

As one looks upward to see the symmetrical hexagon that constitutes the ceiling of the room, one also notices that the white lacquered walls are reflecting that shape in all directions. The experience is a perceptual one but only to the extent that one is led toward a more expanded view of space/time concentrated on the particular design of the room. The shapes have an Islamic feel to them. They are illusions in the sense that they are reflected shapes, yet this relationship between presence and absence at the moment of perceptual cognition suggests the possibility of transcendence. Through the guise of "nothingness" one becomes aware of the phenomenon of the self. Every effort has been made to remove any factors of immanence that might constrain one's thinking processes in terms of the ego. In other words, Mouraud's Initiation Room offers a passage from immanence to transcendence, from language to metaphysics. In the Initiation Room one exists in space/time emptied of language. The experience has the effect of an ablution, a cleansing of the human sensory apparatus. It is the difference between the alienation

incited by the glut of secular imagery in an environment of popular signs and the opportunity to experience isolation in order to reconstruct the significance of the self. For Mouraud, the popular sign is only correctly understood when the self is understood in relation to it; that is, forfeiting the premise of desire and seduction in favor of registering the meaning of things in terms of their logic.

When the phenomenon of the self is understood, Mouraud holds, one's relationship to objects begins to change. This is quite opposite from the views of Barthes or Foucault. The sign no longer functions independently. Mouraud's metaphysical position does not attempt to express itself any more than that of Wittgenstein. Yet it is important to recall that Wittgenstein is not so much against the metaphysical as he is attempting to get a perspective on it through the limits of language. Wittgenstein's metaphysics could only exist within the realm of silence. So it is that Mouraud's understanding of the phenomenon of self exists only by acknowledging that language constitutes an illusion of the world, an illusion that distorts reality. She remarks:

> I am concerned with perception in the aim of posing the question of reality of the object, and thus of the world. Art is a means of knowledge. But my work is definitely not a discourse on art — yet another. I am only pointing out that what we call real is not real, that the picture is not the phenomenon....[16]

Initiation Room No. 4 is an enclosed space, a chamber. One of the most important works in this series, originally conceived in 1970, has yet to be realized. It is a room designed to be built inside a cliff overlooking the sea. It is called *Initiation Space No. 1*. One enters the room at ground level and descends a series of steps, then enters a corridor underground which eventually opens into a rectilinear space that faces the ocean. The position of the "window" is situated so that only the water can be seen; therefore, the light that one perceives is reflected light coming from the glittering surface of the moving ocean. In this space, the participant is solitary — isolated, but not alienated. It is the silence of the self entering into the silence of nature where language seems to lose its ground or, at least, is temporarily suspended in its operation.

IV.

The window on the ocean, as described in *Initiation Space No. 1*, suggests a photographic view of a visual phenomenon. One contemplates a "picture" in the sense that one is looking through a rectilinear opening, a viewfinder, toward something else: the ocean light. Photography, for Mouraud, has been a persistent concern. The black and white print, such as any one of those manifested in her 1981 series called "Vitrines," is fundamental to her cognition of

reality. Mouraud uses the viewfinder — the cropping of an image or of language — to situate the viewer in relation to a phenomenon. Whether it is the popular sign or its metaphysical absence, the artist is concerned with the exact placement of visual information. "Vitrines" are photographs of secularized objects found in various stores. They are objects to be bought, objects for sale, common objects, commodity fetishes. Some will assume personal meaning when they are purchased, others will be thrown away, discarded quickly. They are the objects of a consumerist society, objects that are meant to identify us. These black and white photographs are relatively small, each measuring 13 x 18 cm. They are presented, individually mounted under glass, on a wall in a dispersed grid pattern. One reads these photographs as signs, as words, short words, in the same way that one might read "ICI" and "LA." They are like notations or gifts. They represent us. They are appellations.

V.

Language is not always transparent. Words do not always communicate what they are intended to mean. Poststructural thought is clear about this. The series of fragmented words that Tania Mouraud completed in 1988–89 called "Black Power" are indicative of this problem. The generalized syntax is negotiable. The words are contingent upon their placement. There is considerable slippage in the term. The more obvious analysis is a semantic one: black has power whether it is perceived in imagery or in a text. Black defines the connotation, the tonality and the texture of language. We read print. There is another connotation as well. "Black Power" is a term with political and social significance. It is a term signifying the revolutionary posture of African American people in the United States who advanced the cause of civil rights during the 1960s. There are some observers who would say that the equation between revolution and Black Power is too strong: that, in fact, Black Power was not so much a revolutionary posture as it was an assertion of equality. However, those who experienced the civil rights movement during the sixties — namely, those who demonstrated at the picket lines or rode the buses or marched in the marches — understood that Black Power was a position that needed more than an assertion. Black Power was a social, economic, and political position that required a revolutionary way of thinking. Justice and equality for African Americans has never been an easy struggle. The era of the sixties was an era of passage.

The term "Black Power" is a loaded signifier. It is the term Tania Mouraud has selected for her most recent body of work in which language is the apparent subject. Having lived in New York for a short time during the late seventies, she is not oblivious to the situation of African Americans. One cannot simply claim that Mouraud has chosen the term in order to load meaning into the

work. At the same time, one cannot deny the layering of signification that res-onates from hearing the term. The context is important, but so is the effect. What does she mean, for example, when she abstracts the word "MEME" so that the textured black surface is in the foreground? The visual elements are the negative spaces, yet Mouraud always abstracts the word farther than its lit-eral visualization. There are always adjustments. By foregrounding the absence of the word's visualization, the power of black — that is, the negation of lan-guage — is revealed as the hidden empowerment of conventional visualization. What is normally unseen is suddenly placed in the foreground, given texture and significance. It is also evidence that Mouraud's aesthetic discourse is not simply the name or the phenomenology of Being, but it is primarily an aes-thetic about being in the world. It is an aesthetic concerned with the facts of language and with various states of affairs.

One might also consider that the color black has different connotations depending on where it is seen. In the West, black is a negation, a metaphor of death; in the East, it is an assertion, a metaphor of eroticism, fertility, and life. This difference is a profound one. In Buddhism, there is a term *sūnyatā* that refers to "nothingness," but in a special way. *Sūnyatā* is a concept of "the preg-nant void"— something about to emerge from out of the dark.[17] "Black Power" is Tania Mouraud's signal that something is about to emerge from our processes of thought as we allow ourselves to see language. Language is abstracted, stretched and pulled. Its meaning is often outside the realm of facile recogni-tion. By pulling a word back into focus, by way of its architectonic structure, it takes on a meaning that would not have occurred in isolation of its subject: ourselves. It is in this way, by way of abstraction, that Mouraud's word pieces elude the possibility of any propagandistic device, and become real; indeed, become facts.

11

The Landscape in Recent American Art (1989–1990)

"Any discussion concerning nature and art is bound to be shot through with moral implications"
— Robert Smithson[1]

There is a painting by Duchamp that is constructed in relation to another earlier painting. It is called *Network of Stoppages* (1914), and it represents a kind of topology. By looking at the painting closely one can discover the other painting, a variation of one called *Spring* (1911), turned sideways. The earlier painting, which is in fact covered or concealed by the later configuration, shows two people (Adam and Eve, presumably) reaching for the forbidden fruit from a tree. The style is a late Impressionist one. The colors are not brilliant, but subdued. It is clearly a painting that suggests man's (and woman's) metaphorical relationship to nature. Yet, with the dialectical positioning of the configuration of lines there is another meaning suggested as well. One might talk about *Network of Stoppages* as having a double meaning, as is the case with all metaphors. The earlier study for *Spring,* turned horizontally beneath the later painting, offers a point of tension in relation to "chance operations" used in the diagram above it. It is not merely a metaphor about man and nature; it offers another level of metaphor that is extended to another power of meaning. The topology of the lines in the painting is derived from a "conceptual" work which Duchamp began the preceding year called *3 Stoppages Etalon.* This work is not a painting. It is a series of three templates made of cut wood which occurred by dropping a one-meter piece of string onto a board. Each time that the artist dropped the string a slightly different variation of the line emerged on the surface below. These three variations of lines were the fundamental basis of the three templates used in producing the configuration of lines in *Network of Stoppages.*

Another curious aspect about this painting from 1914 is that it was painted after Duchamp had gone through his Cubo-Futurist style of painting. It was

done at the termination of one period of his formative career and signaled the beginning of another. Instead of simply reiterating the developments of French modernity, Duchamp launches into another territory. His concern shifts from the purely metaphorical surface to another dialectical positioning. The topology of the surface is a map — perhaps a journey, such as the famous trip Duchamp took with Picabia on the Jura-Paris road. In examining *Network of Stoppages*, we notice that there are nine lines so as to imply that each template was used three times. The construction of Duchamp's "pataphysical" topology was not considered a painting, but more of a conceptual exercise to cast doubt "on the concept of a straight line as being the shortest route from one point to another."[2] But then there are many questions that arise in relation to Duchamp's experiment. There are questions about the use of the pastoral painting from an earlier year and its relationship to this topology. The pure metaphor of man and nature is suddenly altered. It is no longer "pure" but now tarnished. The ideal situation, being the pivotal focus of mankind's original fall from divine grace, is now a map. The map is a map of the mind, an imaginary topology, filled with existential desire. Where does it go? What is its destination? The emphasis has shifted to the absurd. Metaphor has become a literal process, a push and pull dynamic. The dialectics of consciousness are no longer ideal. We are in the world looking for signs and meaning, even if the issue of meaning is being held in abeyance. The landscape is a conceptual topology, a place that is marked and divided by a linear configuration within another process of perception and production. The topology and the landscape are not so easily distinguishable. The land may be read as another sign. By contextualizing the land in the form of a linear cut or a trace or a circular ring, the physicality of absence becomes another level of linguistic operation.

American Land Art of the late sixties and early seventies used a similar structural model. One can approach it from two perspectives: the sublime (transcendent) and the literalist (pragmatic). These are the antipodes of the American point of view. This model is particularly appropriate in the development of Robert Smithson's work in the sixties. One can discuss Smithson's work as possessing elements of each tendency, though he was clearly more dogmatic about the literal approach in his "site/non-site" dialectic.

To come to terms with Smithson, it is important to consider the complexity of issues that pervade his work. At the outset of the sixties he was working from an imagistic aesthetic, largely inspired by late Surrealist attitudes. As his work progressed he became increasingly involved with modulated and perspectival devices as in his *Enantimorphic Chambers* (1964) or the *10-Unit Plunge* (1966). In either case, the artist was concerned with the involvement of the viewer in an experience with spatial/temporal concerns. These works had a distinct relationship to the Minimal Art of artists such as Tony Smith, Donald Judd, and Sol LeWitt, but they also had a relationship to Gestalt psychology and to the perceptual theories of Piaget and Merleau-Ponty. To experience

these works was a matter of addressing them pragmatically or literally, yet concomitantly one might be provoked to address their purpose not only aesthetically but from a phenomenological perspective. It is this issue that seems significant in Smithson's passage from Minimal Art to Earth or Land Art. It is the notion that literal form had a certain contextuality, a space that depended on its presence, while the viewer in the act of perceiving the form was in the same space; thus, the viewer was inseparable from the work. To find its wholeness in any relativistic manner requires that the viewer shift from an imminent perspective to a transcendent one.

The site/non-site works from 1968 and 1969 possess a certain detachment and carry a curious cerebral/physical interlocution. One cannot know the significance of a site, such as the *Cayuga Salt Mines*, as sculpture without identifying its context within the art space, the gallery or museum. In one of his "sub-non-sites" from 1969, called *Eight Unit Piece*, using mirrors and rock salt removed from the actual site, Smithson echoes the dialectical relationship between art and nature. The sculpture is somewhere between the gallery nonsite and the salt mines; it is, in one sense, dependent on a "conceptual" reconstruction. To know the piece is to register it empirically from one space to another. In passing from one space to another, the factor of temporality enters the process. Smithson did not believe in the permanence or ossification of material objects but he did advocate a position of physical realization in association with thought. He rejected Conceptualism in its pure sense because it ignored this deeper reality. Instead of permanence, Smithson saw entropy as the condition of all matter and what the psychologist Anton Ehrenzweig called "de-differentiation." He was interested in the "oceanic" consciousness, the metaphorical transcendence between primordial stratification and the Spiral Nebulae.[3] This, in fact, became his resolution in what might be called Smithson's post-structural phase, beginning with *The Spiral Jetty* (1970). In *The Spiral Jetty* his work goes beyond the structural antipodes of site and non-site and toward a unified circumference, completely open and perpetually extending itself into space or contracting back again toward a center. It was this phenomenon that exposed Smithson as having some linkage to the transcendental aspect of nineteenth century American Romanticism.

To mark the land is both a conceptual and a physical action. If we are to accept Rosalind Krauss' argument that sculpture in the late sixties began moving toward "the expanded field" somewhere between landscape and architecture and definitely away from the concentrated notion of the historical monument, it becomes clear that sculpture cannot be separated from theory. Sculpture has come to occupy what Krauss calls "the logic of the space of postmodern practice."[4] By this, she means that the medium no longer dictates the form as it has done throughout most of the history of Modernism. Within this new logic of space, many mediums may be employed. Whether it be the desert "cuts" of Michael Heizer or the "markings" of Dennis Oppenheim, in each

case, the work attempts to substantiate a position about sculpture to the environment that is more than a manipulation of material. Artists such as Smithson, Heizer, De Maria, Aycock, Irwin, Andre, Long, and Morris, at a particular juncture in their careers, diverged importantly from what Krauss viewed as "logical structure" within the frame of art history.

One might interpret this phase of recent American sculpture as an attempt to bring ideas about perception and physical experience back into the content of art. The romantic aspect of this rupture from Modernism is ironic. One might argue that Oppenheim's metaphorical emblems, such as *Branded Mountain* (1969), or Robert Morris' *Untitled Reclamation Project* (1979), which attempts to comment upon ecological disaster, are a form of distended literalness which conceals their romantic impulse. The fact remains that Land Art did provide an approach to sculpture that was unbound in its relation to either the gallery, the pedestal, or the object. It would be an error to assume that Land Art was not involved with material. This is hardly the point. Rather the emphasis shifted from the presence of an overdetermined form to the use of space as raw material and the use of time as process both in the making of the work and in one's perception of it. The history of this break from traditional sculpture is neither chronological nor thematic. The concept began germinating rapidly in the late sixties. One could even point to precursors of the movement in the fifties in works by Herbert Bayer and Isamu Noguchi, not to mention to the various ancient sources that have been discussed elsewhere. The history we are discussing here is one of simultaneity, of concurrent ideas with a desire to return to primordial sources of investigation in art. It was an approach to art-making quite divorced from the object and commodity orientation of the eighties.

The physicality of Land Art, which is itself a subcategory of what has been called Environmental Art, has numerous permutations and applications. The environment is perhaps the more inclusive term in that it encompasses both inner and outer spaces. The environment suggests applications of material to the land and therefore to nature, as, for example, in Nancy Holt's *Sun Tunnels* (1976) in northern Utah or the recent perambulatory viewing spaces suggested in *Tower* (1988), a large-scale piece by Mary Miss in New York City's Battery Park. Both of these works specify a place or site from which the surrounding area can be viewed. In Holt's *Sun Tunnels*, the sitting is exact. One can stand at the core of the piece in the middle of four concrete cylinders placed horizontally on the desert. As one peers through any of the parts, depending on the cardinal point that the viewer is facing, it is possible to discover an intimate relationship with the sun, the moon, and the stars. In the walkway construction by Miss, the sitting is less about exactness and more involved with the complex interchange between nature and the urban situation. *Tower* is a more public piece than *Sun Tunnels*, yet they share the concept of working within a "site specific" situation. That is to say, the piece cannot be divorced

from its place. How the piece interacts with the space around it or within it is essential to the experience of the work. This point has been made repeatedly in defense of Richard Serra's controversial *Tilted Arc* (1981), which was removed from the premises of the Federal Building in lower Manhattan in 1989. However, there are other examples of the site specific concept that predate the *Tilted Arc* by some years and work more directly in relation to the natural (in contrast to the urban) environment. Works such as Beverly Pepper's *Amphisculpture* (1974–77) in Bedminster, New Jersey, or Elyn Zimmerman's *Monarch's Trough* (1978), constructed at the Niagara Gorge in Lewiston, New York are prime examples of site specific sculptures that function as part of the natural environment. It is perhaps more accurate to assert that the concept of using the terrain of nature is more endemic to the rationale behind site specificity. One might consider the architect Frank Lloyd Wright's *Falling Water House* at Bear Run, Pennsylvania (1937) as an antecedent to the concept of constructed forms working as integral units in relation to nature. Wright's house is close to sculpture in that one can examine the interlocking lines and planes as they interrupt the environment of trees, water, rocks, and sky. Yet for a work situated in the expanded field, the theoretical construct of the piece is essential to its meaning. In another work by Zimmerman, called *Sightline I* (1980), built for the Winter Olympics in Lake Placid, New York, nineteen wire mesh panels are spatially integrated in an open field between two woods. The point of the work is to set up a series of measures at human scale to determine a reading of distance, but also to create a pictorial sensation of nature being read from various angles as one moves by or through the modular arrangement.[5]

Two of the more ambitious projects that deal with the site specific concept in relation to nature on a large scale are Walter de Maria's *Lightning Field* (1974–77), constructed on a desert plateau near Quemado, New Mexico, and James Turrell's *Roden Crater Project* (begun 1980), situated in an extinct volcano near Flagstaff, Arizona. One might refer to these works as monumental realizations of constructed form that are completely interdependent with the given circumstances of the natural terrain. Just as Duchamp's *Network of Stoppages* laminates one cultural system of measurement against an altered representation of a bucolic landscape, so De Maria and Turrell use the given conditions of these impressive locations in the vast sublimity of nature to readjust our perceptual and physical relationship to their vistas.

De Maria, along with Smithson, Heizer, and Oppenheim, drew considerable attention to the landscape as an extension of their concerns as Reductivist or Minimal sculptors in the late sixties. Each artist emphasized the empty terrain, the vast plateau and sunken deserts of the open territory. The art historian John Beardsley speaks of this development as an extension of earlier aesthetic notions of the sublime formulated in the eighteenth century, particularly in the writings of Edmund Burke and the Englishman Uvedale Price.[6] Beardsley also suggests a relationship to the aesthetic theories of art historian Christopher

Hussey, who defined the characteristics of the sublime according to several attributes: obscurity, power, privations, vastness, infinity, succession, and uniformity.[7]

Given Hussey's definition, one might observe *Lightning Field* and *Roden Crater* as two manifestations of the sublime in which these terms apply. *Lightning Field* recreates a sense of dialogue with nature, an interaction between earth and sky. There is a certain aura of speculation about it, about an event that is going to happen. The anticipation relates to a romantic longing, a kind of nostalgic wish to get back in touch with the primordial forces of nature. In spite of De Maria's numerical calculation in which he measured a field of stainless steel poles according to a complex system of a squared mile in relation to a squared kilometer, one can ultimately say that there is a spirit of transcendence about the work. One anticipates the lightning as one may have anticipated some sign from the native deities of this region. It is a work in which a dialogue with nature is persistent and transient, a work determined by measurement laminated against a vision of the sublime.

James Turrell's *Roden Crater Project* is also involved with the potential forces latent within the crust of the Earth. The crater is a dormant volcano, the location of enormous power. Turrell has altered or, perhaps, adjusted the way in which the crater is approached. It is a concept determined by the site. The ridge of the volcano is necessary to how our perception works in association with the natural light of the surroundings. Turrell is also interested in an experience of the transcendent, what he calls "celestial vaulting," a feeling of upliftment that one has occupied a place akin to the sacred space.[8] Indeed, one can point to the alchemist's dream in which the dimensions of nature prove immeasurable as do the points on Duchamp's immeasurable topology of nature as it is perpetually given to the condition of chance. In either case, both Land Art projects rely on and make use of the structural paradigm. Whether it be pragmatic or transcendent, nature or the Natural, or sublime or diagrammatic, there is the familiar example of chance operations that ultimately fulfills and completes the meaning of these works.

SECTION IV.
MODERNISM AND
CONCEPTUAL ART

12

Robert Motherwell (1980)

Robert Motherwell's exhibition at the Ulrich Museum of Art on the campus of Wichita State University in November 1980 provided a curious sampling of works completed during the seventies with particular emphasis given to those of the recent year. Some thirty paintings, collages, and graphics were selected by the artist at the request of museum director Martin Bush. They were shown in conjunction with an infrequently seen but comprehensive group of photographs by Motherwell's artist-wife, Renate Ponsold. Together the two exhibitions provided an unusual occasion to view works of considerable magnitude and refinement which hold a somewhat classical stature in the current annals of American artistic achievement.

Although the selection was made by Motherwell himself, the exhibition relied too much upon a happenstantial selection of work in order to carry aesthetic meaning; this constitutes a major criticism of the show, particularly in relation to *Drunk with Turpentine* (1979), an oil-on-paper series of which 12 variations were chosen from the group. The display of such a series revealed a problematic issue which will be further discussed in some detail. One painting which truly matched the monumental style associated with Motherwell's best work was the mural-sized, *Cuba y La Noche* (1979), a rhythmical tour de force of intense yet ambivalent feeling.

Those familiar with the painter's work from the late sixties will find vestiges from the well-known "Open Series" in works from the recent decade, such as *Suchard on Orange with Blue* (1971). This collage has a Swiss chocolate wrapper as its central image within a rectangularly divided space. It is the earliest work represented in the show. Another small painting, *Sicilian Woman* (1972), also carries the sign of a three-sided rectangle etched into the surface of the paint. This theme involving the division of space into partial rectangles, usually emanating from the top edge of the format, persisted as Motherwell became increasingly more involved with printmaking. The lithograph, entitled *Hermitage* (1975), is dominated by a red field in which a flattened cigarette wrapper has been mounted in the lower right corner; in the upper one-third of the composition, black letters from the Slavic alphabet pay homage to the famous Russian museum. By observing the surface closely, one may discover

a curvilinear motif barely marked in the red ink — a motif again reminiscent of the enclosed and partially enclosed spaces found in the "Open Series."

The use of torn collage elements in Motherwell's lithographs relates indirectly to Marcel Duchamp's 1934 multiple edition of the *Green Box*. Duchamp incorporated 93 facsimiles of various scraps, handwritten notes, rough sketches, and smudged diagrams into an edition which manifested the actual appearance of the original. Each fragment was reproduced in a printed format, then cut or hand-torn by the artist. The combination of printmaking and collage occurred to Motherwell as a necessary amalgamation in order to use commercially designed cigarette wrappers in his editions. The packages had to be carefully photographed, color coordinated and separated, and, in some cases, enlarged to fit the size of the printed field. In *Bastos* (1975), for example, the wrapper had to be enlarged considerably in order to match the large-scale format, measuring 40 by 62 inches. As with Duchamp, each simulated wrapper had to be torn separately by the artist, then placed over the first run image.

A more recent lithograph, *St. Michel III* (1979), utilizes a green and yellow St. Michel wrapper run directly over a black image previously printed on hand-made paper, thus eliminating the need for separate papers mounted one on top of the other. In two versions of *St. Michel* presented in this exhibition, Motherwell combined the wrapper and the calligraphy on a single, flat surface; the physical elements of the collage therefore became separate runs of color on a continuous figure-to-ground relationship. In these prints, the artist has sought out a "readymade" image from commercial design, obviously recalling the French Cubist collages. As elements within a pictorial space, the wrappers have a kind of erotic significance, embedded within a highly sensible language structure.

Over the years, Motherwell's prolific output has shown a full range of plasticity and intuitiveness, holding forth somewhere between primitivism and formal restraint. His characteristic primal shapes — triangles, ovals, rectangles, and lines — have asserted themselves within diverse and shifting contexts of meaning. These contexts do not seem to be consciously intended; rather they appear as cyclical evolutions of form which become realized time and again through a metaphorical "ground of Being."[1] This reality is propelled into monumental fields of color, dense whiteness, and organically charged black pigment. The methodology behind Motherwell's painting has little to do with systematic repetition for this reason; his works are not intended as formal explorations in the way that various critical reviews have made them appear. It would be more correct to say that Motherwell's sense of structure is subordinated to feeling from whence the symbolic gestures are generated.

In the major painting *Cuba y La Noche*, there are definite past associations specifically related to the looming black shapes in the long-standing "Spanish Elegy" series. In lieu of straight black and white, figure-to-ground interactions, *Cuba y La Noche* incorporates vertical bands of pink, red, and yellow

which function as Matisse-like cutouts beside a massive, sprawling black shape which rises from the base of the picture plane. The conflict of forces is omnipresent. A mysterious geophysical formation intrudes upon a colorful sense of Latin gaiety. The hot color projects a downward motion which is matched by the upward thrust of an elusive blackness. Through the placement of the gestural nuances along its edges, the shape suggests pressure and weight — a latent force seething with an unknown, destructive impulse. In contrast with the bright colors, black further suggests anger and puritanical vengeance directed toward a playful yet unresolved hedonism.

As in the earlier *Summertime in Italy #8* (1960) and in the more recent *Ancestral Presence* (1975), the black shape has an anthropomorphic quality which may at first appear ominous; yet it also holds a deliberate clumsiness which is not without humor. This formation also relates to a recent brush painting, entitled *The War Machine* (1979), in which two black shapes are held within a dynamic field of activity, one larger shape above the other. Black tentacles reach and dangle between the two, projecting from all sides except the bottom. In *Cuba y La Noche*, only the upper portion of the motif in *The War Machine* has been retained. Its placement against the pink, red, and yellow division of space maintains an expressive force that goes beyond formality and ultimately into a romantic quest for certainty.

The resolution of form and space in such a painting is clearly and paradoxically dynamic. The method is not absorbed in conscientious problemsolving to the extent that other Modernist painters have been known to be; rather, Motherwell's paintings project psychological, if not theological, content into the reality of life and death. These metaphors seem to persist. Their association in terms of current social or political signification does not seem at all contrary or inappropriate to the artist's intentions. For example, much has been written concerning the gestural symbolism in the "Spanish Elegy" series — the imminent threat of Franco's fascist regime to the romantic tradition and lifestyle of the Spanish people. Similarly, one might consider *Cuba y La Noche* to be a statement on the impending threat of political powers struggling among themselves to impose a foreign ideology upon a "third world" country which is rich in its own cultural heritage as evidenced in colorful celebrations and festivities of daily life.

Motherwell has always shown a propensity for working intuitively in order to catch the spirit of spontaneous images, often created through accidental encounters between the artist and his medium. Such a method is not always possible in a large-scale format, but is indeed quite possible on a more limited scale. Perhaps working on paper is less inhibiting than working on a presized canvas; but the fact is visible that different methods are apparent in each approach. Motherwell is a painter who has endorsed the possibilities inherent in working with serial imagery for the larger part of his career; yet serial imagery on paper and serial imagery on canvas seem to have disparate results.

There is a considerable difference between the use of recurrent imagery on a larger scale and the "automatic" emphasis given to his quickly timed brush-strokes in *Drunk with Turpentine* (1979).

During the sixties, Motherwell engaged in two series of works on paper, *Beside the Sea* (1963) and *Lyric Suite* (1965), which were quite extensive in terms of the number of spontaneous variations each brought forth. The linguistic basis for these paper works corresponded somewhat directly to the Surrealist concept of automatism. For the poet Andre Breton, automatism was adopted as a stylistic medium in his more developed literary works, such as *Soluble Fish* (1924)[2] and *Nadja*[3] (1928). Rather than using a logical or systematic style of narration, Breton chose an associative progression of word-sounds toward the production of irrationally conceived imagery; that is, the sound of one word would recall another having little contextual relationship to the first, and that word would in turn recall another, and so on.

In *Drunk with Turpentine*, Motherwell has interpreted Breton's Surrealist method into its purely gestural counterpart: the spontaneous use of irrational signs. For the viewer unrehearsed in techniques of automatism, it may appear that these experimental works involving oil painted gestures on rag paper are trivial. For those versed in Oriental brush painting, the work may appear imitative or inferior by comparison. In the latter case, one may certainly note a superficial similarity between *Drunk with Turpentine* and works by Zen masters, such as Hakuin or Jiun, who engaged themselves in a highly intuitive and stylized method of ink painting. Whereas these works were almost always based on the contemplation of traditional word-images (ideograms), Motherwell's images are — in a more generalized, Western sense — derived from the realm of abstract feeling. They are highly personalized gestures without a rational language structure behind them.

Certain comparisons are available between Motherwell's method and the working processes of other contemporary painters, such as Franz Kline, Jackson Pollock, and the highly underrated Mark Tobey.[4] One might also consider the drug-induced calligraphy by Henri Michaux as a bridge between concepts of automatic writing and image-making. In recent years, Motherwell's *Dutch Linen Suite* and *Samurai*—two serial works on paper which preceded *Drunk with Turpentine*— managed to find acceptance rather quickly within the Modernist vocabulary of the seventies. Yet, it remains an essential task for criticism to distinguish the artist's intentions, regardless of how quickly the work is accepted, from those of orientalia or even psychedelia. The distinction, of course, is partially attributed to method. Although esoteric practices may have had some influence on Motherwell's work, the influence should be regarded more in terms of image-substance than of intentionality or literal process.[5]

Nevertheless, the title "Drunk with Turpentine" does suggest some degree of abandonment of the process, a state of euphoria, often associated with the Dionysian temperament. This feeling also corresponds to the presence of satori

among Zenga painters — particularly those of the rinzai sect — as well as to various states of enlightenment among eccentric Buddhist monks in China.[6] In Motherwell's title, one assumes the metaphor of inebriation relates to the ecstasy derived from the olfactory sense while breathing the scent of oil paint and turpentine. This is a pleasure unafforded by the use of water-based acrylics in contemporary painting; thus, the series suggests a kind of nostalgia for working in a studio where the scent of turpentine lingers and the magic of its lingering becomes pervasive and inspirational. To extend the metaphor, turpentine may work for the painter in a manner sought by Baudelaire in his use of absinthe.

The lack of monumental purpose in the serial paperworks requires that, instead, a continuum of perception should exist from one configuration to another. As earlier implied, this is not a precondition for a painting such as *Cuba y La Noche* or any acrylic work on canvas in which interlocking fields of color and shape combine to make a single entity with closure. Yet in viewing a single variation from the series *Drunk with Turpentine* in a museum, framed and isolated from others in the series, one tends to lose the sense of rhythmic feeling which seems intrinsic to the process of seeing them.

In the Ulrich exhibition, the 12 variations from the series were shown as individual works, scattered throughout the large gallery among other unrelated paintings and graphics. Where no specifications were given by the artist, the presentation of these gestural images may or may not have reflected the spirit originally endowed to the work. Consequently, there was nothing in the way of a syntagmatic relationship in which the viewer might accept these images as a progressive sequence in time as well as space.[7]

In that the gestural motion of the artist's hand played the central role in the delineation of these images, it may be inferred that the literal presence of time was a significant and transformable, qualitative feature; therefore, the idea of progression, as related to the word-sounds of Breton's automatism, cannot be considered irrelevant to their presentation as a whole. Each configuration might express a quickly intuited yet related "variation"— the subtitle, in fact, given to each work — which clearly emphasizes the context of an inspired process or theme. As in a Mozart concerto or a portfolio of etchings by Goya — two of Motherwell's favorite artists[8]— the idea of "variations on a theme" should be a function of presentation as well as of creativity; hence, it would seem appropriate that the series *Drunk with Turpentine* be shown in its entirety whenever possible.

13

The Italian Sojourn of
Joel Janowitz (1987)

Two concurrent exhibitions of paintings by Joel Janowitz were shown last spring at the Victoria Munroe Gallery in New York and the Roger Ramsey Gallery in Chicago. Both dealt explicitly with the theme of the Italian countryside, primarily consisting of still-life motifs with views of the Orvieto Valley. In these new works, Janowitz has managed to expand his spatial references in a more loosely defined direction by working in two distinct media: oil painting and drawings in paper pulp. His pictures hold a peculiar abeyance as if to arrest a moment of heightened intimacy through his subject. They move in two directions. In one the surface recedes or expands into a spatial openness, while in another the surface contracts and focuses upon a specific perception, a specific time and place, a phenomenological instant in which all but the essential meaning of the subject is diffused.

To describe Janowitz's new work in this manner would immediately suggest a historical retreat into the past, perhaps a Post-Impressionist view of reality. However, there are other aspects concurrent with more recent critical theory that seem to place these paintings in the present and thereby avoid the appearance of an academic approach. These aspects are fundamentally about tactility (on the surface) and contrast between shifting planes of light. Together these aspects of Janowitz's work form the basis of a structural vocabulary of painterly terms. Through Janowitz's capacity to balance these aspects of pictorial form in relation to his own mechanism of self-quotation whereby his reservoir of images is pulled from autobiographical sources, often latent with incisive psychological insight, there emerges a quest for certainty in painting that confronts the postmodern dilemma, already infused with pluralistic significance. Yet in order for this significance to evolve as evidence of a clearly formulated structural locus, it is necessary to view these works, based on a visit to Italy in the summer of 1985, as an ensemble without ignoring the specific compositional devices given to each of the pictures. Even though drawn elements appear in many contexts throughout the series, both as painting and paper pulp drawings, one cannot avoid the formal system that allows Janowitz

to enhance his compositions with lyrical bravado; and it is through the coincidence of signs determined either directly or indirectly through these lyrical encounters that makes for the inclusion of deeply penetrating psychological determinants.

My initial experience with Janowitz's painterly style came nearly twenty years ago while the artist was completing his graduate thesis at the University of California in Santa Barbara. One cannot think of Santa Barbara without envisioning the quality of light which characterizes the town. It tends to be sharp more than ambient. The light declares its subject in a most specific way. At the time, Janowitz was doing gestural abstractions, lyrical in content, with broad, sweeping areas of color, often muted in grays. The colors were muted but not the shapes. The shapes were, in fact, the obverse reconciliation of the shifting spaces, created through the bold gestural sweeps which emphasized diagonal counterpoises (a characteristic which distinguishes the recent Italian works as well).

Five years later, I inadvertently stumbled into Janowitz at a local gathering of artists in a renovated loft in Boston. I visited his studio, then in Cambridge, some days later and was surprised to see that his work had moved from gestural abstraction to New Realism. Concomitantly, his sense of tactile engagement with surface shape, subtly modulated, was still present as well as other familiar concerns: contrasting segments of light and his use of a nearly concrete formal vocabulary. These paintings, some of which were shown in the Whitney Biennial in 1973, dealt with one's perception of roads and open landscapes by using the vantage point of an automobile. The spatial openness of these pictures was strikingly similar to the earlier abstract work; the subject matter, however, carried another kind of referential meaning — less romantic, more in touch with the exterior world, the everyday environment.

Janowitz investigated the properties of perspective by tilting the horizon on a diagonal plane, thus giving the sensation of viewing the subject a refined transitory feeling. One might experience these highway visions in a fleeting glance or with a kind of Zen enlightenment, making metaphors of concrete reality. Throughout the seventies and early eighties, Janowitz would continue to explore and assert the abstract parameters of this concrete reality. The concern for a tactile surface in relation to the representation of shapes appeared utterly dependent upon shifting modular planes of light. This quality of investigation resonated throughout his work from this period in many different forms and guises.

In his recent exhibitions in New York and Chicago of recent work inspired by the Orvieto Valley, Janowitz remains consistent in his appreciation and understanding of those formal terms which have sustained his style of painting over the years. The tension between elements of space, shape, light, and form is clearly focused and deliberately charged with lyrical vitality. In addition to the formal elements which constitute the tactile sense of painting's surface,

there are those contrasting elements which structure the work's content. Identical objects appear and reappear in these paintings, often shown from the same point of view. What recontextualizes these objects is their scale and placement and sometimes their cropping, but the angles, for the most part, are consistent. Pitchers, vases, books, fruits, flowers, chairs, tables, even the human figure — these are the contrasting parameters of his pictorial field. For example, a view of a milk pitcher appears in the lower left of a painting called *What You Saw When You Leaned Forward*. The pear-shaped opening of the pitcher points toward a landscape at the end of a white table. The edge of the table is diagonally situated and perpendicular to the pear-shaped opening. The shadow on the tablecloth is logically connected to the position of an overhanging branch of a nearby tree. The perspective is less linear than inverse. The flattening of the pitcher and the background landscape is entirely deliberate so as to emphasize the tactile resonance of the brushwork.

The same elements are found in another smaller painting called *Landscape and Pitcher* (1985) which actually preceded the larger painting just described. The smaller painting reveals more of the pitcher's shape while the angle of the interior spout is turned slightly more upward. Again, the pitcher's opening is pear-shaped in relation to the white tablecloth and points toward the landscape situated at the top of the painting. In this case, the landscape elements are positioned on a curve that seems to echo the graceful shape of the spout. The direction of these elements are essentially moving toward the upper right of the painting, but then fall short enough so as to bring the cycle of pictorial movement around and back to the pitcher again.

In a watercolor diptych called *Orvieto Romance*, one can see the transition between *Landscape and Pitcher* and the more developed painting *What You Saw When You Leaned Forward*. On the left side of the diptych one gets an expansive view of the Orvieto hills simply painted in soft ochres and blues. On the right side is the familiar motif of the pitcher on the tablecloth again. The tablecloth is broken not by a curved edge but by an angle. Also one sees a patch of sky in the upper corner of the landscape, reiterating the bluish glaze of the shadow on the table below.

In all three versions, the overhead angle of the pitcher is approximately the same. Its counterpoise in relation to the earth tones of the landscape is also the same. The flattening of the space through obverse perspective is a third characteristic that the three works share. Perhaps the most original quality about these paintings is the emphasis Janowitz has given to the tactile structure of the surface coupled with the use of contrasting elements of shape and space suggestive of erotic significance. Characteristic of the majority of these recent paintings, Janowitz's eroticism is overtly simple in pictorial terms. It succeeds through a convincing sense of optical intimacy. One may recall the famous essay by Ortega y Gasset, called "On Point of View in the Arts," in which he describes the metaphorical sensation of the eye making contact with the surface

Joel Janowitz, *What You Saw When You Leaned Forward* (1986). Oil on canvas, 84 by 60 in. Photo by Dorothy Zeidman. Courtesy Joel Janowitz, Victoria Munroe Gallery.

of the painting. For this sensation to occur, the plasticity of the form and space must come alive, so to speak. The relationship between form and space in Janowitz's work carries erotic feeling because of this optical contact that one makes with the surface and because of the clarity of tension that exists between the discrete patterns and shapes contrasted through the implications of light

that define the elements of the picture as visual metaphors, as a narrative description of an event, a passing of time.

Janowitz shifts and realigns his still-life motifs with an assortment of landscape vistas. This process of perceptual realignment is always connected to his structural intentions. Just as postcard manufacturers will replace a sky of cumulus clouds over a desert landscape with one of clear blue in order to intensify a dramatic effect, so Janowitz will shift one plane of a table, for example, so that the view of the valley equalizes the tension on the top half of the picture plane. Compare, for example, a 1985 version of *Blue Table* with another painting from a year later called *Green Table Blue*. In the earlier painting, the landscape of the valley is lush, green, and accented with a patch of ochre light. In the later painting the same table is situated in a similar way in the lower half while the upper half has been replaced with a textured shadowy blue, evenly applied from one side to the other. Also, in the second painting, the height of the table is slightly raised on the picture plane so as to meet the horizon on the middle ground of the picture. The inevitable result is, again, one of ineluctable tactility that spreads across the pictorial field and reaches the eye directly and without equivocation. The tactile experience allows a certain poignancy with the surface imagery, a certain pleasure in the recognition that the material which constitutes the image is directly applied and aggressively meets the optical gaze halfway. The connection that is made between the viewer's gaze and the physical substance of the work is a kind of rendezvous, yet without the constraints of puritanical secrecy. The sum of these Italian pictures — mostly painted after the fact in his New York studio, though based on sketches done on-site — is an arcadian tension and balance which, in itself, serves as a metaphor for our viewing experience.

This statement recalls the works of another painter: Matisse. Yet contrary to the more abbreviated and bold textures of Matisse, Janowitz is less involved with the primaries and secondaries. The textures in Janowitz's Italian paintings are derived from the light and dark tones of earth colors. This gives such canvases as *What You Saw When You Leaned Forward* or the two-panel *Inside and Out* a sense of earthiness that is neither ethereal nor extravagant. These paintings are severely "grounded" in the perception of their subjects. Even though the parts in relation to the whole are constantly being shifted around, given new syntactical meaning, there is a logic of perception that is based on actual information and direct experience. In both paintings, the components have been altered to focus attention upon the internal function of the specific composition as well as its narrative mood. The essential tension of the relationship offers a convincing reference to what the artist actually observed.

Inside and Out is based on two discrete observations and two diametrically felt experiences. Still there is a complementary aspect to the painting's discourse. The inside table with the bowl and the book, observed from an obtuse overhead angle, suggests an obverse component, a threatening road

with distorted perspective and an imposing dark cypress tree looming up in the foreground. Even in a painting as psychologically provocative as *Inside and Out*, there is never the slightest hint of existential futility.

With Janowitz's new work one senses that even in the most threatening circumstances, there is a power of transformation, a visual realignment that may open the doors of desperation to reveal another kind of vista held in a kind of arcadian suspension. The Orvieto Valley apparently did this for Janowitz. The Italian countryside that is situated beside or around the still-life arrangements offers richness in texture and contrast of meaning. The tones of dark and light, persistently defined and assured, are always fiercely alive. When he includes the human figure, as in *Sarah* and *Notes*, the tight perspective offers an intimacy and an insight that emerges through a carefully arranged formal vocabulary. The fact that these devices work so well, over and over again, in their various, shifting contexts, is as interesting as it is elusive. One gets the impression that in spite of their looseness and their boldness, these paintings hold a good deal of reflection about them, the kind of reflection where every stroke represents a structural entity that cannot be left alone without the full support of the others — and then some.

14

Collage Environments: *Rauschenberg Photographs* (1982)

One may indeed wonder why Rauschenberg felt the compulsion to have the assortment of photographs that make up *Rauschenberg Photographs* printed as a group of unique individual pictures. As a collage artist, whose works are fraught with hybridizations of visual sense data, including found objects, textiles, clay, ink, and paint, Robert Rauschenberg has used photographic imagery from borrowed sources with increasing redundancy over the past two decades.

Prior to discovering his predilection for photo-images in magazines and newspapers, Rauschenberg dealt directly with hard materials — that is, junk from the streets, road signs, tires, old mattresses, construction materials — actual three dimensional things, formal flotsam and gestural jetsam. His rather ingenious and subtle method of brushing, splattering, and dabbing paint around and upon these objects gave a much-needed lift to the spirit of American art during the late 1950s, a period when Abstract Expressionism — or "A and E," as his former Black Mountain instructor Josef Albers used to call it — was on the wane. Too much paint had spilled off the edges; drips and splatters were becoming too academic. But here again Rauschenberg came to the fore with his brilliantly conceived duo entitled *Factum I* and *Factum II*. By now his obsession with newspaper media was coming into full view. By the mid–1960s, America's golden boy of the avant-garde had moved from the paint-splattered *objet trouvé* toward the realm of readymade images — the world of photo-repros transferred directly to canvas. What fun! Simply take an image — any image, but preferably a politically or commercially loaded one — then repeat it several times, giving it a slight alteration, a new twist. Pick an image on the run, a news event, a candid shot of someone or an absurdly posed portrait, such as the negligible subject used in his sardonic mockery of Dante's *Inferno*: change its position on the surface, give it a new swatch of color, then on to the next.

It is difficult to look at Rauschenberg's photographs free of past associations — although, according to some vague phenomenological method, that is exactly what the viewer is expected to do. On the one hand, we are supposed to see "the presence of imagery that has made him known as one of the most

important and original creative artists of our time." Given a second encounter, we are asked to consider the photographs as "the most direct communication in non-violent contacts"—a statement made by the artist himself. But what does it *mean?* The implication has something to do with optical lovemaking; to be detached from your subject is better than being involved. Intimacy is apparently not a condition of direct involvement. Herein lies the inherent conflict in Rauschenberg's photography. As long as the subject remains formally distanced from the player's eye, it can be freely manipulated. This accounts for the success of photo-imagery in some of his printmaking endeavors, for example, but again, it is the precise reason why his own photographs as subjects unto themselves have difficulty breaking through the rigidity of the photographer's calculations.

It is not surprising to find that in a much too obviously abridged and cosmeticized interview transcription, the artist eulogizes the transitory essence of photography while abnegating his concern for "perfection"; thus, he echoes all the right statements made several years earlier by his theoretician friend John Cage. Of course, lack of perfection is neither new nor particularly revolutionary, especially give the art history of photography over the past two decades; but, in the case of Rauschenberg, by making it into an issue, he comes off as hedging: "Sometimes you make all the right decisions and sometimes you can only be either right or very wrong, and sometimes the wrong makes just as interesting a photograph as being right."

But why does perfection become an issue? Rauschenberg's notion of perfection seems related primarily to the act of seeing, while for the interviewer the implication is toward technical perfection as if some sort of absolute adherence to the zone system, for example, was a form of monotheistic measurement for determining quality pictures. Rauschenberg falls into the trap by elucidating on the virtues of darkroom time as essential to the craft. Yet, for Rauschenberg, the issue has very little to do with perfection, either in optical or in chemical terms; rather the issue has something to do with commitment to the medium. One may sense that something is amiss with regard to the artist's orientation to photography. Of course, there are numerous artists — many Conceptualists, for example — who *use* photographs in their work. But with Rauschenberg, there seems to be a pretension that he is a truly accomplished photographer — among other things — and therefore deserving of a place in the annals of photographic history.

In a rather terse introduction by Pontus Hulten, we are told that Rauschenberg was a photographer before he became a painter — the implication being that the artist has had a history of involvement with the medium, and therefore we are not to take these images as peripheral to his main body of work. Hulten further alludes to "a rigorous yet flamboyant sense of design, pictures in which art and real life coincide." This statement easily reinforces the artist's famous rationale as spoken some years ago that he is trying to close the gap

between art and life. A nice rationale — but more appropriate to an artist such as Yves Klein than to the golden boy of the 1964 Venice Biennale.

The book *Rauschenberg Photographs* (New York: Pantheon, 1982) is divided into two sections: those photographs made between 1949 and 1965, roughly from the outset of his career to the time of his coronation by the international art market, and those made in 1979 and 1980. From a documentary point of view, the two sets of photographs curiously reveal the sensibility of Rauschenberg the collage artist on the one hand and Rauschenberg the printmaker and set designer on the other. From a critical perspective, the earlier prints remark upon a quality of seeing through a less pretentious mode of selectivity than is evidenced in the later prints. It is, in fact, this pretense toward selectivity — or better, the institutionalization of "chance operations"— both in terms of subject matter and composition that aborts the possibility of any genuine vision in the recent images.

Ironically, the images obtained in 1979-80 possess qualities of articulation, resolution, and contrast, which may testify to a more sophisticated lens and camera apparatus. By these standards, they are, of course, "technically" superior. Yet it is for the same reason that the earlier prints are much more interesting as photographs. Not only do they document artist-friends, such as Merce, Cy, and Jasper, struggling to establish themselves within their creative settings, but they also possess a semblance of dedication and commitment to the medium of photography. Not that dedication and commitment to a medium will necessarily insure superior pictures, but at least such traits provide an essential grounding whereby one may then accept or reject its inherent properties. With Rauschenberg, it is not clear that the ground exists.

As far as the later photographs are concerned, if the artist fears a propensity toward perfection in photography, he need not worry about it any further. As stated earlier, these photographs are "perfect" beyond belief. Nothing appears accidental; everything is posed meticulously, frozen in space. Nothing moves — in spite of Rauschenberg's testimony that he would like his photographs to display "a confirmation of the fact that everything is moving." One may scarcely recall an artist's statements working in such dire opposition to what is visually apparent! What might appear as a rare chance encounter by artist-photographers, such as Robert Frank, William Klein, or Lee Freidlander, is transformed into a paralytic confrontation by Rauschenberg. The objects and portions of objects fastidiously cropped are posed to perfection. What is revealed, in addition to perfect composition and tonality, in these later pictures is an equivocal Romanticism that suggests a paradoxical containment of emotion. It is actually quite remarkable how abrupt the differences appear between the later and the earlier work. What Hulten refers to as "primal energy" in Rauschenberg's images does not occur in the 1979-80 works; the feeling is, at best, a formal stasis.

So the problem is not one of technical perfection, contrary to what the

interview suggests. It is simply an ambivalence about the medium. The medium is more than a technical reduction, more than talk about lens, shutter, and chemicals. There is a particular relationship in photography between the one who photographs and the subject which is photographed. Certainly there are artists who use photographs and artists who use the camera for other than empirical purposes. Undoubtedly Rauschenberg at his occasional best has *used* photo-imagery in his various multi-media works. The difference between using a camera or photographs for other purposes and actually making a singular photographic print — to carry its own meaning apart from exterior structural claims — is that the former task requires no specific commitment to the image other than its operation within a theatrical, decorative, or conceptual context.

In most conventional photography, it is difficult to ignore subject matter and difficult to ignore the emotional content that subject matter is bound to incite. Yet, with Rauschenberg, everything in front of the camera appears more or less neutral. For some artists working in seriation or sequence, this condition of "neutralization" is significant, as in the earlier books of Ed Ruscha. In Rauschenberg's photographs, "neutrality" is more a symptom of wanting to move outside the frame, to transform the photographic image into an abstract sign as in his early silkscreen paintings (1962–64). Yet, concurrently, he wants his photographs to signify the allure of multimedia and theatricality. When Rauschenberg's photographic images remain neutral and are placed within the context of paint, objects, constructions, and silkscreened images, they are more likely to succeed. Their neutrality is transformed into abstraction. The problem with the 1979–80 photographs is that they are trying to stand on their own as photographic prints and, as a result, rarely move beyond the appearance of artful documentation. Rauschenberg is at his best when he lets go of the photograph as a self-signifying object and allows its content to function freely and abstractly in time and space.

15

Sol LeWitt's *Geometric Figures and Color*: The Politics of a Portable Art (1980)

Sol LeWitt's books are predicated on specific syntactical constructs expressed as visual signs, thus revealing a substantial variety of modular equivalents. His most effective books, such as *Geometric Figures and Color* (Abrams, 1979), are those in which the signs are congruent and metaphorical, matched through language. There is a certain intrigue about the system. To resort to Peirce's semiotics, the visual components in *Geometric Figures and Color* function on the iconic level of appearance, but there are other indexical and symbolic modes of interpretation available as well through the numerical permutations of the color-shape coordinates. These color-shape coordinates are, in fact, the direct iconic assimilation of visual information which we experience directly as form and content through a serial progression within the structure of the book.

The subtitle, *Circle, Square, Triangle, Rectangle, Trapezoid, and Parallelogram in Red, Yellow and Blue on Red, Yellow and Blue,* establishes a dialectic between the objective language and its nonobjective visual form (in one sense, close to the earlier experiments of the Russian Formalists). Through this dialectical encounter, the reader/viewer (conceptual inquirer) discovers that there is not a dominance of color theory over serialized interpretation; that is, the structure of language and color functions interactively and temporally as a unified whole. As the subtitle reveals, there are three equally visible, color-coded sections: the first, "On Red," the second, "On Yellow," and the third, "On Blue." Each of the geometric figures in the title advances in the order given; thus, the viewer may apprehend the color relationship of figure-to-ground based on the foregoing knowledge of what geometric figures are expected to appear. The sequence of figures is planned so that the same order follows in each section. It is the color that startles the viewer's expectations (even though the grid-sequence of each progression is clearly stated at the front of each section as well as a total grid-composite listed at the conclusion). The

128

color shapes are not intended to trick the eye into some type of illusion about one color in relation to another; this was more in the domain of Albers' book, *Interaction of Color*, which has no direct connection to LeWitt's concern for the physicality of color as it relates to primary shapes.

Consequently, LeWitt's images are not involved with value changes, but with shifting expectancies in terms of figure to ground. The permutations are clear, the rules are set, the variables have been delimited clearly at the outset; nothing is violated. The system is investigated within its given parameters. The viewer may be delighted or surprised, but certainly not shocked at the resulting configurations.

It is the simplicity of its literal schemata that may lend *Geometric Figures and Color* an edge of controversy. Undoubtedly there was some editorial input as to what the market for such a book might be. For example, in its present state, one might take it for a Montessori primer. Hence, the question is raised as to its pragmatic use, as, for example, in design education. What happens to the ideas after the educational system has placed them in a curriculum? Can the ideas be carried through as art without distorting their original significance? Albers, in fact, confronted this very problem in relation to his own "Conceptual" color experiments. His resolution was to declare what was practical and research-oriented in contrast with those paintings or prints designated as having their own significance beyond the dimension of utility. LeWitt, being a Conceptualist, cannot declare his books as illustrations of original art; the point is just the opposite. The books are the art. Still, the confounding problem is what to do with them given the fact that they border on the appeal for practical use. Can they be applied and still retain meaning?

The decision for an artist of LeWitt's stature to enter his work into an expanded commercial market does not seem at all unreasonable. The fact is that both pitfalls and obvious advantages exist in accepting this privilege. One advantage is the possibility of expanding his audience beyond the domain of pure art into other applied areas. Given the cultural lag that still occurs in coming to terms with visual things in the environment, LeWitt's *Geometric Figures and Color* may assist in awakening the visual sensory apparatus toward seeing shapes not only in terms of systems but also in terms of pleasure. Even so, the danger of trying to direct artist's books, even on a more commercial scale, to a wider non-art audience's that they may miss the mark entirely. People who are accustomed to thinking about reality in terms of quantitative relationships generally do not have a high tolerance for making qualitative leaps into the domain of purely aesthetic pleasure. This is true not only in the natural sciences and applied sciences, but also in the social sciences. Again, it was Albers who used to qualify his paintings as metaphors of social interaction. LeWitt's book does not function quite the same way. Metaphor is simply not an appropriate vehicle for coming to understand the literalness in LeWitt's conceptualism.

Generally speaking, LeWitt's theory of art is embedded in a linguistic system which achieves closure through visual execution. In his more abstract, non-objective books among which *Geometric Figures and Color* can be included, the system unfolds through time; that is, the seriality is literally bound into a book; the system is contingent upon how one reads or looks through the book. The struggle for a new readership outside of the recognizable art world is partially a task of transforming the way our culture tends to approach visual books. Given LeWitt's linguistic schema, his books are simply not pictures in the abstract, but pictures which have a language counterpart. *Geometric Figures and Color* is concerned with a visual-verbal interaction, a complicity, a lamination of one against the other. If politics can be defined as an organizing principle that governs actions and influences behavior, for better or worse, then the impulse to revolutionize book design and book utility may indeed be a profound and subtle political maneuver.

Books have the potential to function politically without being about politics. They may be about the perception of a new organizing principle. The manner in which that principle governs actions has more to do with the readership than with the book itself. The interesting aspect of this argument is that the artist's book presents the reader/viewer with the opportunity for a correspondence. It is, perhaps, one way of getting at the heart of cultural progress, of finding a fusion between the technological world and the world of intimate understandings of ourselves and one another. In *Geometric Figures and Color* one is aware of enjoying cyclical permutations as they arise from language, permutations of thought as they transform themselves into pure visual signs, even at the most fundamental levels of thought and perception. Thus, primary shapes take on a social meaning through their active induction as formal design in a culture that needs the reinforcement of language awareness, probably as much as animal diagrams were needed as a basis for hunting and survival in the caves of Lascaux.

16

"Painting Advance/ Stamm 1990" (1989)

"I am interested in making a work which is read as a totality in its situation and remains confrontational by perceiving its nature and installational effects upon the actual exhibition space. This is achieved as described. The installation insures the implied extension of the work's elements and implies a relational weight to the floor. These works have maintained their frontality and the inherent materials of painting (support, canvas, paint), because it is here where I feel my research can extend the language and possibilities of painting."

—Ted Stamm (1944–1984),
"Statement of Plans" (undated)

I became acquainted with Ted Stamm in the summer of 1981 while attending a dinner party in a mutual friend's loft in lower Manhattan. His paintings were vaguely familiar at the time. I had seen a work of his the year before in Princeton, and recalled its utter completeness, its fundamental refinement, and stark elegance. Meeting Stamm came at a time when the reductivist position in New York painting had nearly vanished. The outset of the 80s represented another tendency; the epithet of the day was "Maximalism." The issue in painting was no longer how little, but instead how much. Very few artists, and fewer dealers, were interested in its former opposite. With the heavy influx of European Expressionist styles, augmented by such exhibitions as "Bad Painting" at the New Museum and "New Image Painting" at the Whitney Museum of American Art in the late seventies, Minimalist aesthetics were fading.

The reduced statement in painting, with very few exceptions, was struggling to maintain a position. Those artists who had established a reputation in this genre during the sixties and early seventies were continuing to show work on a regular basis. Younger painters who had not secured a reputation earlier were having a difficult time.

It was within this recent historical context that I came to know Ted Stamm and to appreciate his work. It was also within this context that I came to under-

stand the kind of commitment and personal strength required to maintain an "outsider" position when the art market takes an abrupt shift. I perceived in Stamm's paintings, and later in his discourse, an extraordinary energy, a dynamicism that is rare among artists in postmodern times. He insisted that his work was not about Minimalism. He preferred the term "reductivist." Again, from a historical vantage point, the latter term is unquestionably more appropriate; and from a practical viewpoint, it was clearly shrewd and necessary to avoid ambiguous references which might imply imitation.

In spite of his obvious allegiance to Ad Reinhardt, and to a nearly equal extent, Barnett Newman, Ellsworth Kelly, and early Frank Stella, Stamm allowed his paintings to progress in a more personal direction. The term "formal" is not misleading, but the label "formalist" clearly is.

Formalism suggests that the content *is* the form, whereas with Stamm the linkage between content and form was more intertwined with references to industrial imagery and media culture. One can perceive these linkages most evidently in his later series of works, the "Dodgers," the "Sliders," and the "Honeycombs." The individual paintings have abbreviated titles, such as *CDD-002* or *SLDR-001*. This kind of abbreviation, which in some cases has rather arcane references, suggests a systemic underpinning in Stamm's work. I recall on one occasion his delight in receiving a sequence of "I got Up." postcards from the systemic Conceptualist On Kawara. The fact that Stamm de-emphasized any quality of brushwork or any reference to gesture or personal touch is not happenstantial. It begins with Duchamp, of course, and carries through most of the early conceptualists, some of whom were also directly inspired by Reinhardt's endgame aesthetics. The titles and their corresponding works also manifest certain industrial design processes and packaging methods. There is an outright efficiency about the way Stamm "finished" his paintings. Any extraneous mark was anathema. He was interested in the mute presence of the thing — how it looked and felt upon first glance. The methodology was clearly industrial in concept, and eventually it was going to become industrial in its realization. One of the last projects on which Stamm worked was a series of "Honeycombs" which involved sending out specifications in order to have the corrugated aluminum shapes cut and assembled.

Stamm claimed an interest in "frontality" — that is, how one dealt with a painting in its most economically visual state within the context of architectural space. He was concerned with the initial instant of confrontation as the viewer approached the work for the first time. Given the more successful formal strategies used in paintings such as *ZCT-002* (1982) and *ZYR-4* (1980), the interior black shapes subvert their structural support. This is a crucial aspect of Stamm's evolving maturity as a painter, beginning with the "Dodger" and "Zephyr" series of 1977–78.

In *ZCT-002*, for example, there is a tension made visible, a hint of acceleration held in check by a long and a short horizontal black bar. This tension

Ted Stamm, *DGR-42* (1977–78). Oil on canvas, 43½ by 113 in.

gives a visual effect which has little to do with painterly mystification; yet it is also considerably more than a retreat to predetermined perspectival gimmicks. Stamm worked out his ideas on graph paper sheets initially, but then in the process of upscaling his image, often changes and adjustments had to occur. Any pretense toward perspectival mani-pulation became coincidental and occurred within the process of the work. The visual and formal tension in *SCT-002* functions in relation to three basic factors: 1) the interior hard-edge image painted on raw canvas, 2) the structural support of the canvas which functions as a contrasting element in relation to the image, and 3) the perspective achieved through the placement of the painting close to the floor in an attempt to associate its visual references with the surrounding architecture.

Stamm's evolution and development of these basic concerns occurred with a series of eight drawings he completed in his Wooster Street studio in 1978. These drawings would eventually become known as the "Wooster" series. They were each permutations in which a diagonal line was abutted to a square. The connection of the diagonal line to the side of the square created a new polygon which the artist emphasized and delineated by painting three of the four sides with a thick black line. (In later modifications of this motif, Stamm used aluminum paint as well.) In the "Wooster" series he defined the painting in linear terms almost to the point of giving it a sculptural connotation. As the drawings were transformed into paintings, most of the interior space was translated as raw canvas. There was a slight suggestion of dynamic presence in the "Wooster" series, but the power of the square module held any further implication of motion in check.

At an exhibition at the Clocktower in 1981, Stamm showed a very large rectangular canvas titled *R-1,* which was situated horizontally and hung no

Ted Stamm in his studio, Wooster Street, New York, 1983.

more than two or three inches from the floor. Flat black pigment covered nearly the entire surface with the exception of two areas cropped in the upper left and upper right corners. The dominance of the image offered a mute presence which the two diagonally cropped corners helped to accentuate. There is a stasis about *R-1* that predominates, a stasis that was also given to the earlier "Dodgers" and "Zephyrs." Yet in spite of the muteness of *R-1*, one can see the

artist's involvement with contrasting image and frame, and how both are inextricably tied to the architectural context. The painting is "grounded" in such a way as to cue the position of the viewer's gaze as it moves across the rising floor plane and meets the baseline before ascending upward and upon the mute presence of the painting. In this kind of situation, the painting confronts the viewer in a special way by extending the gestalt principle of the spatial field from object to planar surface.

Yet this maneuver in itself is not the major achievement that I understand in relation to Ted Stamm's short career as a painter. The following year, after the Clocktower exhibition, Stamm began to concentrate intensively upon a new group of paintings for his 1982 exhibition at the Harm Bouckaert Gallery. During this highly energetic, productive interval, Stamm produced some of his most noteworthy work. The aerodynamic, high-speed metaphor reached a new level of visual fruition in paintings such as *ZCT-002*, *ZCT-004*, and the profoundly elusive *CDD-002*. These paintings are noteworthy because they transform the explicit muteness and the metaphysical stasis (not to be confused with "mystification") of the earlier "Dodgers" and "Zephyrs" (1977–80) into a new kind of kinetic voyeurism. *CDD-002* is a fully streamlined painting, elongated, close-to-the-ground, hovering in space before our gaze. The metaphor is speed, light, and industry. There is also a reference to popular culture, hot rods, and sleaziness. Perhaps, most significant of all is how far Stamm was able to refine his intentions. In so doing, we are left with a painting that nearly works as a machine. It is so perfectly contained, yet so capable of projecting itself beyond itself. In this way, *CDD-002* acts as a metaphor of space-time on the brink of science fiction. The form is complexly integrated, an invented form, in which the interior components deflect our recognition of the physical support system. And never do we lose sight of the painting's material substance or its paradoxical hygienic awkwardness. The ultimate effect is not so much a "floating" sensation as it is a taut pictoriality suggestive of acceleration. It represents a view of the fourth dimension.

Shortly after the Bouckaert exhibition, I received a postcard from the artist painted black with a silver stamp which read "Painting Advance/Stamm 1990." Just as the paintings from the last two years, including one year of a Guggenheim Fellowship (1983–84), came to represent a personal position about painting despite the powerful resurgence of Expressionism, so did this phrase come to suggest a possible leap, a metaphysical acceleration toward the next decade, an impossible idealism made possible by thinking far enough ahead. Ted Stamm's last paintings suggest an adaptation of human perception while moving at high speed. Their momentum breaks free from conventional religious attitudes toward gravity, once held sacrosanct in Western painting.

17

John L. Moore (1992)

The invention of an arcane symbolism or an autosymbolism in a painting is one the most significant attributes of the *fin de siècle*. The search for meaning has once again proven worthy of art, and that meaning is about far more than the empty gesture. In the recent paintings of John L. Moore at SoHo's M-13 Gallery one may get the sense that an exigent personal vocabulary has accumulated over many years and is still in the process of refining itself. It is a process of abstraction in which the artist is perpetually defining himself through a specific vocabulary of forms. Moore's attitude toward abstract refinement is not merely formal. It is expressive and deeply psychological. One might appreciate a certain lingering cultural trace in Moore's work — the trace of a sub-cultural heritage in relation to a dominant white power elite. Perhaps this is projecting a message onto Moore's formal intent, but I think not. I read these new paintings as provocations towards a new awakening, a new language that seems to diffuse the problematic aspect of American large-scale painting since Abstract Expressionism. I am referring to the involuntary schism between formal issues — as in Color Field painting — and Expressionist values. With Moore's work it is nearly impossible to make this distinction. To express an idea through an abstract configuration of shapes and surface textures is more complex than designing the placement and juxtaposition of stylistic nuances. Moore's paintings express deep personal emotions, and the weight of that expression has something to do with an internal struggle — a struggle to resolve a sense of identity within a conflicted cultural situation.

Discussions of recent painting — particularly abstract painting — often avoid issues of content other than on a purely theoretical level. The emotional weight of a Moore painting is not related to the work's physical assessment. (This would better apply to the early assemblage paintings by Julian Schnabel!) Rather, the weight in Moore's work — or the feeling of weight — arrives out of necessity. Put another way, there is a heaviness to the content that engages the viewer on an experimental level. The emotional weight of the content bears down on any notion of a superficial formal device. The weight of a conflicted personal situation subsumes the struggle of the artist in search of his own resolve within the domain of abstraction.

John L. Moore, *First Vertical* (1990). Oil on canvas, 80 by 68 in. Photo by Dan Dragan. Courtesy John L. Moore.

There is a curious aspect to Moore's painting in that it defies the delimitation of early Color Field painting by attending to the figure/ground elements. Since 1987, these elements have taken the form of large black ovoid shapes. Often these shapes overlap one another. They collide and reconfigure as if to imply that there is something behind the surface. This figure/ground conflict or coherence almost appears regressive, yet it is precisely this sense of going back into the tension of an illusory space that gives the ovoids their formal tenacity.

The content is largely attributed to how deftly this maneuvering is handled. Two recent paintings, titled *2 Blacks* and *First Vertical*, exemplify Moore's formal ability. Both paintings present a collision of shapes, a congestion, in fact, where the space is purposefully delimited. The congestion is heavy. It is both tense and intense. The power of the pictorial void is evoked within the spacial density. The painterly ground consists of a repetition of linear striations representing the sky. (The technique is reminiscent of the late nineteenth century Norwegian symbolist Edvard Munch.) The allegorical and narrative potential in Moore's painting is considerable. There is little defense for a pure Modernist aesthetic in these works.

In lieu of purity, Moore's paintings deal with the referential aspect of abstraction in everyday life. The artist represents a position of conflict and of being in a situation of semiotic chaos. His paintings portray the turbulence after the storm, yet they also offer a warning of another turbulence, another overthrow of purity — the kind of purity that modernist abstraction came to accept and finally had to devour. Moore devours Modernist purity the way Saturn devours her offspring. All the formal elements are in place, but they are in the process of being transgressed. Moore does not proceed in the obvious way by attempting to achieve a formalist resolution, but moves according to the subtle placement of shapes. He gives an attentiveness to painting by being aware of the cultural history to which it lays claim. In so doing, he maintains enough distance in order to move directly into his own process of meaning.

18

Catherine Lee: *Thirds* (1981)

The painting *Thirds* (1980) by Catherine Lee (formerly Catherine Porter-Scully) is enigmatic because of its embedded lyricism within a loosely defined group of reductivist hard-edge shapes. *Thirds* is not a "flat" painting in the literal sense. The oil pigment is neither stained into the fabrics nor flush with the surface. Instead, the brushstrokes have a relief quality. Each rectangular dab of unthinned paint is slightly raised at the edges. The force of the brush is clearly apparent.

Three rectangular divisions appear within a six-foot square. Each division or surface area can be identified according to a systematic application of a mixture of unmodulated pigment. A vertical rectangle composed essentially of cadmium red deep and alizarin crimson occupies the right third, while two lateral rectangles in white and ivory black occupy the left two-thirds of the canvas. The application of each pigment involves a rhythmic system once the dimensions of the stroke have been established in direct ratio to the surface area of the rectangle. Although a system is employed by Lee, it is not apparent upon first seeing the work from a distance. These deceivingly simple divisions of form and color are, in fact, built upon a complex structural interaction of ratios and proportions.

What distinguishes *Thirds* as a painting is not so much the rejuvenation of a hard-edge Constructivist motif, but the invention of a controlled gestural process which confounds a clearly reduced grouping of color shapes. *Thirds* actively displays shapes within shapes. The artist sets up a necessary tension between the conceptual aspect of painting and its purely corporeal appearance. There is an absolute quality about the three shapes, an undeniable persistence about them. One is reminded of Cézanne, who clearly established geometric perspective within the act of seeing. Perception of the external world was commensurate to the interior vision once the spiritual synapse had been located through the gestural act.

The geometry in *Thirds*, however, is unrelated to the external world of direct significations. Here the surface and lyrical application of the paint are recognizable within each stroke — analogous, perhaps, to the construction of a deliberately crude vessel. Although consciously placed, each stroke appears

uneven. The stoke holds forth as a unique modular plane which has evolved through the artist's self-determined action. Each stroke builds through repetition a sequence which, upon completion, becomes one of 48 horizontal rows within a given area. The application of pigment in *Thirds* provides a contrast to Cézanne's composition and to Pollock's overall rhythms, yet it is conceived on the basis of understanding these nuances. Lee applies pigment systematically upon the surface, composing her field by weaving modular dabs in progressive rows, back and forth, over one area at a time; her vision is totally inward.

As with the *de Stijl* painters, geometry frees the artist to find a lyrical sensibility without forcing her intentions. Each pigment holds properties of its own. The cadmium applies differently from the white, and the white applies differently from the black. The formal concerns in her painting are phenomenological to the extent that the focus registers a trace of each action. At the same time, the image field is consciously suspended and held apart.

In viewing *Thirds*, one may grasp a heightened sense of the action upon the surface, the substance of being there with one's mind and body, the knowledge that painting has its own reality, its own pleasures and ideas, and the assertion to act purposefully upon one's own vision. In *Thirds* there is a freshness that allows ideas to determine form and thereby to reveal the process of human intelligence as a palpable and physical substance.

SECTION V.
PERFORMANCE
AND INTERMEDIA

19

Blue Man Group: *Tubes* (1991)

With Blue Man Group a new hybrid emerges between painting, theater, music, and opera. For the audience that witnessed the performance (La Mama, New York City, January 3–26, 1991), it may not have looked much like opera given the mannerisms of the three performers — Matt Goldman, Phil Stanton, and Chris Wink — but indeed there was a resemblance. The operatic motif had much to do with the mixing of media, perhaps the complete resignation of the tools of the trade to a kind of Wagnerian potpourri, a *Gesamtkunstwerk*. "Tubes" had a kind of beauty to it, an auratic spectacle that shimmered in its own tragic/comic making. There was a certain lavishness and alertness about the performers in spite of the slow routines in which they engaged, each accompanied by drumming.

Tubes was a journey into the hyperreal as much as the surreal. It took the audience outside the normal routine of mediated hallucinogenic reality — that is, the mass media spectacle — and into the realm of psychic distortion, but within a sci-fi milieu. The performance was fastidious, yet also raucous at times. Tubes — actual plastic tubes and hoses — were not only suspended from the ceiling of the theater where the audience sat, but were embedded throughout the stage props, including within the tight-fitting costumes of the Blue Men. The performers seemed obsessed with tubing throughout the performance as they indulged narcissistically in various forms of scatological behavior. They seemed obsessed with the absurd.

I was warned before I went to this performance at La Mama that Blue Man Group was the closest thing to evolve in recent performance art to the work of the Kipper Kids in the seventies. I found this to be a superficial comparison. What was striking about Blue Man Group was the quality of their performance. In fact, it was truly about performance, about the act of performing, not simply about making actions or doing trite mannerisms for the sake of conducting a ritualized spectacle. The operatic sense of *Tubes* was in the timing, the precise episodic movements of the three performers in relation to the visual phenomena, which included squirting pigments in red, yellow, and blue

(like De Stijl with diarrhea) from the bodies of the Blue Men. There was a peculiar sense of subdued evanescence in their quirky mechanistic gestures, reminiscent of "Invaders from Mars" or other fifties features that represent a bygone era of science fiction in cinema.

Tubes was a little less than outrageous, but it was very entertaining. The work included a certain amount of audience participation where, in fact, people were actually pulled from the audience to go up on stage and perform. In one sequence, a strange gooey substance was exuded from the chests of the Blue Men, who exchanged their individual varieties with one another and masticated the stuff with total, nearly euphoric abandon. Meanwhile, a female participant tried to copy their movements but ended short of actually eating the substance that was put before her. While it sounds terribly mundane, it was really quite funny. The acting was so carefully staged that the alien scatological meal carried some sort of weird significance, not unrelated to the actual fare being served at certain fast food "restaurants"; hence the hyperreal strikes back. The whole mood of *Tubes* was set at the beginning as members of the audience in the front rows near the stage were equipped with large disposable garbage bags to protect them from the array of nondescript substances that would be projected in their direction. One might say that *Tubes* was less metaphysical than metaphorical of the indulgence left at the end of the eighties when material goods were somehow not enough to carry the load of psychic rupture and disturbance.

20

Mimi Garrard Dance Company: *Walking on Gravel* (1990)

This collaborative multi-media dance project evokes a certain nostalgia for the kind of energetic output and excitement that one generally associates with the late sixties. There is an unforgettable presence about the work as one watches the interaction of movements emanating both from the figurative gestures and electronic lighting elements that operate in this performance. While Garrard sees the work as an interactive, participatory piece, she does not sacrifice the rigorousness of her choreography. Structure and improvisation play off one another, and it is this general theme that serves as the infrastructure for the content of the piece.

One may regard *Walking on Gravel* (University Art Museum, University of California at Santa Barbara, October 22–26, 1990) as a kind of urban metaphor. James Seawright, the acknowledged master of computerized sculpture, has provided a set for the dancers that functions in relation to the gestures and directional movements and does not hamper or obscure them. The piece consists of six dancers. Each of their roles is assigned to certain areas of the floor space. For example, there is a male clown figure who works in relation to a female tap doll. The clown figure seems to wander through the spatial arena between four other dancers dressed in white. The tap doll only moves according to a right angle that has been placed against two abutting walls. The sound of her shoes offers a profound rhythmic sensation to the display of fluorescent light fixtures that align the walls. The light fixtures are positioned in modular columns at even intervals. The computer program is designed so that the columns flash in rhythmic sequence, either as segments of the column or as a whole column. In addition there are floor lights at the base of each column resembling those used in a movie theater or jet airplane. This allows the floor space to become darkened. There are intervals in which the tap doll's shoes are lit so that we hear and see her movements in relation to the space.

The urban message of *Walking on Gravel* is reiterated with an audible

145

utterance from the tap doll who says, "It takes a big taste to make it in the big town." This repeated phrase is heard in relation to the movements of the other dancers, including the itinerant clown. At times Seawright has used projected images that fill the walls or the floor of the darkened space. These projections are often commercial signs that suggest a commercial environment, a billboard environment, in which messages inundate our optical nerves. There is a bizarre dissemblance, although not unpurposeful, between the staggering lighting effects and the projected slides, as if they are meant to disorient the viewer or the participant, if the viewer chooses to become a participant.

Another repeated element in *Walking on Gravel* is the sound of circus music. The urban metaphor is further complicated by the music so as to suggest a Fellini-style happening where chaos is only apparent on the surface. Garrard's and Seawright's collaboration implies that structure is not so much a hidden element in everyday life as it is revealed in particulars. When those particulars are distilled in the form of kinetic art one may begin to see life differently. Humor is not foreign to their message. It is an omniscient effect. There is something so sophisticated, yet so indelibly childlike about this form of dance theater as to connote the reification of a Paul Klee painting or, perhaps, an extension of Oskar Schlemmer's vision into poststructural times. For Garrard and Seawright the structure of the dance is merely a means to get beyond itself into the fringe areas of where we actually move, see, and think.

21

Todd Alcott: *The Users Waltz* (1990)

Over the last decade and a half it has become apparent that much performance art has crept into conventional theatre just as the experimental and underground film-making of the fifties and sixties has found its way into feature films. *The Users Waltz*,[1] written by Todd Alcott, a New York performance artist who specialized in humorous monologues, has proven that he is capable of managing a narrative script that really works. The four characters in this play are credible and the storyline has a certain slow momentum with plenty of interesting digressions to feed our perceptions of the characters' personalities including their inner ticks and mannerisms. Indeed, *The Users Waltz* is a story written for the stage. The fact that the story is about an artist — Art Brut, played by performance artist Paul McMahon — carries a doubling effect that is not altogether absent from peculiarity.

The story involves an artist and drug addict (who prefers to call himself a "user"), Art Brut, who is involved with two women: his not-quite-ex-wife, named Lil, played by Kathryn Chilson, and a presumably wealthy young card-reader, named Ana, played by Eloise Zeigler. The fourth character is a factotum named Mat who appears previously associated with Ana in a weird masochistic way. Alcott fails to make his lead character, Art Brut, convincing as a drug addict. McMahon's acting is not altogether different from his performing. (There is an important essay in Michael Kirby's *The Formalist Theatre* that discusses this distinction in general terms.) As Art Brut, McMahon plays a role of a sensitive, impulsive artist who is inevitably attracted to women who offer him unlimited ego sustenance. It is clear, for example, in Alcott's script that Lil is operating as Brut's mother — an attraction that the male protagonist does not recognize. Nor for that matter does he see his role in relation to Ana as the manipulated sap at the mercy of his repressed urges. The problem with the scenario is that the role of drug user is always a peripheral role, a ancillary role, compared to his other ego difficulties in relation to women. It is never apparent whether Art Brut is messed up as a result of drug abuse or disturbed in his inability to come to terms with himself as an equal

partner in a mature relationship. He does not seem capable of telling the truth about himself and coming to terms with his professional role as an artist. The vacillation that occurs as Brut moves from Ana to Lil, then back to Ana again, is not graceful. It is much too jerky to function as a waltz. The sources of his torment are much too obvious. Drugs may feed the absent ego as it strives to overcompensate with endless blind pursuits of independence in a typically Oedipal fashion. This postmodern revival of the complex at the end of the eighties is timely to a certain extent.

Whereas theatrical performance art tends to stress the literal uses of time, theatrical fiction emphasizes something else. *The Users Waltz* definitely leans on the latter but also pulls from the former. In addition to fiction — presented in a nearly Brechtian detached manner, wherein McMahon's deadpan cynicism really works — the play also has its moments of literalism where time is felt as a presence. This is especially true in the tryst encounters between Art and Ana. Curiously, it is less true when Art confronts Lil — and it always seems to be a confrontation full of defensiveness and an absence of communication. This is to suggest that the literalness of time is most felt in his escape from his male ego through Ana — or his attempts at escaping. With Lil, the entering into time makes the play function more as a drama. The reality of expressed emotion between Art and Lil — i.e., son and mother — pulls time inward into the realm of metaphorical fiction. In *The Users Waltz,* performance art becomes a type of simulated "soap opera" for the stage — a phenomenon fully consonant with a decade of such television spectacles as *Dallas* and *Dynasty.* The play unwittingly suggests a manner of relating that emerged in the eighties through the soporific impotence perpetrated by the commercial media.

22

James Tenney (1991)

One of the most curious aspects of contemporary avant-garde music is the extreme formality and structural rigor that exists in relation to many of the compositional methods. Clearly if one were to talk about modernist music, such as the works of Satie, Webern, and Schoenberg, as having formal properties in much the way that modernist painting depends on formalism as its *raison d'être*, one might see that much of the musical avant-garde is, in fact, music about music. Yet, even as modernist painting asserts its method as being essentially self-critical, it also allows for a kind of poetry to emerge through the compositional method. This "poetry" can also become the ultimate effect of good avant-garde music. Of course, it is beneficial and, in some cases, quite necessary to be informed as to the theoretical concept that supports the music. The mathematics of the concept is what the Fluxus (now anti–Fluxus) artist Henry Flynt saw as the basis of his "concept art" as early as 1961— the same year that James Tenney began to study computers (with Kenneth Gaburo) in relation to generating a complex randomness in musical composition.

What was particularly satisfying about the recent James Tenney retrospective concert in New York (Greenwich House, May 2, 1991) had a lot to do with the composer's versatile insight, his command of musical theory, and his ability to retain poetry in relation to abstraction. (What music is not abstract?) The retrospective spanned a period of almost twenty years. The earliest piece, which was energetically performed by Judith Gordon on the piano, dated from 1969, right after Tenney had left computer music behind. The latest piece, entitled *Rune*, was completed in 1988; this was its New York premiere.

James Tenney has been a major force in the world of contemporary avant-garde music for nearly three decades. As a disciple of early John Cage, Tenney developed his own musical agenda based on pitch and harmonics. The informative program notes, written by John Kennedy and Charles Wood, describe how Tenney evolved a theory of "harmonic space" by identifying certain "temporal-gestalt units"— the smallest possible units of perceived musical significance. These units operate as structural blocks or groups which the composer identifies as "clangs"; finally, the clangs add up to become "sequences," which are the most advanced components within Tenney's compositional hierarchy.

Rune (1988) was the opening work in the concert and was based on acoustic percussion in which a single timbre or instrumental type functions as the primary structural element. The six musicians interacted precisely in order to create a constellation of sound with a diversity quite distinct from the genre known as "phase music." In other words, the harmonic texture of the piece differed considerably from the evolving progression of sounds used by composers such as Steve Reich and Philip Glass. *Three Indigenous Songs* (1979) achieved a richness of subtle nuance. The instruments included piccolo, alto flute, bassoon, and percussion. The sense of haiku being written in time and space carried a certain transcendence as if the sound, though heard for an instant, were infinite in its resonance.

23

Daniel McIntosh:
Mindset (1987)

Daniel McIntosh, a young choreographer and member of Elizabeth Streb Ringside Inc., premiered a new work entitled *Mindset* as part of a series of dance works this fall at New York City's P.S. 122 (September 11–13, 1987). Other choreographers in the series included Donald Fleming, Benoit LeChambre, and Tina Dudek. McIntosh involved video monitors and music (by Arthur Russell) in his dance. Time was a major factor in terms of the heightened awareness one felt in relation to the movement of the solo dancer.

McIntosh wore a handsewn costume, designed by Allison Salzinger, which might have easily been mistaken for a Color Field painting by Frankenthaler. The appearance of the costume was not in vain, however, in that the colors seemed to coordinate in a mysterious way with the electronic bursts on the video monitors. This in itself was an interesting aspect of *Mindset*: the fact that clothing could somehow simulate the look of television.

For most of the dance, McIntosh worked with the monitor as an object that could be held and embraced and manipulated through gestural response; that is, there were occasions when the dancer simply allowed the color burst from the TV to radiate against his rather attenuated movements.

Oskar Schlemmer's Bauhaus dances were designed in response to industrial society; they were stiff, regimented, yet strangely lyrical, even humorous, at times. With *Mindset* the source of the dialectic is not industrial society so much as a further extension of the electronic, postindustrial age in which television images glut the imagination and transform viewers into narcissistic robots. Nonetheless, with *Mindset*, there is a bit of an internal critique. McIntosh never allows self-indulgence to gain control of the distance he has established between himself and the television. The dialectical contact persists throughout the choreography as if to suggest that stretching the body in response to television light may be the best motivation for beginning to deconstruct the impact of coded transmission.

One striking feature of *Mindset* was the physicality of time expressed in the movement of the TV monitor from one location to another in a kind of

horseshoe movement on the dance floor. The time of the movements was very gradual so that it obscured the dancer's movements. One tended to concentrate upon the flickering color bars on the raster pattern. The actual shift of location of the monitor from one place to another seemed as if the audience might have been on a revolving stage looking at the electronic flashes without noticing who controlled them.

In dance, the effect one gains from the timing of movements is essential to the experience. Whereas so much dance chooses to emphasize quick or frenetic movements, it is refreshing to see a dancer vary the pace with exact attention given to slowness as well as lightning agility. McIntosh's *Mindset* shows considerable promise and intelligence. I could not help but observe it as a work of art; crafty pretensions never entered into the experience.

24

MOCA: Mecca for
the Latest Art (1986)

Arata Isozaki's new building is both splendid and appropriate. It marks the culmination of a plan which began over seven years ago. With New York as the East Coast Mecca of the American and still to a large extent European art worlds, it was time that Los Angeles got into the act. It is peculiar in a way that a place with all that Hollywood glitter and cinematic indulgence would embrace such a spectacle as the new Museum of Contemporary Art. After all, the silver screen moves and most painting and sculpture is still static. According to some aestheticians, the spectacle of movement cannot be considered on the same high plane as that of static art. Hopefully, some of these stodgy academic attitudes, meant to defend the rigors of classicism, will fall by the wayside as audiences come to Los Angeles over the next year to view one of the best post–1940 art shows ever mounted. In fact, there is both static and kinetic art here. And certainly one's relationship to the new Isozaki building is as much a kinetic experience as any work of cinema.

To call the Isozaki building "Postmodern" is too easy. Yes, one can speak of historical references and cross-cultural nuances. One only has to contrast the pyramidal skylights with the vaulted dome of the museum's library and conference room to get some hint of Isozaki's configuration of signs. The historicism is perhaps more illustrative than concrete. The pyramids and the barreled· vault are not so much about Egyptian and Romanesque design as they are about how diverse primary shapes make sense in terms of how a museum of contemporary art is supposed to function. Isozaki understood at the outset that the interior space and appearance of the galleries should not compete with the formal and expressive equivalence of the artwork. Keeping in mind that MOCA was, in fact, a place to show and study and enjoy contemporary art, the architect refrained from indulging in heavy-handed classical structure. While the interior system of supports and ambient lighting, which descends from the pyramidal skylights (with some in the shape of elongated triangular rows of glass ingots) is meant to accentuate the character of individual works of art, the exterior surface of MOCA is less invisible and more given to decorative

explicitness. The use of rich red sandstone from India, combined with green painted aluminum panels, separated by thin diagonal rows of pink, is not as ostentatious as it might sound. The building complex is a tight nexus of shapes and these surfaces in red and green pull the Moorish diversity of parts together, thus giving the ambulatory experience of walking through the galleries a kinetic quality with subtle modulations and passages, occasionally extending into modular curves and cubistic alcoves.

Apparently Isozaki and his compatriot architect, Frank O. Gehry, who designed the earlier structure a few blocks away, affectionately referred to as the Temporary Contemporary, were asked to place the works by the 77 artists chosen for the inaugural exhibition in the various galleries and spaces. Gehry's structure also works masterfully in relation to those works which were selected to augment it. More adventuresome than Isozaki's building Gehry's Temporary Contemporary sits at the end of a cul-de-sac in a former warehouse near a predominantly Japanese section of downtown Los Angeles. Whereas Isozaki's formality suggests artists of a more abstract and refined approach to painting, Gehry's space is more open and flexible, allowing for works of Pop, Conceptual, Luminist, Neo-Expressionist, and even Earth Art to coexist without diverting from the internal discourse of each artist's statement. More than divert from the intentionalities of the various works, Gehry's space actually allows for interesting discoveries which otherwise might not be seen. For example, a penciled word-piece by Conceptual artist Robert Barry offers a striking contradiction to the early word-paintings of Californian Ed Ruscha. Sol LeWitt's Structuralist seriation of modular arcs is visually counterpoised with a major new large-scale piece by sculptor Richard Serra. Similar to a work shown a few months earlier at Leo Castelli's Greene Street gallery, Serra's current *Call Me Ishmael* involves two enormous Cor Ten steel plates, each measuring 12 feet by 52 feet by ½ inches. They are each exactly the same shape, though the way they are bent — that is, leaning to the side — suggests that they are different. What is particularly sensuous and magnificent about *Call Me Ishmael* is the manner in which they contain space and the manner in which they suggest a passage through the space. Somehow the architectural containment of Serra's piece by Gehry's renovated structure adds tremendously to the effect, perhaps much more so than if the piece were situated out-of-doors.

In Isozaki's building, the experience of viewing art is much quieter — without the deliberately conceived contradictions which Gehry, in fact, celebrates. The tall open spaces of the galleries give a magical presence to the work — a presence that makes grand work appear really grand, and less grand work to become evident. The selection for this component of "Individuals: A Selected History of Contemporary Art, 1945–1986" is definitely more Greenbergian and more obviously formal in its intention. Frankenthaler's early stained paintings from the 1950s make their point, perhaps better than in any other museum setting I have seen. The cross-hatched paintings of Ed Moses,

a Californian, extend the meaning of the grid into a dynamic lyricism; they have both strong and weak points. An adjacent gallery with large works by Yves Klein and Agnes Martin is profoundly thought-provoking and completely engaging. The large gallery with early black and red paintings by Frank Stella on one side and Cy Twombly's scribbled proto-graffiti paintings on the other is ambiguous. While the point of comparison between structure and lyricism seems clear, two of the Twomblys hardly match up to the power of the Stellas.

The "anti-art" hybrid forms of Eva Hesse suggest some form of participation. They are both formal and playful, a kind of organic Minimalism to offset the rigid epistemological ideas of Dan Flavin across the hall. Some of the very best Rothkos were selected for this exhibition, giving the gallery an inspired occasion. The calligraphic gestures of Franz Kline are in perfect company with the small-scale, welded steel sculpture of David Smith.

What may intrigue the visitor who attends this exhibition, spread out in two very different architectural environments, is not so much the qualitative consistency of the work (which is more likely to be found in the Isozaki building) but the richness of the total experience. The scale and selection of the work by curator Julia Brown Turrell is more than a lexicon of Modernism and more than a simple rehash of Neo-X (Schnabel and eventually Salle's traveling show, among others); it is an exemplary effort to show that the adventure of seeing good art is contingent upon many factors: architectural, economic, ideological, sociological and, of course, aesthetic. But this is the beginning of another discussion, more theoretical in scope.

25

Three Works by
Anastasi (1992)

The concept of the wall is a fascinating compression of a space-time continuum. To perceive a wall or the walls of a room is to determine a placement, the placement of where one is, as an arbitrary definer of one's physicality. This is, more or less, a Gestalt reading; but it could also amount to a phenomenological reduction, a projection of one's existential awareness at that moment, wherever and whenever that moment becomes realized. To perceive a wall as a wall is an act of recognition, but also a kind of dissolution of consciousness; in doing so, there is the determining factor of realizing the transmission of a geometric imagination, an imposition of someone's quantitative evaluation of space; however, the moment one enters into that preconceived space, time also becomes a factor. To recognize a wall as a wall is more than a meaningless linguistic exercise. In one sense, a wall represents the absence of an event. Rather than the emptiness of a room, one might consider the fullness of space as defined arbitrarily or as an objective corporality.

To construct a wall in conceptual terms is to construct an absence. Consequently, to deconstruct a wall is to relieve that absence of its burden of signification. It is worth considering that walls are grammatical incidents in such a case, transformers that move material into syntactics. Indeed, walls have both an objective and a subjective presence. They are grammatical incidents within culture in that they carry the weight of the space and the language that helps us define ourselves, however temporarily. They are neither without ideology nor without social significance. They are neither without psychological resonance nor are they without ontological provocation. Walls are as much about the culturally specific as they are about generalized notions of display, of decorum, of exhibition, of structure — indeed, of art.

Those familiar with Anastasi's work know about his fascination with walls. It is both a spiritual and a dialectical relationship. Anastasi's wall pieces are projected evanescences of the soul. They are hidden membranes that expose the theoretical conditions of aesthetics at the core of Minimalism. Yet Anastasi never aligned himself with Minimalism *per se*; that is, he never allowed his

William Anastasi, *Trespass II* (1991). Wall removal, 17 by 14 in. Courtesy Sandra Gering Gallery.

"frame" of reference to belong outside the resonances of his own search for those conditions. Theoretical conditions? For an artist so obsessed with the likes of Duchamp and Jarry — not to mention James Joyce (*Finnegans Wake*) — it is strange that such a term would enter into such a reductivist discourse. These conditions — that is, the conditions under which art is made — are perhaps less theoretical than emotionally intense, no matter how distilled the concept, no matter how vestigial the antagonism against the conformist notion of beauty or advertising or the processes of irretrievably mindless mediation.

William Anastasi, *Sink III* (1991). Steel, water, 19 by 19 by 1 in. Courtesy Sandra Gering Gallery.

Anastasi's art is about the conditions of chance. It is an art that establishes the conditions of chance between the perceiver and the perceived.

The artist's seminal painting *Wall on a Wall* (1966), initially shown at the Virginia Dwan Gallery the following year, revealed the development of a discourse that the artist was further investigating in *Trespass* and *Issue*. In each of these pieces the artist's attention was focused on the conditions of space/time in such a way as to connect the viewer's eidetic sense of a wall with the conditions of consciousness at that moment of receivership. Put another way, the processes of removal that are subtly apparent in both *Trespass* and *Issue* are metaphorical resonances that connect with a state of mind, a type of metamorphosis in which the viewer may relate to physicality as a conceptual action. One might talk about disappearance from several points of view — social, psychological, aesthetic, political. It would be inappropriate to limit the discourse. The power of Anastasi's wall removals is in their visuality, their premise of revealing in a direct and intimate way — a process, in fact — what has been concealed. To permit the surface beneath the surface to reveal itself, the conditions of a Minimalist aesthetic take on much more than a Gestalt or epistemological connotation. These resonances are, of course, there; but what is equally present is the fact of the artist's mind — the trace of cultural information distilled

through private experience — as the marks incise themselves into memory and consciousness.

Sink, the earliest of the works shown here, is less about the metaphor of removal and disappearance than it is about the tautology of things or the teleology of matter. These modular plates of steel, are, of course, refined aggregates of matter taken from the natural iron ore that is excavated from the earth. The impurities have been taken out of the iron ore in order for the steel to be made malleable. Anastasi discovered in an early version of *Sink* (1963) that by watering the steel plate as a diurnal routine the oxidation process incited by the constant water poured over the steel would, in fact, bring back the impurities removed from the natural alloy. Instead of removal, in the case of *Sink*, there is a recycling process, a regeneration of the etiology of the substance, and an evidence of paradoxical entropic manifestation. Again the metaphor of *Sink* is in effect insofar as one notices the transitory aspect of the piece as having to do with actual physical processes that happen within a space-time continuum: matter transforms itself by way of intervention and, to a certain extent, ritual.

In a recent conversation at his studio, Anastasi said: "Maybe I can make a kind of ideal utopia within myself and not have to wait for a general utopia." He was, of course, referring to the fact that idealism has its human limits and that paradise is not likely outside the state of mind that one recognizes through being in the world. This process of being in the world is most ebullient when the terms of idealism are reversed, not through cynicism, but through the rejection of paradise as something other than a mind-body process.

26

Allan McCollum's
Perfect Vehicles (1988)

The "Perfect Vehicles" have, by now, appeared in many diverse contexts according to various arrangements and numbers and have recently gotten much larger. The original vehicles, which I became acquainted with in spring 1986, were more like "objects" — more readily commodifiable. They sat on pedestals, generally below eye level, and tended to work playfully in a smaller room. The larger versions, which are figurative in scale, actually a bit larger than the Vetruvian Man, seem more related to architecture and, in one way, less associated with the plight of the artwork as commodity.

McCollum's work is, after all, to a large degree Conceptual in that he conceives of an idea or a plan and then proceeds to realize it in terms of a three-dimensional artifact. Even the earlier framed wall pieces of varying sizes are less about the frame than they are about the consumerist object, the thing desired, available to be plucked from the gallery space and inserted into one's domicile. Many artists I know have a grouping of these early cast frames and cherish them as signs of smart art — that which incites discourse upon visual contact and which offers itself as a decoy for art: a representation effected reversibly by mass culture and art world consensus.

If one were to imagine what twelve 6'5" vehicles were to look like, each painted in a distinct color taken from a commercial paint manufacturer's chart, the variety of responses could not be that distinct from one another. Apparently a great deal of effort went into organizing the placement of the vehicles so as to create the most stimulating interior to walk through and gaze upon them; in other words, to present objects in such a way implies a cynical view of the entire art world establishment. Yet, this ultimately becomes an anti-heroic gesture as if to offset the effect of much Neo-Expressionist painting.

It is impossible to dismiss the decorativeness of the larger vehicles in spite of what their cynicism is trying to encapsulate for the viewer. The photograph on the gallery announcement taken at the Venice Biennale last summer suggests a more interesting discourse than the context in which they are presented. The

Allan McCollum, *Five Perfect Vehicles* (1985–86). Acrylic on solid cast Hydrocal, 19½ in. each. Courtesy John Weber Gallery.

pristine designer colors taken from the everyday secular world of commerce and given to these figurative monuments (figurative in the sense of scale and shape) in an older space makes for an interesting statement, one that is clearly bound to a context, a site-specific instance.

In some sense McCollum's challenge is not far removed from that of Daniel Buren in the mid-seventies; that is, to make those striped configurations function politically they required an inventiveness of placement, one that would consider the exact place in which they would be seen. For McCollum to subvert the nature of recent art it would appear that his arrangement of the vehicles is an essential component of the work. On the contrary, one could always acknowledge their relationship to commercial logos which generally exist free of context; logos may appear anywhere at any time in any space and somehow communicate their referent, regardless of how annoying this fact of advertising might be. Logos are two-dimensional signs, however, and art — no matter how distanced from its origin — is not. The simpler the format the more obvious the context of its delivery becomes. Put another way, form cannot exist without a cultural space.

Notes

Section I.

Chapter 1.

1. Clement Greenberg, "Modernist Painting," in Gregory Battcock, ed., *The New Art* (New York: E.P. Dutton, 1966), pp. 100–110.
2. Harold Rosenberg, *The Tradition of the New* (New York: McGraw-Hill, 1965).
3. Marcel Duchamp, "The Creative Act," in Michel Senouillet and Elmer Peterson, eds., *Marchand du Sel* (New York: Oxford University Press, 1973), pp. 138–140.
4. David W. Ecker and Eugene F. Kaelin, "The Limits of Aesthetic Inquiry: A Guide to Educational Research," *Philosophical Redirection of Educational Research,* Seventy-first Yearbook, Part I (Chicago: University of Chicago Press, 1972), pp. 258–286.
5. Joseph Kosuth, *Protoinvestigations and The First Investigation* (1965, 1966–1968), Vol. I in J*oseph Kosuth: Art Investigations and 'Problematics' Since 1965* (no date or place of publication; distributed by Leo Castelli Gallery, New York City).
6. Octavio Paz, "The Ready-Made," in Joseph Masheck, ed., *Marcel Duchamp in Perspective*, The Artists in Perspective Series (Englewood Cliffs, New Jersey: Prentice-Hall, 1975), pp. 84–89.
7. Clive Bell, *Art* (New York: Capricorn Books, 1958; originally published 1913).
8. Robert Hughes, "The Decline and Fall of the Avant-Garde," *Time* (December 18, 1972), p. 112.
9. John Rockwell, "Today's Blank Art Explores the Space Behind The Obvious," *The New York Times* (Sunday, July 17, 1977), Section II, pp. 1, 14.
10. John Dewey, *Art as Experience* (New York: Capricorn Books, 1958; copyrighted 1934).
11. Suzanne K. Langer, *Problems of Art* (New York: Scribner's, 1957).
12. Bell, *Art.*
13. Sol LeWitt, "Paragraphs on Conceptual Art," *Artforum* (June 1967).
14. Ann-Sargent Wooster, "LeWitt Goes to School," *Art in America* (May-June 1978), pp. 82–84.
15. Lucy R. Lippard, "Sol LeWitt: Nonvisual Structures" in *Changing: Essays in Art Criticism* (New York: E.P. Dutton, 1971); previously published in Artforum (April 1967).
16. The author first saw this work during the Kienholz Retrospective at the Kunstmuseum, Zurich, 1971.
17. This version is presently installed at Oberlin College, Ohio.

18. Allan Kaprow is the author of numerous essays and articles dealing with various aspects of performance art in the avant-garde. His anthology, *Assemblage, Environments and Happenings* (New York: Harry N. Abrams, 1965), contains a major statement about the earlier work. Since 1973, some twenty booklets have appeared in the form of illustrative texts and or documentation of the more recent Activities.

19. Allan Kaprow, "The Education of the Un-Artist, Part I" in Gregory Babcock, ed., *New Ideas in Art Education* (New York: E.P. Dutton, 1973), pp. 73–90.

20. David W. Ecker, "Happenings In and Out of School: An Interview with Allan Kaprow," *School Arts* (March 1966), pp. 23–28.

21. Allan Kaprow, *Blindsight* (Wichita, Kansas: Wichita State University, 1979). The Activity was performed April 8–12, 1979.

22. *Ibid.*

Section II.

Chapter 5.

1. Witold Rybczynski, *Taming the Tiger: The Struggle to Control Technology* (New York: Penguin Books, 1983), p. 225.

2. Jack Burnham, "Art and Technology: The Panacea That Failed," in Kathleen Woodward, ed., *The Myths of Information: Technology and Postindustrial Culture* (Madison, Wis.: Coda Press, 1980), pp. 200–215.

3. *Ibid.*, p. 213.

4. *Ibid.*, p. 214.

5. Burnham, *Beyond Modern Sculpture* (New York: Brazilier, 1968) pp. 331–376.

6. Burnham, "Art and Technology," p. 212.

7. This was a popular slogan among the French avant-garde which eventually characterized the Dada movement.

8. This is to suggest that Mondrian's "style" shifted to a more secular point of view upon coming to New York in 1940.

9. It is a well-known fact that Ruskin's aesthetic position changed in mid-career from that of an aesthetic revivalist to that of a socialist.

10. See my essay, "The Spectacle in Time: A New Look at Art and Technology," *Arts Magazine*, Vol. 62, No. 2 (October 1987), pp. 76–79. The works discussed in this essay were from the collection of David Bermant.

11. See Martin Esslin, *The Theater of the Absurd* (Garden City, New York: Doubleday, 1961).

12. Raymond Roussel, *Impressions of Africa*. Trans. Rayner Heppenstall and Lindy Foord. (London: John Calder, 1983).

13. Gail Levin, "Forecasts: Visions of Technology in Contemporary Painting and Sculpture," Nerlino Gallery, New York (October 1988), catalog essay.

14. Gyorgy Kepes, "Introduction," catalog essay for exhibition "Tsai: Cybernetic Sculpture Environment," Cambridge: Center for Advanced Visual Studies, M.I.T., Feb. 6–March 3, 1971).

15. Rybczynski, *op. cit.*, p. 226.

Section III.

Chapter 9.

1. Maurice Merleau-Ponty, "Cézanne's Doubt" in *Sense and Non-Sense*. Translated by Hubert L. Dreyfus and Elizabeth Allen Dreyfus. Chicago: Northwestern University Press, 1964.

2. Vladimir Zakrzewski, taped conversation with Robert C. Morgan, Warwick, New York, June 4, 1990.

3. Zakrzewski had an earlier exhibition of his prints in New York at the Carlton Gallery in 1974.

4. Artist's statement, printed for exhibition at the Marian Goodman Gallery, New York, 1981.

5. Laszlo Moholy-Nagy, "Space-Time Problems," in R. Kostelanetz, ed., *Esthetics Contemporary* (Buffalo, New York: Prometheus Books, 1989 [revised]).

6. Laszlo Moholy-Nagy, *Painting, Photography, Film* (Cambridge, Mass.: MIT Press, 1967).

7. Zakrzewski, taped conversation, June 4, 1990.

8. Zakrzewski, typed sheet sent to the author, dated June 1990.

9. Henryk Stazewski, statement for catalog, *Vladimir Jan Zakrzewski*, Galeria Zapiecek, Warsaw, 1979.

10. *Ibid.*

11. *Ibid.*

12. Anton Ehrenzweig, "The Hidden Order of Art" in Matthew Lipman, ed., *Contemporary Esthetics* (Boston: Allyn and Bacon, 1973), pp. 395–396.

13. *Ibid.*, p. 398.

14. *Ibid.*

15. *Ibid.*, pp. 401–402.

16. *Ibid.*, p. 402.

17. Interview with Vladimir Zakrzewski, Amsterdam, the Netherlands, 1977.

18. Naum Gabo, "The Constructive Idea in Art," in Robert L. Herbert, ed., *Modern Artists in Art* (New York: Prentice-Hall, 1964), p. 109.

19. *Ibid.*, p. 112.

20. Zakrzewski, taped conversation with Robert C. Morgan, Warwick, New York, July 16, 1990.

21. *Ibid.*

22. Giles Deleusz, *Spinoza: Practical Philosophy* (San Francisco: City Lights Books, 1988).

23. Robert C. Morgan, "Formalism as a Transgressive Device." *Arts Magazine* (December 1989).

24. Marjorie Welish, "Vladimir Zakrzewski at Marian Goodman," *Art in America* (January 1982), p. 145.

25. Flip Bool, catalog essay, *Vladimir Zakrzewski: Paintings and Drawings, 1978–1987*, Haags Gemeentemuseum and Museum Bochum, 1987.

26. *Vladimir Zakrzewski: Drawings of the 1980s*, The Brooklyn Museum (Sept. 29–Nov. 27, 1989).

Chapter 10.

1. Ludwig Wittgenstein, *Tractatus Logico-Philosophicus*, trans. D.F. Pears and B.F. McGuinness (London: Routledge and Kegan Paul, 1961; original German edition, 1921), pp. 17–18.

2. *Ibid.*, p. 16.

3. Justus Hartnack, *Wittgenstein and Modern Philosophy*, trans. Maurice Cranston (Garden City, New York: Anchor Books, 1965), p. 25. According to Hartnack, "The historically developed language, which Wittgenstein calls 'everyday language,' is clothed in such a way that its logical form is not immediately apparent; it is veiled, and the business of logico-philosophical analysis is to unveil it" (see Proposition 4.002, *Tractatus*).

4. Wittgenstein, *op. cit., p.* 5.

5. An early example of this activity is suggested in Buren's essay entitled "Beware!", *Studio International,* vol. 179, no. 920 (May 1970), then reprinted in Ursula Meyer, *Conceptual Art* (New York: Dutton, 1972), pp. 61–77.

6. I have attempted to illustrate this important aspect of Kosuth's work. See my essay "The Making of Wit: Joseph Kosuth and the Freudian Palimpsest," *Arts Magazine* (January 1988), pp. 48–51.

7. Hartnack, *op. cit.* p. 18.

8. Wittgenstein, *op. cit., p.* 5.

9. *Tania Mouraud,* Centre D'Art Contemporain, CAC Pablo Neruda, Corbeil-Essonnes, Jan. 20–Feb. 27, 1989. Interview with Jerome Sans, n.p.

10. Ludwig Wittgenstein, *Notebooks 1914-1916* (2nd Edition), trans. G.E.M. Anscombe (Chicago: University of Chicago Press and Oxford: Basil Blackwell, 1961, 1979), p. 42c.

11. *Ibid.*, p. 42c.

12. *Ibid.*, p. 42c.

13. C.A. Van Peursen, *Ludwig Wittgenstein: An Introduction to his Philosophy,* trans. Rex Ambler (New York: Dutton, 1965), p. 40.

14. *Ibid.*, p. 40 (see Proposition 2, *Tractatus*).

15. Wittgenstein, *Tractatus,* p. 5.

16. *Tania Mouraud.*

17. Edward Conze, *Buddhism: Its Essence and Development* (New York: Harper Torchbooks, 1951), pp. 130–131.

Chapter 11.

1. Robert Smithson, "Frederick Law Olmstead and the Dialectical Landscape," in Nancy Holt, ed., *The Writings of Robert Smithson* (New York University Press, 1979), p. 121. Originally published in *Artforum,* February 1973.

2. Anne D'Harnoncourt and Kynaston McShine, editors, *Marcel Duchamp* (The Museum of Modern Art and Philadelphia Museum of Art, 1973) pp. 273–4.

3. Robert Smithson, "A Sedimentation of the Mind" in Holt, *Writings,* pp. 82–91. Originally published in *Artforum,* September 1968.

4. Rosalind Krauss, "Sculpture in the Expanded Field," *October 8* (Spring 1979), p. 44.

5. For a discussion of this work see Elyn Zimmerman, "Palisades Project and Related Works, 1972–1981," catalog to an exhibition organized by the Hudson River Museum (Jan. 24–March 14, 1982). Essay by Charles F. Stuckey.

6. John Beardsley, *Beyond Earthworks* (New York: Abbeville Press, 1989), pp. 61-62.

7. *Ibid.*

8. James Turrell, statement quoted in Beardsley, p. 163.

Section IV.

Chapter 12.

1. For a clarification of this term see Paul Tillich, *The Courage to Be* (New Haven: Yale University Press, 1952).

2. Reprinted in Andre Breton, *Manifestoes of Surrealim* (Ann Arbor: University of Michigan Press, 1969).

3. Reprinted by Grove Press, New York, 1960.

4. Referring specifically to Tobey's ink drawings, entitled Sumi (1957), which he made upon his visit to Japan.

5. It is curious that the gestural motif which Motherwell uses in many works of the "Samurai" series closely resembles the Japanese character for "samurai".

6. For example, Hsu Tao-ning (c. 1000 A.D.) painted magnificent lyrical scrolls depicting the Chinese landscape in a state of utter exhilaration induced by drinking wine.

7. For a discussion of syntagmatic progression see Roland Barthes, *Elements of Semiology* (New York: Hill and Wang, 1962).

8. This was expressed in a conversation with Motherwell in his New York home, December 1970.

Section V.

Chapter 21.

1. "The Users Waltz" was performed from July 20 through August 7 at the Funambules Theatre Club, New York City. It was written by Todd Alcott and performed by Eloise Zeigler, Brian Hotaling, Paul McMahon, and Kathryn Chilson. The performance was directed by Varda Steinhardt.

Index